Chuck
Close
Prints

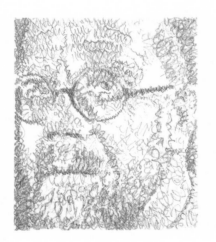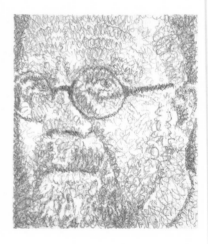

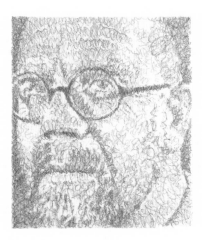 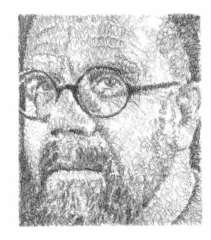

TERRIE SULTAN
WITH AN ESSAY BY RICHARD SHIFF

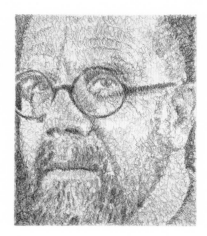 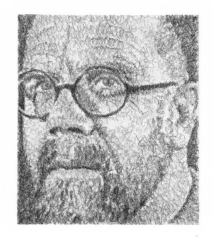

PRINCETON UNIVERSITY PRESS

BLAFFER GALLERY, THE ART MUSEUM OF THE UNIVERSITY OF HOUSTON

Chuck Close Prints

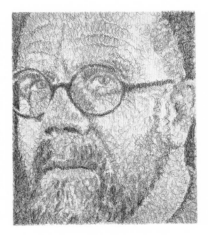 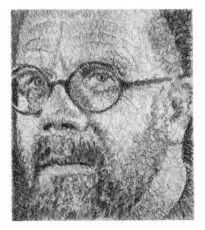

PROCESS AND COLLABORATION

The Neuberger Berman Foundation is proud to underwrite the publication and exhibition **Chuck Close Prints**, organized by Blaffer Gallery, the Art Museum of the University of Houston.

The Neuberger Berman Foundation was established in 1999 by the investment advisory firm of Neuberger Berman to support the arts and charitable giving.

NEUBERGER BERMAN
FOUNDATION

The exhibition was made possible, in part, by a major grant from Jon and Mary Shirley, and by generous grants from The Eleanor and Frank Freed Foundation and from Houston Endowment Inc.

Financial support has also been provided by Jonathan and Marita Fairbanks, Dorene and Frank Herzog, Andrew and Gretchen McFarland, Carey Shuart, and The Wortham Foundation, Inc., with additional funds from Karen and Eric Pulaski, and Suzanne Slesin and Michael Steinberg.

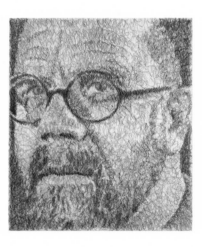 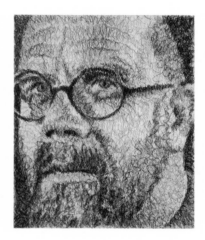

Front cover: **Self-Portrait/Pulp**, 2001 (plate 46)
Back cover: (paperback and cloth edition, top): Chuck Close checking **Self-Portrait/Pulp**, 2001 (plate 62); (cloth edition only, bottom): Printing **Self-Portrait/Pulp**, 2001. Photo: Dieu Donné Papermill
Casing and endpapers (cloth edition only): **Self-Portrait/Pulp**, 2001 (detail of plate 46)
Pages 1–7: **Self-Portrait/Scribble/Etching Portfolio**, 2000, progressives 1–12 (plates 124–35)
Pages 44–45: **Lucas/Woodcut**, 1993 (detail of plate 106)

CONTENTS

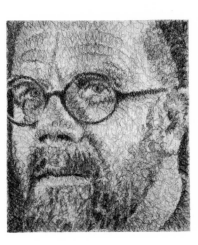

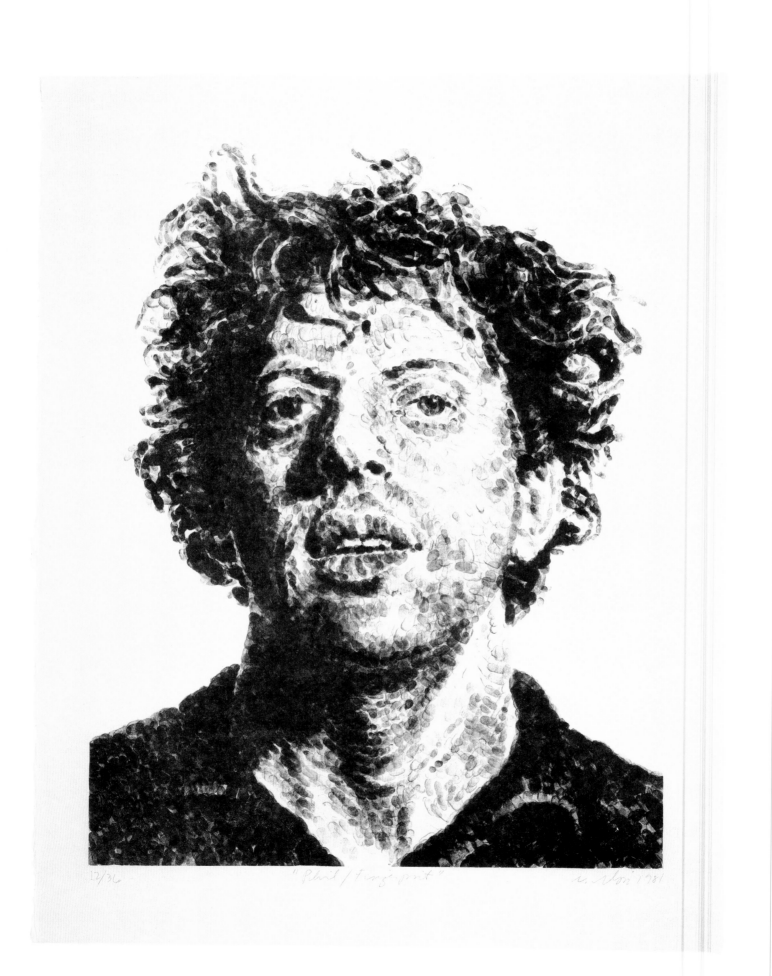

12/36 "Phil / Fingerprint" C. Close 1981

INTRODUCTION

Chuck Close Prints

TERRIE SULTAN

CHUCK CLOSE HAS DEVELOPED A STRATEGY for mapping the world in a system of visual metaphors. His paintings, photographs, and prints mark an intersection between representation and abstraction that is simultaneously of the moment and timeless. Close makes his paintings through a rigorous process of creating and editing a series of abstract marks that coalesce into a coherent representational image. He has often described his artistic methodology as a series of corrections, sometimes evoking the metaphor of a golf game, in which players move from the general to the specific, starting with the biggest, broadest stroke and refining their activities incrementally until they reach the ultimate goal. That metaphor grew out of Close's engagement with the art of printmaking, and it reinforces how he builds his images layer by layer. The imposed order and extremely precise practices inherent in traditional printmaking allow him to translate the language of paintings into another idiom, with shades and nuances conveyed through an entirely different set of notations.[1] Early in life Close developed systems to help him with his difficulties memorizing school lessons. Similar processes of systematization, developed and reinforced through his love of printmaking, have become the basis of his studio practice. "Virtually everything that has happened in my unique work," he asserts, "can be traced back to the prints."[2]

Close's paintings are labor-intensive and time-consuming, and his prints are more so. While a painting can occupy Close for many months, it is not unusual for one print to take more than two years to complete, from conception to final edition. And with few exceptions—separating the Mylars for silk screens or carving the woodblocks—Close insists on a decidedly interactive approach to the creation of

his prints. He carves linoleum blocks, draws on and applies acid to his etching plates, and personally directs all the intricate handwork involved in pulp-paper multiples. He also revels in his collaborations with master printers: "Like any corporation, I have the benefit of the brainpower of everyone who is working for me. It all ends up being my work, the corporate me, but everyone extends ideas and comes up with suggestions. It is a very different attitude than coming into an atelier, drawing on a plate, and giving it over to printers to edition. My prints have been truly collaborative, even though control is something that I give up reluctantly."

The relationship between Close and the master printers is key to the success of his prints. But it is only part of the story of this collaboration. The other essential element is the role of the publishers who, Close emphasizes, "put their money and their faith up front." In this regard, Close has been fortunate in working with visionaries who place their trust in what is essentially an unknown outcome. The early prints were published by Robert Feldman of Parasol Press, Ltd., and Kathan Brown of Crown Point Press. Since the late 1970s, almost all of Close's prints have been published under the auspices of Richard Solomon at Pace Editions, Inc., in New York.

Close has described himself as "an artist looking for trouble" because pushing the limits of a technique gets him in trouble, and extricating himself from a technical corner becomes an essential catalyst to his creativity. Prints often provide the arena in which he can work out solutions to the aesthetic problems his restless imagination poses. "Prints have moved me in my unique work more than anything else has," he asserts. "Prints change the way I think about things." Often he will experiment with a new approach and then set it aside, letting it rest before returning to the problem with a new point of view. "I have said for many years that problem solving is greatly overvalued in our society. Problem creation is much more interesting. The questions you ask yourself are the most interesting, because they put you in a jam. Then your solutions are going to be personal solutions, not art-world solutions. If you can ask yourself the right kind of questions, the solutions become self-generating."

Close credits Jasper Johns as one of the primary inspirations of the printmaking renaissance that began in the 1960s: "Jasper elevated the print from ugly stepsister status to princess of the ball. It was clear in his prints that he was serious about creating a physicality and quality of visual experience that was different from, but equal to, his paintings." Johns and many other artists of his generation made some of their first prints at Universal Limited Art Editions (ULAE), founded by Tatyana Grosman in 1957. It was at ULAE and at the Tamarind Lithography Workshop (founded by June Wayne in 1960) that the notion of a collaborative printer was

established as a professional category. Ironically, Close has never worked with ULAE, perhaps because the primary focus there has been on lithographs. Although Close did make several early lithographs, including Phil/Fingerprint (plate 1) and Keith/Four Times (plate 2), he never felt entirely comfortable with this medium. "I don't like litho because it is all chemistry. You must work within the difficult-to-control tendency of the stone to attract or repel ink. You might get an image that you like in proof, but in edition, one chemical reaction can change everything. I like tooth— something I can dig my fingernail into. I want to carve, I want to etch, I want to play around with pulp. I want to squish things with my fingers. I want to lay on color so you can see one layer on top of another. I don't want ephemeral, chemical change. I want that physical experience."

Close's long engagement with prints began in the early 1960s, when he was completing a double major in painting and printmaking at Yale University. He studied technique with the renowned printmaker Gabor Peterdi and the history of prints with Egbert Haverkamp-Begemann, the noted scholar and curator, who was then teaching at Yale. Close also took care to study Yale's fine print collection. "We were allowed to see and touch remarkable prints by Rembrandt and Dürer, among others. I could study state proofs of Rembrandt's Descent from the Cross, and I was able to clearly see the choices and decisions that Rembrandt had made. I could hold them a few inches from my nose, I could touch them and feel the tooth of the etching. Most important, I could see the process evolve through the progressive states. I really understood printmaking for the first time then." Another important aspect Close gleaned from Yale's print collection was an understanding of the essentially collaborative nature of printmaking. "In those Dürer prints I saw that the artist had done what was easiest for him. He glued a sheet of paper on a block of wood and drew with a pen. The easiest way to draw tonal gradations with a pen is to make a crosshatch stroke. The hardest thing for the printer who must follow the artist's drawing to do is cut a crosshatch, because you have to go in and cut out the little spaces between. If Dürer had to cut his own block, he would have made only one crosshatch drawing and then said, 'Hey, wait a minute, what am I doing? I have made something so difficult.' He would have immediately abandoned cross-hatching. But because other people cut the block, he could go ahead and draw whatever he wanted, and it became their problem."

Keith/Mezzotint (plate 28) was a defining experience for Close, establishing many of the practices that would propel him over the next thirty years: relentless self-education, ambitious innovation, and extremism in both scale and technique. Close was clear about what he wanted and didn't want in a print. "A lot of artists for a lot of years didn't know much about making prints, and what they

got was a photomechanically derived offset reproduction on a good piece of paper. My generation of artists was the first to be educated through graduate school, and we all studied printmaking. We are not afraid of the medium, and we know what it is to put ink on paper in a variety of mediums." *Keith/Mezzotint* was the first print Close had undertaken since graduate school, and the first since abandoning his early abstract style. He deliberately selected a process that, though popular with eighteenth- and nineteenth-century artists, was little used by his contemporaries. In that sense, his decision was audacious: neither he nor printer Kathan Brown at Crown Point Press knew how to make a mezzotint, and they had to learn together. His determination to pursue this difficult medium was complicated by his decision to work on a scale—51 x 41½ inches (129.5 x 105.4 cm)—heretofore unheard of for

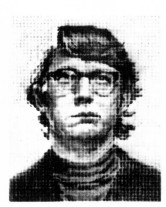

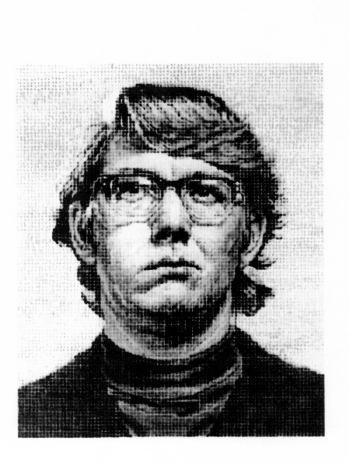

PLATE 2
Keith/Four Times, 1975
2-color lithograph from
8 stones
30 x 88 in. (76.2 x 223.5 cm)
Edition of 50
Landfall Press, Chicago,
printer (Jack Lemon,
David Keister)
Parasol Press, Ltd.,
New York, publisher

mezzotint. Crown Point Press had to acquire a special press just to be able to print Keith. For several years Close had based his mammoth painted portraits on a grid system that disappeared with the completion of the painting. In *Keith*, Close purposefully revealed the grid that had been the invisible armature for his painting system. The minute details of Keith's face are conveyed square by square, so that the print reads like a topographic map. Conflating iconography and methodology, *Keith* foreshadows Close's later decision to reveal the grid matrix in his painted portraits.

By 1977 Close had become deeply engaged in all aspects of printmaking. As printmaking became a well-established part of his studio practice, many editions followed, using different techniques and a diverse range of publishers. These include the lithograph *Keith/Four Times*, created at Landfall Press in Chicago (plate 2);

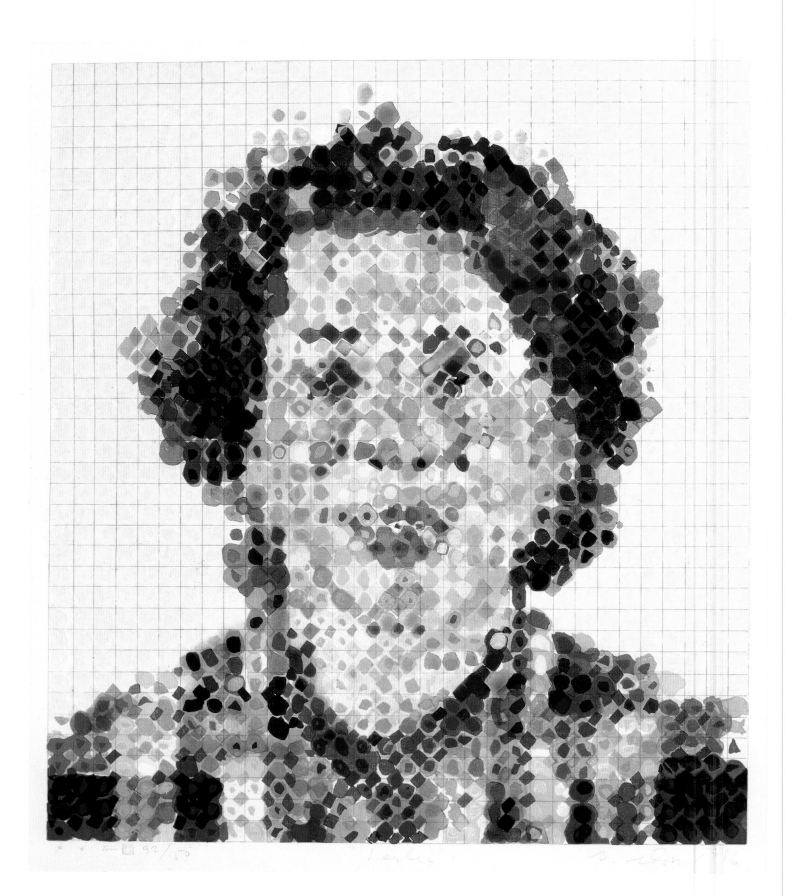

etchings for Graphicstudio, at the University of South Florida (1985); his first wood-block print, *Leslie* (plate 3), created in Kyoto, Japan, with Tadashi Toda for Crown Point Press; his first spitbite etching, *Self-Portrait* (plate 63), made with Aldo Crommelynck in New York; and—in what signaled a major expansion of his printmaking reper-toire—pulp-paper multiples with Joe Wilfer in New York (1981). Wilfer was appointed publications director for Pace Editions in 1984, a position he held until his death in 1995. During this time, Wilfer worked with Close on many multiples and prints, serving as his quintessential problem solver. "Joe was a very creative guy. I remem-ber when I was trying to make color prints, and we needed a way to make finger-print drawings in yellow, red, and blue, and have them print in black. But the yellow didn't block light, so you couldn't use it to block out a plate. So he thought of us-ing PABA, the stuff that is in sunblock, grinding that into the ink, so even though it was transparent yellow, it would not let the light through. This was the way he thought. There was never a mistake so big or an accident so great that he couldn't use it somehow." Wilfer encouraged, teased, and pestered Close into exploring the possibilities of pulp paper, a medium the artist had previously dismissed as being too craft-oriented. The resulting body of work consists of eighteen editioned paper multiples, as well as a number of unique works. Close recently returned to this medium with *Self-Portrait/Pulp* (plate 46). Developed and executed by Wilfer's col-leagues Ruth Lingen and Paul Wong as a collaboration between Dieu Donné and Pace Editions, this extremely complex stencil pochoir pushes pulp paper to a new level of sophistication.

Each time Close approaches a print, the making is different, and so is the visual experience. His interpretation of his iconography over time results not so much in similarities as in differences, as if each image were the artist's first take or initial perception. Close recycles images. His subjects repeat over and over. We be-come familiar with Phil (Glass), Keith (Hollingworth), Leslie (Close), Alex (Katz), and of course the artist's own visage. But in many ways Close's familiarity with the por-trait subject is beside the point. Beyond the physical resemblance inherent in any portrait representation, his print images fascinate because they reveal how they were constructed. The lithograph *Phil/Fingerprint* (plate 1), the pulp-paper *Phil III* (plate 36), and *Phil Spitbite* (plate 66) are all based on the same photograph, yet each time Close addresses the image of Phil, he blurs the certainty of achieving a definitive depic-tion. What we become enmeshed in is the freedom with which Close manipulates the convention of representation, maneuvering tonal valuations to suit the enforced order of grid-based seriality. The extremes of this approach can be seen in two prints of Alex Katz made within two years of each other. The shimmering ninety-five-color Japanese-style ukiyo-e woodcut *Alex* (plate 94) is a hallucinatory composite of abstract

PLATE 3
Leslie, 1986
Woodcut
30 x 25¼ in. (76.2 x 64.1 cm)
Edition of 150
Tadashi Toda, Kyoto, printer
Shunzo Matsuda, block cutter
Crown Point Press, San Francisco, publisher

gestures assembled from forty-seven woodblocks that culminate into a recognizable image. *Alex/Reduction Block* (plate 72), on the other hand, establishes a nearly corporeal verisimilitude. The oppositional stance of these two pieces—each deriving radically different solutions from the same image—embodies how Close is "always looking for how one piece can kick open the door for another possibility."

All of Close's art presents an abundance of information in a dislocating scale that alters the terms of engagement between viewers and his art. Our role as viewers is to determine the relationship between the parts and the whole and to discern between the surfaces of his representational inventions—brush strokes, fingerprints, dots, dashes, pulp-paper particles—and the host of competing metaphors for legibility or illegibility that they suggest. In some ways portraiture is a honey trap for Close, an alluring veneer that attracts viewers only to bring them face-to-face with reality unmade into a host of competing compositional marks. In this sense, Close's portraiture is not so much psychological as perceptual. Whether the surface of his images must be visually pierced, as in his early works, or pieced together, as in his most recent art, the recognition that the sitter is Phil or Keith gets us no further than the basic act of categorizing, of separating A from B. To understand these images, we must return to the artist's notations, to the means he has used. His individual marks can be read as diaristic entries in his daily effort to express an image. Taken together, they create a portrait of Close's sensibility, vision, and intellect that is more revealing than any of his self-portraits.

This book is entitled *Process and Collaboration* because those two words are essential to any conversation with Close about his prints. The creative process is as important to him as the finished product, and these works strive to reveal the routes taken to get to them. Showing the progressive and state proofs here along with the editioned work demystifies the artist's decision-making process, allowing us to visualize how these complex images are made, how he was thinking when he made the mark. "My images are like variations on a composition originally written for violin and piano that can be rescored for different instruments. It will have the same melody line, but it will become a different experience."

NOTES

1 Traditional printmaking is defined as those works made by means of a separate printing surface, called a "matrix"—etching plate, lithography stone, woodblock, or stencil—that is interposed between the artist's hand and the final image. This distinguishes hand-drawn printing techniques from photographic reproduction.

2 All quotes by the artist, unless otherwise noted, are from a series of interviews conducted by the author between May and August 2002.

Gatefold (left to right):
Details of plates 63, 40, 32, 79, 46, 137, 91, 136

Page 17:
PLATE 4
Detail of plate 96

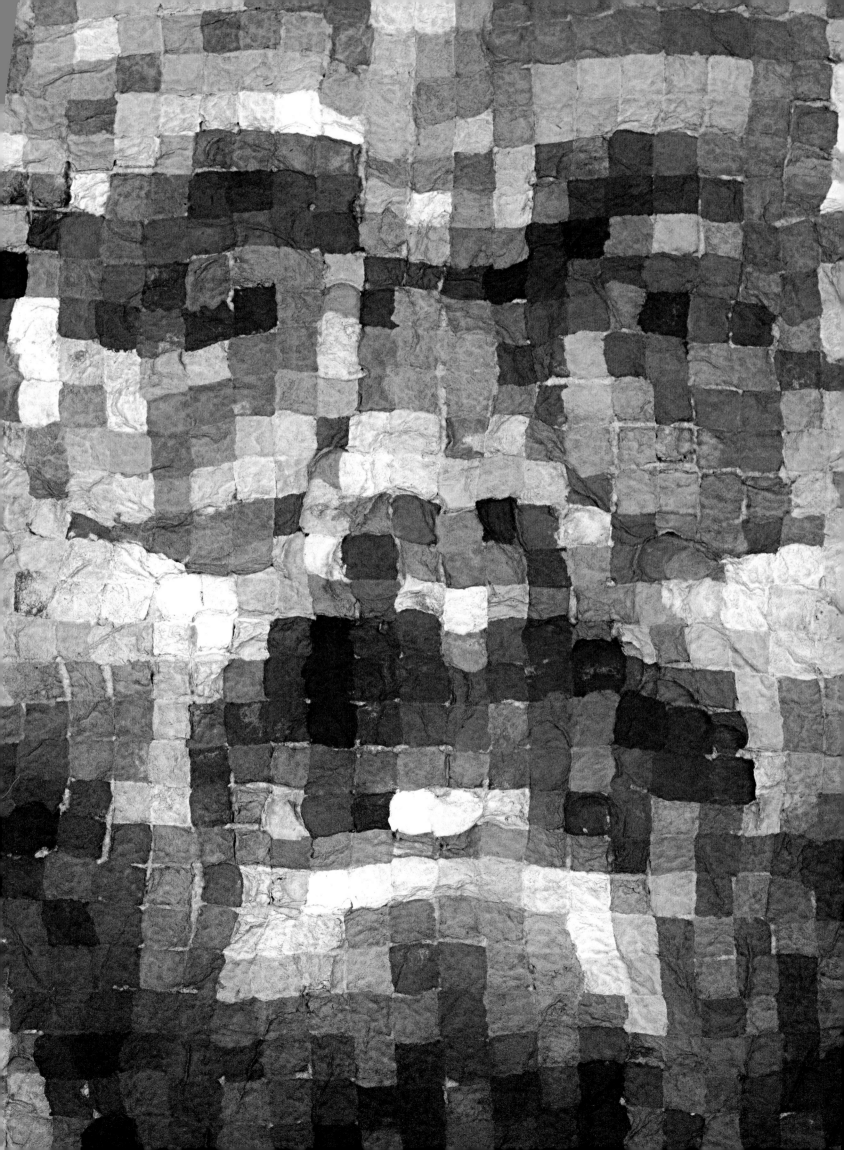

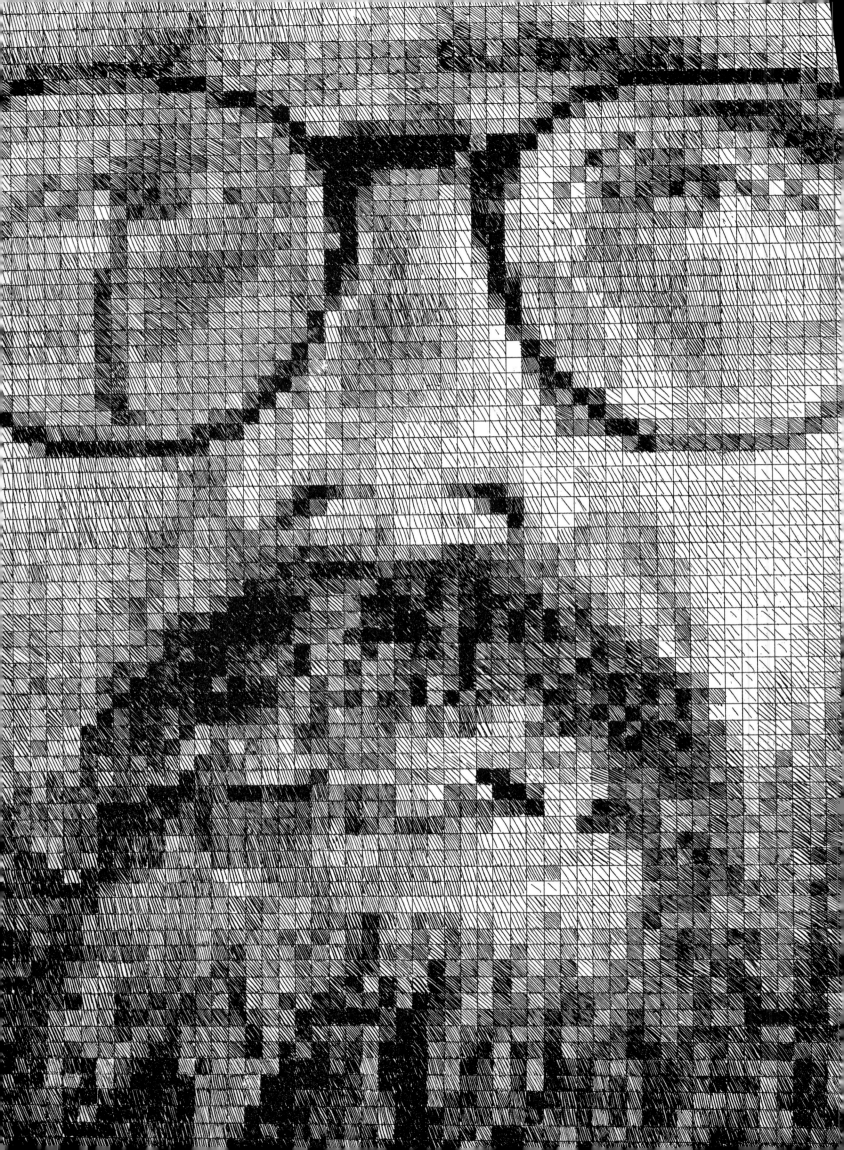

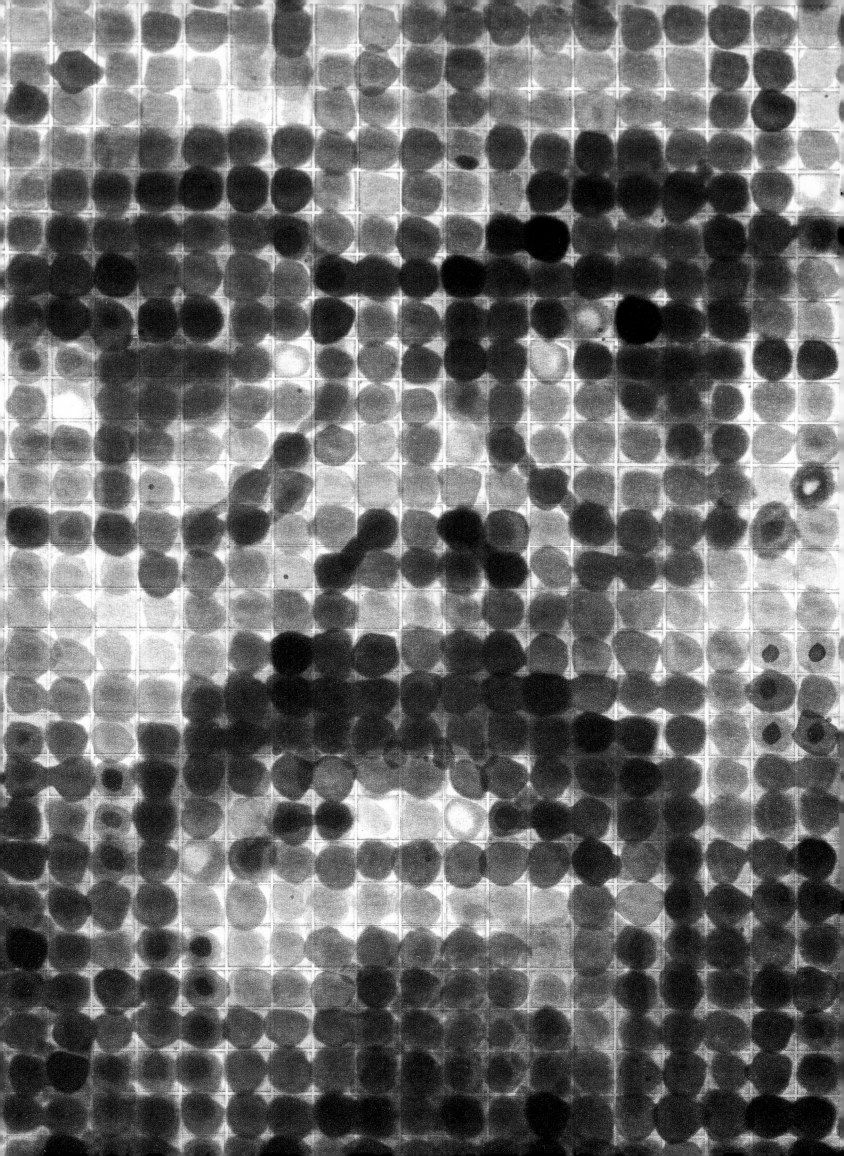

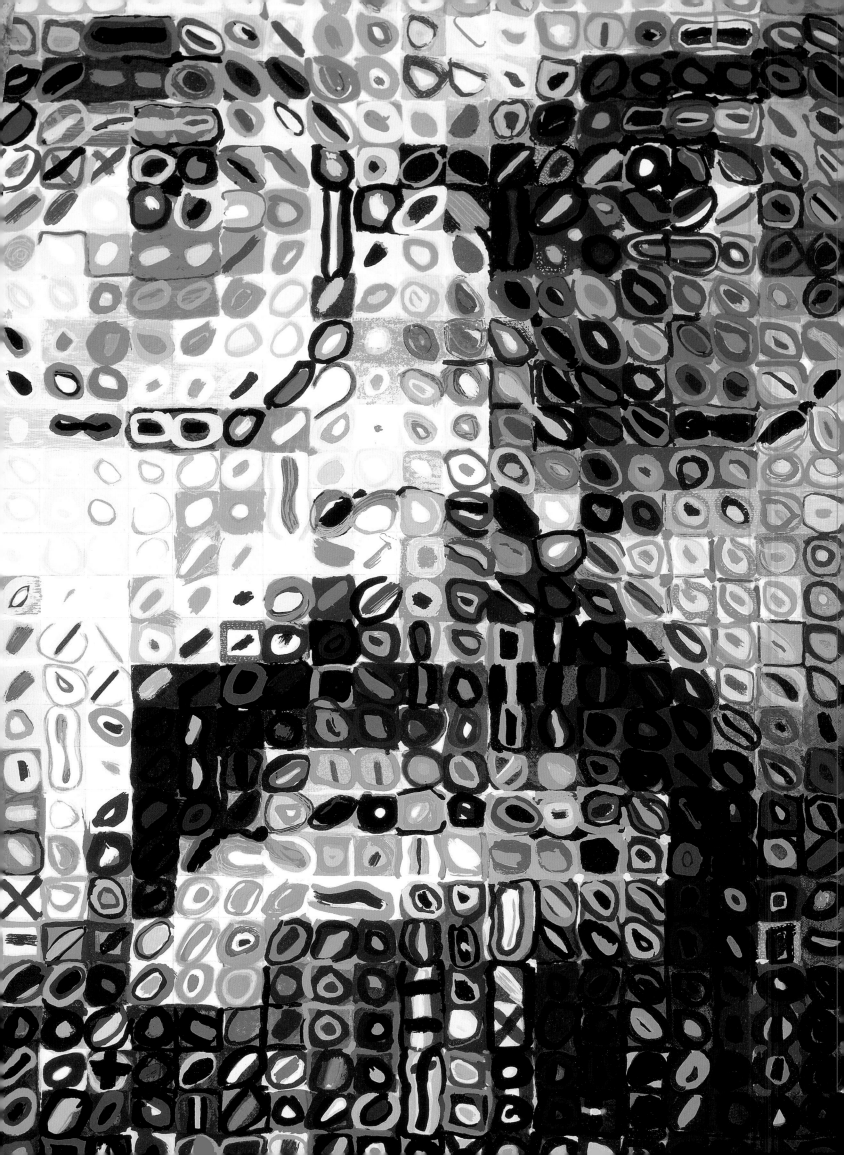

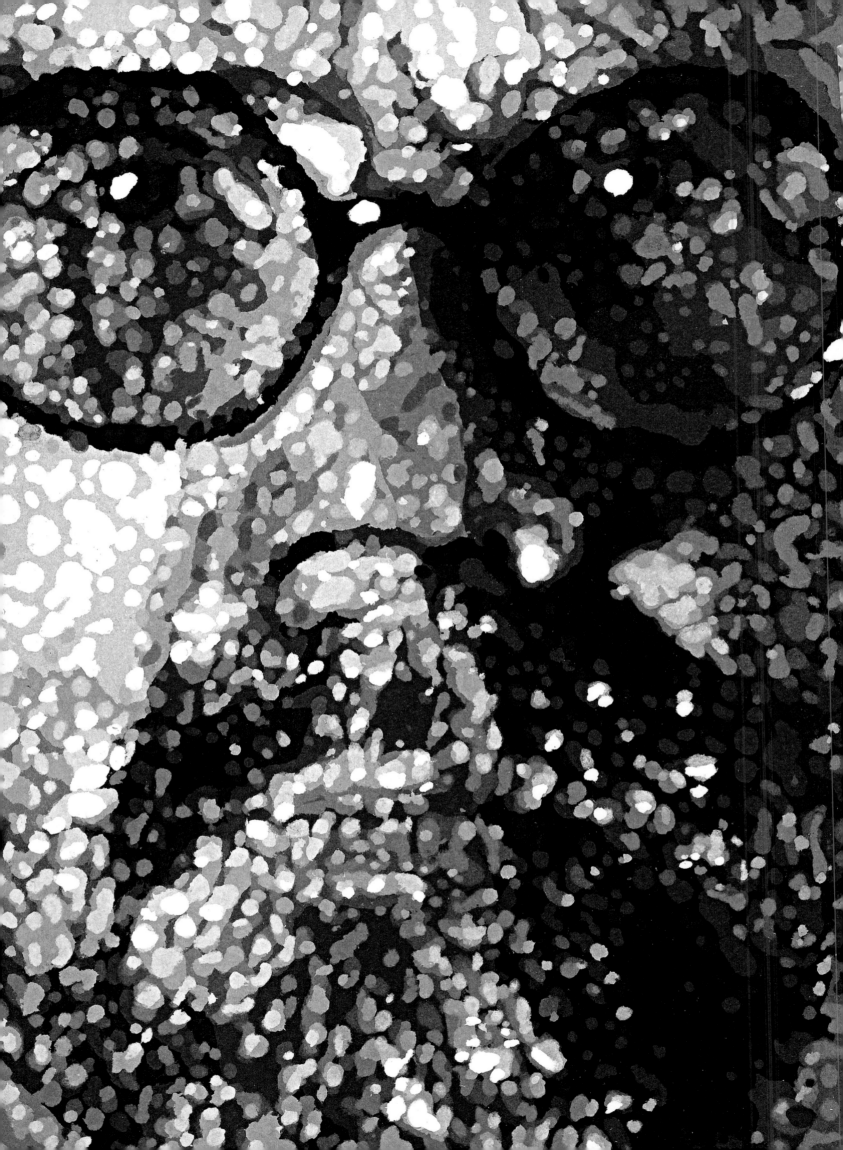

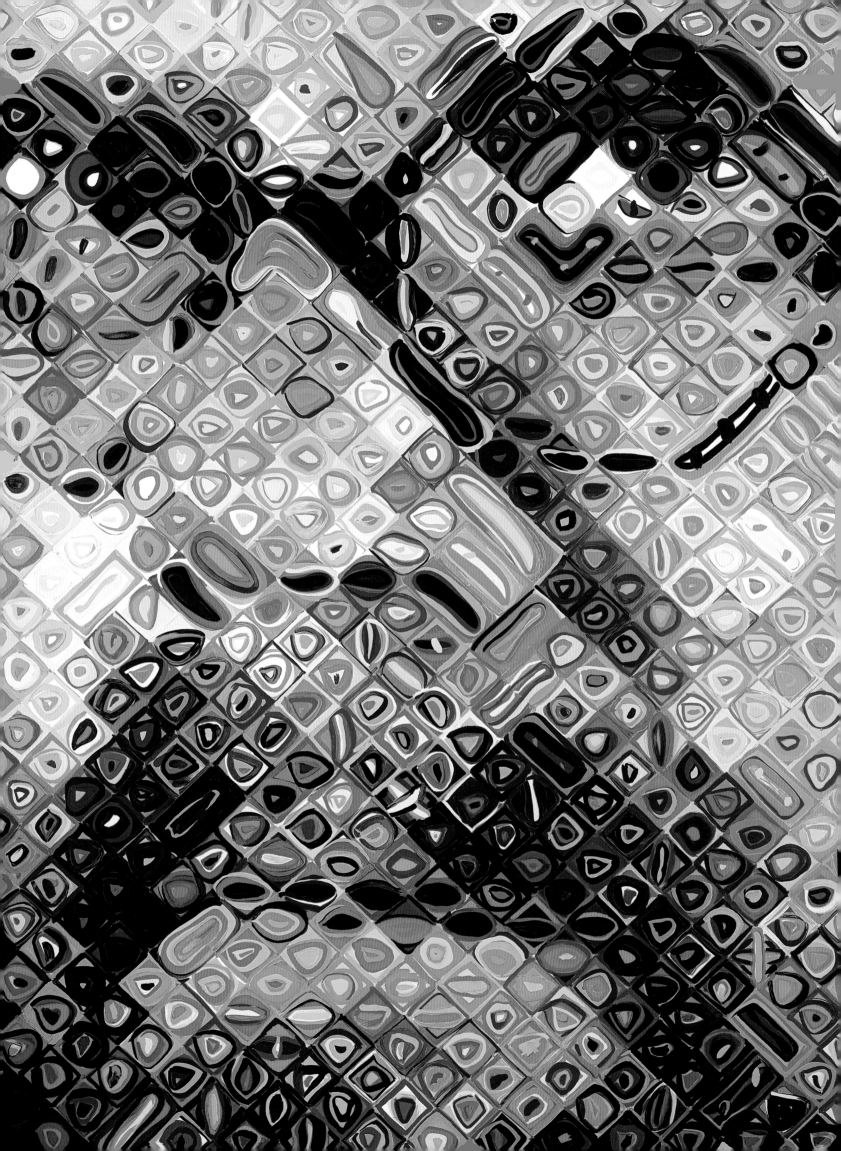

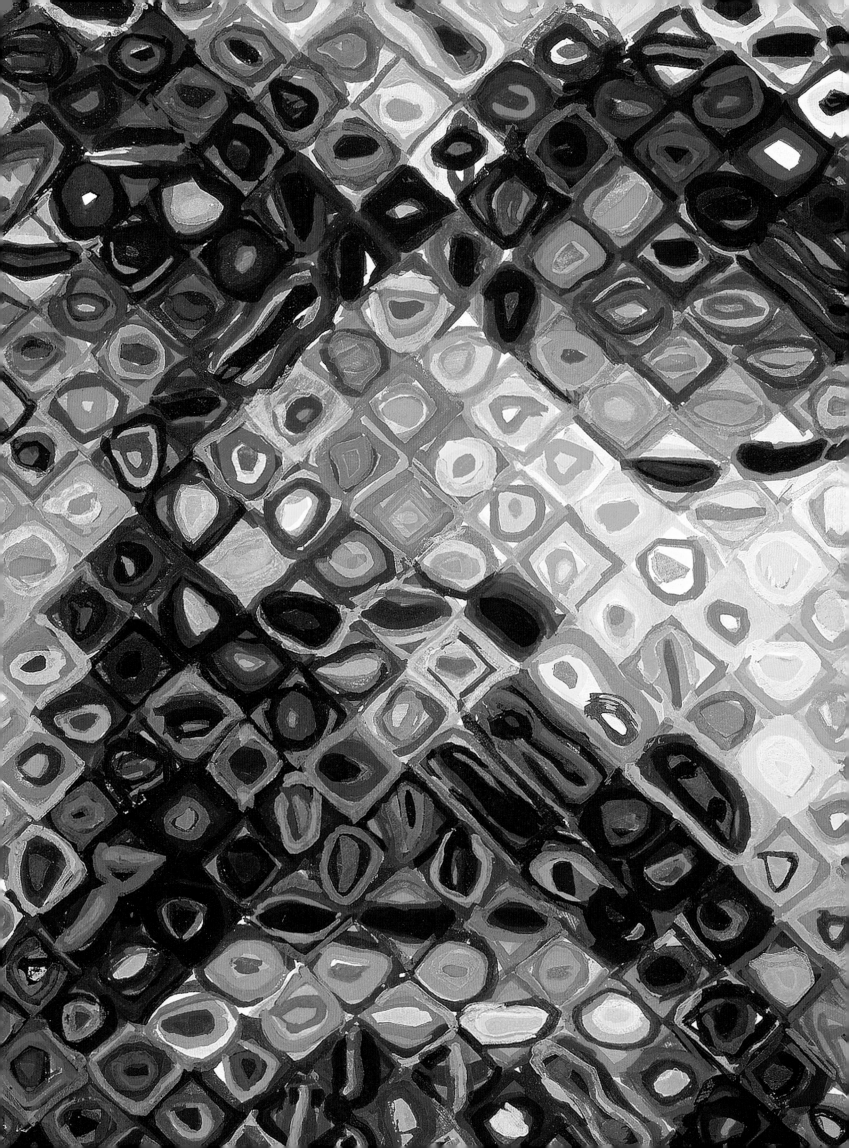

Through a Slow Medium

RICHARD SHIFF

It is the compulsion, the absolute constraint upon us to think otherwise
than we have been thinking that constitutes experience.

—CHARLES SANDERS PEIRCE,
"Phaneroscopy or the Natural History of Concepts," c. 1905

I make experiences for people to look at.

—CHUCK CLOSE, 2002

A FAMILY PHOTOGRAPH taken when Chuck Close was about six years old shows him
dressed as a magician (plate 5). Magic was but one of his youthful talents in arts of
illusion. While becoming adept at sleight-of-hand, he also began to paint in oils with
unusual facility, quickly acquiring the technique of perspective after seeing a few ex-
amples. Initially, magic may have been the more advantageous skill: not only did
Close excel at it, but it also attracted an admiring audience of his peers. He didn't en-
joy such status in more typical childhood endeavors. A learning disability set him back
in most of his classroom studies, and thick eyeglasses made him an awkward athlete.[1]

　　To an attentive audience, even familiar acts of magic hold surprise and
seem new because the routines defy the normative order of nature. By C. S. Peirce's
reasoning, magic should provoke a strong form of "experience." This is because it
forces people to question the state of things—what they know and how they know
it. Peirce associated experience with change in patterns of perception. Compelled
by the illusions of a magic act, a person reassesses belief and expectation, if only

for the brief moment that perception of the illusion lasts. Usually, it doesn't last long.

Chuck Close, magician become painter, creates "experiences for people to look at." According to many of his critics, the labels *photorealist* and *realist* ought to suit him. Yet both terms make him uncomfortable (for reasons that will become evident).[2] Certainly, his pictures provide information about real people—the shape of the head of "Jasper" or "John," the tonality of the skin of "Lyle" or "Robert"— observed elements that the model's presence would normally confirm. And viewers can return to Close's illusions at any time, from any angle. In this regard, they hardly resemble a magician's fleeting illusions, which depend on disguise or distraction to obscure links of cause and effect. To the contrary, Close performs his representational magic without deception. The process that causes the effect is apparent in the product . . . for the most part. I hesitate because Close's process lies in plain sight, yet its working sometimes becomes invisible.

The sources for Close's painted portraits are not his models but their photographs. Printmaking adds another transformation to the relationship established between painting and photography. Some of Close's graphic works take a finished painting or drawing as the model, and some return instead to the antecedent photograph. Others use an earlier print work as the source: *Self-Portrait/ Pulp* (plate 46) enacts a transformation of *Self-Portrait I (Dots)* (plate 71), a reduction linoleum cut. Each visit back to a given face (already represented at least once) translates into a new experience of making, destabilizing what had been fixed. One medium or process inflects another. To complicate matters, Close's involvement with the image in painting and printmaking affects his photography reciprocally; photography has become more than a point of reference to aid his other work. In 1979 he began to experiment with large-format Polaroid cameras, then later with new techniques of digitized ink-jet printing, and most recently with the daguerreotype process, a technology largely unpracticed for generations. Close moves from the historically oldest forms of photography to the newest ones and back again, exploring their potential.

When Close transfers an image from medium to medium over an extended period of working, he comes to understand visual representation by moving ever deeper within it, each repetition presenting a familiar image under a new aspect. A single photograph can serve as the source for numerous hand renderings, all of which resemble each other more convincingly than they may relate to the live model, a person physically changing through time. That person's photograph doesn't change. Rather, change occurs in the active production of the secondary image—everything that happens between the fixed source and its fixed final appearance. The nature of this change itself changes as Close moves from one

Kirk, 2002
Daguerreotype
8½ x 6½ in.
(21.6 x 16.5 cm)
Courtesy Pace/MacGill
Gallery, New York

medium or technique to another. Each image reflects its medium as much as it derives from the common source.

The term *aspect* is appropriate here because it assumes a fluid double meaning. First, it refers to the momentary appearance of a person's face, an effect that still photography was designed to represent. Second, *aspect* has a technical sense, consistent with its use in linguistics where it pertains to the general nature or state of a process, as signified by the form of the verb. The aspect marks temporality: the beginning, continuation, habituation, progression, repetition, succession, duration, or ending of an action are among the features expressed by verbal inflection ("he was going," "he kept going," "he used to go," and similar constructions).[3] As complicated as the temporal factor in discursive narration can become, the possibilities of *visual* inflection are much greater and not readily expressed in words. Consider Chuck Close as today's master of visual inflection, creating experience in space and through time ("for people to look at," as he says in deliberately low-tech language).

It may seem that when an artist fixes a person's appearance ("aspect" as countenance), the temporal factor ("aspect" as process) vanishes. One aspect renders the other inapparent. Yet the quality of an illusion and the resemblance it brings to mind are contingent on the process that generates these effects. All art, including photographic art, embodies a tension between the two kinds of aspect. There is always a process and always a result. When Close photographs his subjects, he radically reduces the depth of field (process), preferring to set his model right next to the camera—"at a near-licking distance from the lens," says Kirk Varnedoe, having become a daguerreotype (Kirk; plate 6).[4] By dramatically compressing the area of the subject's head that appears in sharp focus, this variation on photographic practice accentuates the play of optical resolution typical of views projected through lenses. Although Kirk follows mechanical and optical laws, the result is strangely unfamiliar as a picture.

The characteristic effect of Close's daguerreotypes may seem ironical to those who know the history of the medium. Its nineteenth-century masters exploited

whatever capacity it had to present detail crisply. To this end, they distanced the apparatus from their subjects, extending the focal area while also struggling to eliminate the blur that would result from movement. Close now violates the hard-won, pragmatic conventions for studio portraiture. Having controlled movement by increasing the illumination and reducing the exposure time, he willfully reintroduces blur in the fuzziness caused by the severely restricted focal area. Nothing about the medium dictates a proper pictorial standard—tradition's type of resolution as opposed to Close's. Typically, the area of sharpest focus in Close's photographs appears on the plane of the cheekbones, eyes, and mouth, with the tip of the nose in front of that plane and the ears behind it both far less resolved: "sharp focus data within a sandwich of blur."[5]

Because the variation in focus is graduated, a representation of continuous space results, suggesting that the image is an immediate totality as opposed to a constructed composite. Close incorporates this type of focal variation in his paintings and prints in imitation of the photographic effect, representing a photographic result in terms of a hand-rendered process. By using a grid as the transferring device (and even without one), he creates paintings and prints bit by bit, as composites. This divided, segmented construction applies even to Close's airbrushed black-and-white "continuous tone" paintings, such as Big Self-Portrait (1967–68; Walker Art Center, Minneapolis) or Phil (1969; Whitney Museum of American Art, New York). Despite their aspect of instantaneous wholeness, Close generated these works according to the sequence of the grid, square by square. Each of the visually continuous strands of hair was the product of multiple applications of pigment that might have been days apart, or even more if the hair happened to cross a grid line. A long strand might intersect with several orthogonals, its continuity cut by Close's painting process at every crossing. Yet here the generative method is hidden by its result.

We tend to call a picture "realist" when the fixed aspect, not the process, dominates. Initially, Close called his early black-and-white portraits "heads" to stress the importance of their impersonal, process-oriented construction—he was certain he wasn't doing portraiture, nor was he a realist or even a photorealist.[6] Yet most features of his process became invisible to viewers because of the strength of his illusion. Without the advice of an art historian, a person is likely to regard paintings having firm contour lines or copious elements of detail as inherently more "realistic" than Impressionist or Expressionist paintings that leave contours unresolved and manifest a larger individual mark. The latter type of painting features a changing, generative aspect. Though complete by the standards of its own method, its sketchlike surfaces connote a state of being "in process," a transition as yet incomplete. Modern artists have often created this process-effect to indicate the imme-

diacy of their observation of nature or their involvement with their own mercurial emotions. Signs of process can also indicate an artist's physical struggle with the material medium.

Whether the medium is photography, painting, or printmaking, temporal experience is central to Close's arts, either as the representation of a moment (the observational, photographic aspect) or in the systematic transfer from the image of photography to that of a painting or print. The difference in aspect, felt as Close works his way through the transformation, can be recognized as a temporal difference from the very start: "A photograph is complete in an instant," he states, "but a painting is incomplete until it is finished; with a painting, each thing you add changes what is already there."[7] An "instant," of course, is not no time, but time imperceptible under ordinary conditions. The temporal nature of Close's painting and printmaking should be correlated with the many imperceptible shifts that combine into the constructed whole of his image. These little details often have a grid to guide their sequence, but no aesthetic hierarchy to guide their order. The same applies to the human features Close represents: he determines not to expend more energy on an eye or mouth than on a tuft of hair, a blank passage of cheek or brow, or even a background of vague illumination. Yet every mark of a Close surface has followed upon some other mark with which it has engaged, joining its neighbors in a play of action and reaction. Take any small detail from the six images of *Keith/Six-Drawing Series* (plates 7–18), where Close represented the same "Keith" at the same scale in six different techniques of analysis and transfer. The chosen detail will prove to be different in each image, not only because the medium is different but because the internal structure has shifted ever so slightly to accommodate the immediate set of graphic and tonal relationships within the local context of the sheet. Look closely, in fact, at any Close illusion. Suddenly, even in full color and continuous tone, it won't look naive, unaltered, or natural.

AGAINST NATURE

PROUD OF HIS ARTISTIC ACCOMPLISHMENTS, Close is also modest, even self-deprecating. His nature, he claims, is to be "lazy and slobby and indecisive." To counteract these faults, he volunteers for new habits, willingly accepting structure in his life because he's fundamentally disordered. In 1997 he explained the situation to Robert Storr: "I realized that to deal with your nature is also to construct a series of limitations which just don't allow you to behave the way you most naturally want to behave. So I found it incredibly liberating to work for a long time on something even though I'm impatient . . . to make very neat, precise paintings."[8]

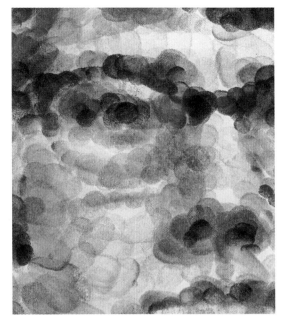
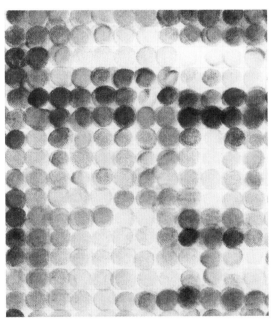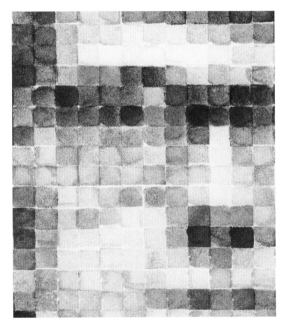
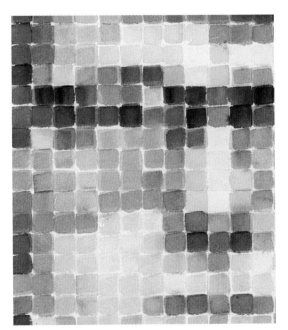

On another occasion, in 2000, he put it more bluntly: "You don't want to be held captive by your nature."[9]

This may be good folk wisdom as well as good therapy, but it resists the mainstream of modern art practice, with its mythology of self-expression. From the early-nineteenth-century Romantics forward, self-consciously "modern" artists sought to express their inner, independent selves, in the belief that they might transcend (or at least bypass) restrictive social conventions framed by ideologies of the past. The inner human nature of the individual would hold truth and freedom. Liberation for Close, however, meant imposing himself on himself. If his character flaws had originated in the social world, he had internalized the syndrome so thoroughly that freedom would require resisting his own nature, not revealing it. In other words, aid would come from engagement with the outside world, not by searching within. Just as one medium transforms the image of the other, so you reform and transform yourself—slowly, through practice in a medium. Printmaking is often the slowest of all: "I pump my ideas through a slow medium, and where you have to slowly build what you want, slowly find what you want instead of going directly to it."[10]

Close first engineered release from his all-too-human nature around 1965 to 1967, thoroughly critical of his talents. He had mastered the style of Abstract Expressionism, but it had simply been too easy for him. So change was in order. For his endlessly inventive but indecisive abstractions, Close substituted the rigors of imitating a photograph. Suppressing his natural talent for color, he restricted his imagery to black and white. The mechanics of airbrushing replaced his elegant, organic gestures; this new method required neither brush nor hand to touch the surface. "I was trying to get my hand out of there," Close explains. This concern, as much as any imitative function, accounts for the depersonalized, photographic effect of "continuous tone" in his paintings of the late 1960s. He touched the canvas only to set down an underlying grid, which then largely disappeared, not because Close actively erased it but because he restricted its function to guiding his transfer of imagery. The grid never became the content of his art as it did for others: "I spend two weeks getting a fine pencil grid on the canvas," he muses, "and if I were Agnes Martin, I'd be done."[12] All of these new conditions were "limitations that would guarantee change"—not necessarily from artistic convention and the associated ideology, but from the artist Close himself had been.[13]

Then Close reversed himself, or rather, added some twists. In 1970, he returned color to his work; but, like his grid, it didn't show itself off as an invention or an expression. Instead, it was subordinated to a process. He used airbrushing to recreate the color separations of photographic printing, superimposing three layers of acrylic pigments to match the standard dyes known as magenta, cyan, and yel-

low. This was a way of reexperiencing the effect of full color without the "lazy and slobby and indecisive" situation of having hundreds of equally good choices and being free to indulge in the arbitrary. Not long after he reintroduced color, Close allowed his hand to return to direct, physical mark making, but here too in an odd way. The hand reappeared in his first major printmaking project, Keith/Mezzotint (plate 28), a collaboration with master printer Kathan Brown. As far as Close was concerned, the attraction of mezzotint was its challenge to his inherent nature and habits. The process required him to develop his image by adding marks of white to a black surface rather than adding blacks to white, as he had done in his "continuous tone" paintings. He describes his action as "working backwards."[14]

Yet through it all Close retained much of his former self. Within the confines of his precision, he was adventurous, experimental. And adventurousness is disorderly. Maintaining a high level of illusionistic representation, Close devised ever new ways of doing it. Rather than the security of a predictable order, it may be that he merely needed the structure of work itself, the durational aspect of regulated, repetitive activity. For him, work is better understood as expenditure of time, not energy. Just as we know we can divide space into finite units (as Close does with his grids), time too is incremental, a feature to which Close is very sensitive. Keith/Mezzotint was important to the artist's later development because the graphic process put added emphasis on the incremental nature of the construction, leading him to think differently about the grid, which became a pictorial element in itself: "It was the first piece where I allowed myself to deal with the increments as individual units which would not ultimately get pushed together to make a cohesive whole . . . keeping the grid visible and thinking in bite-sized terms, making an image in a square and keeping it a square as well as a whole."[15]

In the structural unit of a grid, working time becomes equated with spatial distribution. Close likes to recall watching his grandmother knit a sweater or make a quilt, a creative process that could be interrupted repeatedly without this interference damaging the final product, in which the segmented structure was never intended to be disguised. Close prefers work that can stop and start in just this way, independent of the intensity of his other concerns and even his moods. He is, after all, at work against nature, against its habitual inertia, which in human conduct becomes laziness. Where nature just keeps going, Close interrupts his work with decisions. As a result, some of his collaborative print projects, inherently time-consuming, required unusual degrees of effort and developed more slowly than even his largest paintings. John (plate 80), a silk-screen print, required 126 color separations; begun in 1996, it was signed in 1998. Work on Emma (plates 20 and 97), a traditional Japanese woodcut containing 113 colors, began in 2000 and continued into 2002.

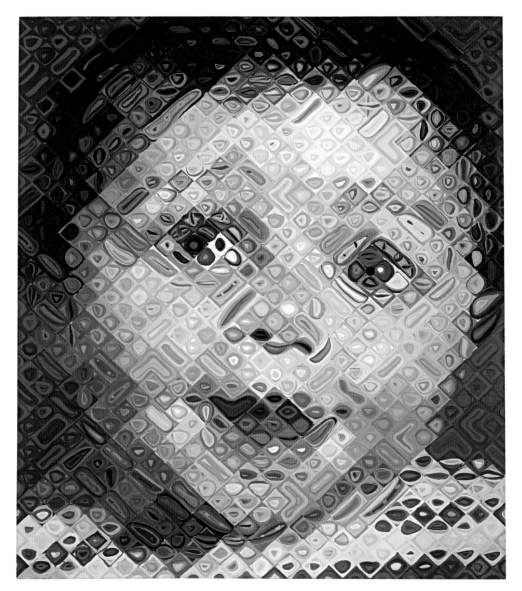

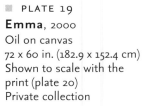

PLATE 19
Emma, 2000
Oil on canvas
72 x 60 in. (182.9 x 152.4 cm)
Shown to scale with the
print (plate 20)
Private collection

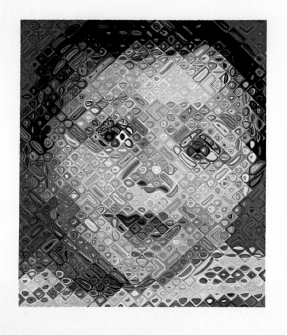

PLATE 20
Emma, 2002
113-color Japanese-style
ukiyo-e woodcut
43 x 35 in. (109.2 x 88.9 cm)
Edition of 55
Pace Editions Ink, New
York, printer (Yasu Shibata)
Pace Editions, Inc.,
New York, publisher

PLATE 21 (opposite)
Detail of plate 20

Close is content to be involved in a process even if he is uncertain as to where it will lead—or rather, how it may lead to wherever it goes. When he uses a photograph as a source image, he has the goal of capturing the photographic appearance; and with a print, he often seeks the look of painting. He foresees a certain end, but the means of getting there (which determines the end) is yet to be devised. "I have this naive belief in systems," he proclaims, "that if you believe in a system and follow it, you will create something."[16] At a certain stage, Emma the woodcut print became independent of Emma the painting (plate 19); every medium asserts its particular character. While the woodcut remains faithful to the gridded pattern of Close's idiosyncratically painted shapes, its quality of illumination differs—it is lighter, more ethereal—because its semitransparent inks are materially distinct from opaque oil paints. By following the "system" of the woodblock process, Close and his printmaker created something new. In a comparison of individual units of the grid, slight shifts in hue appear, here and there; where the painting might have pale violet, the print might have pale blue. A distinction is also to be sensed between the print's cut edge and the painting's brushed edge. The print imitates the painting, but in spirit more than in body. Yet to step back is to see that much of this difference averages itself out of existence. You don't know whether to be more impressed by how alike the two works are, or by how unlike they are.

A critic faces a dilemma: Are the two versions of Emma to be appreciated for their sameness or their difference? The magic of Close's practice can be framed by analogy to what linguists know as the perfective and imperfective aspects of an action. Close's pictorial illusion acquires a "perfective" aspect when the resultant image dominates or contains its process, its construction. This was true of his black-and-white heads of the late 1960s, at least in the context in which they were first received. Now, however, when Close looks back at Big Self-Portrait, he notices how loose, varied, and willful was his manner of marking.[17] Perhaps he defeated his undisciplined nature less fully than he thought. Whatever the case, the "perfective" aspect of his work can shade into looking "imperfective" (which should not be confused with merely looking unfinished or sketchy—perfective and imperfective forms can be equally complete).

Such transformation occurred with Keith/Mezzotint because the incremental working process began to show in the physical changes the plate endured. An illusion becomes imperfective whenever its construction is evident. To conclude that the two versions of Emma converge in a single identity is to see them as mutually perfective, with all their differences in process averaged out. For the averaging to be apparent, however, there must be a certain viewing distance. The closer

you approach these images, the more specific their differentiated elements will become—the little violets and blues, when objects of intense attention, cease to look alike. Where, then, should a viewer stand? Close himself enjoys watching gallery visitors moving back and forth as they observe the different degrees of separation between his illusion and his mark. They try to see the image under both aspects—perfective and imperfective, image-dominant and process-dominant—caught by experiential incommensurability.

Ever down-to-earth, Close frequently uses a golf metaphor. This is a game in which start and finish are fixed, but anything can happen in the spatial and temporal play between the tee and the cup. To combat his art-making facility, Close likes to "tee off in the wrong direction."[18] Having initiated the painting process with a surprisingly arbitrary move, he relies on intuition to make his way through the system to return to something resembling his source (his work, he says, "has always been far more intuitive than anybody thinks").[19] For example, Close knows that the skin tones of most of his subjects will eventually need to look pink, yet he may choose to begin with a layer of green or violet, setting himself the task of generating the effect of flesh by the end of the game. In the painting Emma, Close initially rendered a fragment of brow chartreuse green, only to convert it to orange, red, and blue at a later stage. Traces of the green remain, affecting a complex play of mutually intensifying and mutually neutralizing hues.

Close also sets a trap for his medium by laying his transfer grid over the source photograph so that it divides a prominent physical feature; this forces him to devise a way to maintain the grid's apparent fragmentation and the organ's apparent wholeness, simultaneously. The transfer grid, invented to make art easier, becomes by Close's design a cause of difficulty. In the two versions of Emma, a threefold subject of representation—the dark pupil of the eye, the glint of light it reflects, and the surrounding white of the eye—falls into a single unit of the exposed grid (diamond-shaped because Close set the grid on the bias). Close preserves the joint appearance of the three features by setting a dark ellipse within the surrounding whitish diamond, with all elements just slightly askew, or seeming so. Are they askew? From what? From the grid? Or from the baby's eye? This may be impossible to determine. Close seems to have intuitively placed the elements of dark and light in just the right proportion and position to cause the depicted glint in Emma's "eye" to vibrate and "move." Surely, thoughts of the lively baby (the perfective illusion) contribute to a perception of animation in the image, but the set of abstract marks (the imperfective process) also seems animated in itself.[20] We are either perceiving a picture of a twinkling eye or perceiving that Close's marks are themselves twinkling. There's a difference, but not an easy one.

Printmaking techniques appeal to Close because, with their disorienting reversals of left and right, light and dark, they "tee off in the wrong direction." With printmaking, you can't be "held captive" by your own nature, because the nature of the medium presents too much resistance itself. Each of the various painting and printmaking processes has a given structure, and Close delights in setting its level of demand arbitrarily high. One set of conditions meets another, and then both image and medium need to be adjusted. In Close's art one aspect, the appearance, interacts with the other aspect, the process. Twinkling encounters twinkling. Close plays the adjustor, not the divine creator. He doesn't set himself above the pictorial tradition to reform it; he stays within it, exploiting it, negotiating it, expanding it. He didn't invent the majority of the different media he uses, only new ways of using them—all the better to understand what they do.

Perhaps this situation justifies the modest, even prosaic explanations Close tends to offer for his series of artistic choices. He attributes his astounding representational forms to the most ordinary, no-brainer logic. Why did he choose to use his fingerprint in works such as Keith/Square Fingerprint (plate 10), or Leslie/Fingerprint (plate 22)? "Because I was looking for an incremental unit that was automatic, not determined by taste or anything else. A stock, standard unit. The size of the thumb and the size of the index finger. My body was a tool." In certain works Close took his corporeal ingenuity one step further, manipulating wet pulp-paper multiples by hand, not for the sake of adding a mark but to introduce the push and pull of bodily whim into an image rendered systematic by its grid. Self-Portrait/Manipulated (plate 40) looks as if it had been subjected to the disorienting force of underwater currents. As the paper dries, it fixes the temporal aspect of its creation, becoming a picture of flux. As a material, pulp paper has this attraction for Close: its nature is to pass from a malleable state into a permanent form that captures the sense of transformation. Pulp paper is not a ground but the image itself—image and process at once. Recently, to support or "ground" an image constituted of pulp, Close used a grid of string as an armature, sandwiched between Plexiglas within a boxlike frame; here, all the more obviously, image and process unite (Self-Portrait/String; plate 41). And so, too, in Phil/Tapestry (plate 23), where the act of weaving constitutes the image, simultaneously creating the textile support that bears it.

It's tempting to argue that Close's use of fingerprints and other hand maneuvers (Phil/Fingerprint, plate 1; Fanny/Fingerpainting, 1985, National Gallery of Art, Washington, D.C.) cleverly pun on paintings that feature an expressive "signature style"—the kind of gestural stroke that Willem de Kooning, Franz Kline, or Philip Guston would make, each artist set on being distinct from all others. No one else has Close's fingerprints, so no one can imitate his finger-mark. In this case, the

PLATE 22
Leslie/Fingerprint, 1986
Direct gravure
54½ x 40½ in.
(138.4 x 102.8 cm)
Edition of 45
Graphicstudio, University of South Florida, Tampa, printer (Patrick Foy, George Holzer, Deli Sacilotto, Donald Saff) Graphicstudio, University of South Florida, Tampa, and Pace Editions, Inc., New York, publishers

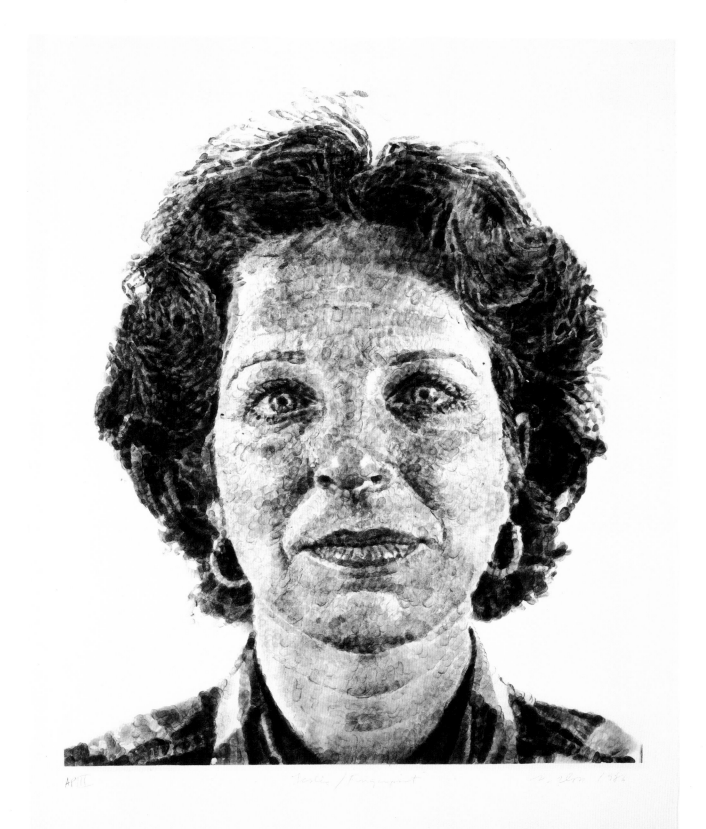

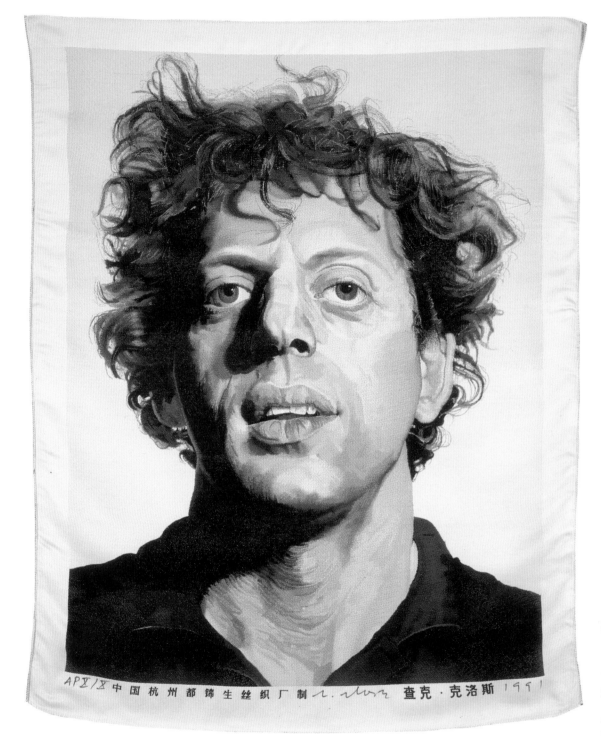

APX/X 中国杭州都锦生丝织厂制 查克·克洛斯 1991

■ PLATE 23 (left)
Phil/Tapestry, 1991
Silk tapestry
49 x 37 in. (124.4 x 93.9 cm)
Edition of 50
A/D Gallery, New York,
printer and publisher

■ PLATE 24 (opposite)
Lucas/Rug, 1993
Handloomed silk on
linen warp
79 x 66 in. (200.6 x 167.6 cm)
Edition of 20
A/D Gallery, New York,
printer and publisher

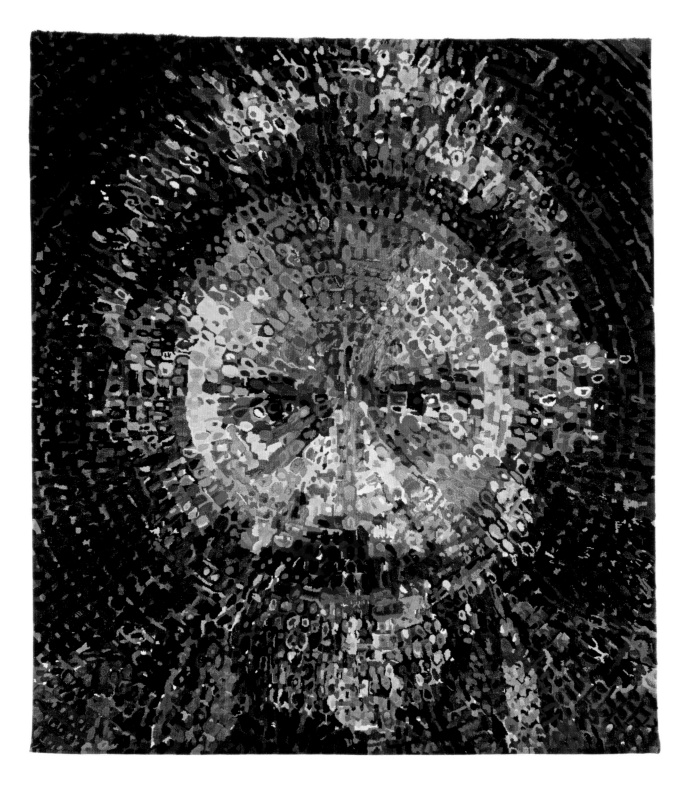

artistic gesture comes with its authenticity guaranteed, seeming to solve a critical modernist problem with a long history. Close appreciates interpretations of this sort, but he doesn't offer them himself. His concerns are more fundamental. He will say that he was merely solving the workmanlike problem of mastering the painter's tool. Eliminating the brush, he had a tool at hand, his hand, of which he was already the master: "I could feel how much [ink] I'd picked up by how much pressure I was putting on my finger and the viscosity of the ink. I could press lightly, press harder, or rotate my finger." Close is a magician with everything exposed, nothing up his sleeve.

FACING PROBLEMS

WHEN CLOSE WAS PRACTICING HIS CHILDHOOD MAGIC ACTS, he was working toward impressing his friends; odd man out at school, he wanted to be appreciated for a special skill. As a young adult and an artist, he abandoned his significant accomplishments in abstract painting to become a (nominal) realist, or at least a figure painter, or, more precisely, a face painter. Close's substitution of photographs for live models derived from personal need, just as his cultivation of magic had. Close suffers from prosopagnosia, face blindness. He forgets faces. As a result, he worries over live models whose hair will grow and who are likely to gain or lose a little weight from one studio session to the next.[21] The difference in most instances could be very slight, hardly visible under ordinary circumstances. Yet for Close, a minor alteration in physical presence or emotional mood becomes so noticeable that it renders his recognition of a particular face impossible. In his daily life, minor differences caused by a process (such as aging) destabilize appearances. Close has trouble enough with no change at all: "Someone walks into my studio"—perhaps the model from a day before—"and I have to figure out why they're here. When I make someone flat I can remember that image."[22]

For Close, a change in time, in temporality, is a change not only in appearance but potentially in identity. Time and space relate for him in ways that may make art easy but life hard. Because he sees difference nearly everywhere, he lives with an excess of challenges to perception, which results in more "experience" (by Peircean definition, always new) than other experienced adults have to handle. During the 1960s, to negotiate the situation, Close started photographing his subjects, then re-formed each flat projection by hand, as if he were mapping unknown territory. The effect was to crystallize the appearance within the process. His ease with a constitutive process is matched only by his difficulty in identifying the totality. Once Close has a photographic plan of a face, he can make it all the more memorable as a painting or print to be traversed slowly at his convenience, unit by gridded unit and

mark by mark. Printmaking, an extra-slow medium, gives him added time to know a face and invent new means of rendering that extend his understanding.

To every portrait image in his repertory, Close transfers the visual array he associates with the monocular photographic process, as opposed to the developing, existential life of his subject: "I'm constantly dealing with the fact that it's not a [living] person; in fact, it's not even a painting of a person as much as it is the distribution of paint on a flat surface."[23] To a great extent, his actual subject matter becomes the representational process, which is what Close so expertly controls. When he "builds" a face piece by piece, he keeps it in mind as well as in vision, in the way that someone with an excellent sense of direction internalizes and can retrace a course of movement without need of remembering signposts along the way. Close's distribution of marks constitutes his personal mnemonic map, a system of relations in which each element informs every other element, especially those that lie in its vicinity. For one of his exhibitions held at Bykert Gallery during the late 1960s, he proposed to hang a work upside down to demonstrate that the most "realist" of his paintings projected a formal coherence independent of the depicted figure.[24] A map can be read from any direction, even reversed in a mirror, just as a route can be followed backward.

Ironically, Close's personal needs and natural aptitudes have been aligned with cultural trends, all the more evident to him retrospectively. He was always his own person, yet also a creature of his time. Does such correspondence occur of necessity or by chance? Answering this question merely indicates the philosophical and ideological orientation of the writer. Close himself answers both ways, perhaps an indication of his tendency to consider all possibilities, a kind of intellectual adventurousness as much as indecision. Having revealed his personal motivations, Close, an astute observer of art history in the making, often refers to the general situation of the 1960s as an alternative account of his origins. If his own testimony concerning his perceptual peculiarities were lacking, we would readily attribute his systematic mark-by-mark renderings of the human face to his membership in an anti-Expressionist generation. As a device to make their intentions clear many of his contemporaries developed depersonalized, systematic, abstracted imagery, whether figural or not. Taking cues from Close's remarks, we can characterize the difference between his art and what preceded it: the Expressionist painters performed their magic with the nature of its device, its essential process, disguised by dextrous flare and virtuosity, whereas the magic of Close and his generation reveals its device. At stake in this difference are the cultural values of intellectual and emotional honesty as well as procedural openness and freedom, and even a certain antielitism.[25] Close explains:

Everything [in Abstract Expressionist painting] seemed to hinge on a certain kind of facility and a certain kind of virtuoso performance. But no painting ever got made without a process. . . . Think of Richard Serra's lead prop-pieces. What is lead? You can roll it, you can fold it, it's got weight, and so the lead pole will hold the lead plate to the wall [Prop; plate 25]. The process made it happen and is one with the image. . . . Free from associations with the past, [Serra and others] were free to exploit the properties and characteristics of their material.

Perhaps the major artists of any period are those whose personal desires, interests, and obsessions parallel the most timely issues that occupy the cultural imagination of their society.[26] The correspondences can be cultivated or occur by accident. In the decade of civil rights, women's liberation, communes, and psychedelic drugs, young American artists sought release from the clichéd modes of personal expression associated with their recent past, both aesthetic and political. They wanted assertive physicality in place of dramatic, rhetorical gesture. In Serra's case, the weight and inertia of heavy objects, his fascination since childhood, became the physical link between personal needs and social interests: "It is the distinction between the prefabricated weight of history and direct experience [of weight and gravity] which evokes in me the need to make things . . . to rely on my own experience and my own materials."[27]

For Close, the link to social history was in the face, which both introduced the discipline of representational illusion and epitomized his personal struggle with identity, memory, and learning in general. Without losing their humanity, Close's faces lose their conventional expressiveness. His subjects don't pose for the camera. Although based on a photograph, the aspect of Emma (both painting and print) is open, imperfective, unfixed. Similarly, the flux of resolution in Close's daguerreotypes, and even in his Polaroid-based images, produces virtual animation. It might be argued that Close as photographer has rendered inoperative the old metaphor of "capturing" the image—not in a mechanical and chemical sense (a pattern of reflected light is indeed recorded), but in an experiential, phenomeno-

PLATE 25
Richard Serra (American, born 1939)
Prop, 1968
Lead antimony
Dimensions variable
Installed, approximately
89½ x 60 x 54 in.
(227.3 x 154.9 x 137.2 cm)
Whitney Museum of American Art, New York
Purchase, with funds from the Howard and Jean Lipman Foundation, Inc.
(69.20 a-b)

logical sense. To an unprecedented degree, he succeeds in representing the temporality of an image within the totality of its experience: the way we scan all parts of its field, not only its conventional "features," which tradition has predetermined as targets for capture. In a face as Close reveals it, everything is featured: the appearance, the mark, the work, and an entire set of cultural values.

ILLUSION AND DEVICE

MAGICIANS' ILLUSIONS ARE LIKE FAMILIAR FACES that a repeat audience never fully recognizes. Close wonders whether magicians themselves see everything there is to see. When watching other magicians perform, do they "see the illusion, the device that makes the illusion, or perhaps a little bit of both"?[28] If you're someone for whom identities are hard to grasp, then everything you perceive might assume the appearance of a magic trick that causes an individual who is one to look like many. Nature, like magic, can be deceptively imperfective; it can present a person under many aspects, not all of which seem consistent with the general characterization already assigned to the individual. This condition makes Close all the more attentive as an investigator of aspects and appearances.

Whether the mind's reason ever catches up to the eye's discriminations remains an open question, for it may be impossible to perceive a situation on two levels at once—hence, Close's bemused thoughts about magicians observing magicians. According to common wisdom and an old phenomenological adage, the person who concentrates on understanding what a pencil is, what this instrument feels like when held in the hand, won't be able to write with it. By analogy, when you see the illusion, you aren't in a position to see the device responsible for it. The illusion and its production should be mutually exclusive phenomena. Years ago, when first presented with the classic example of the pencil, I was impressed by the cleverness of the thought that seemed only too true to experience. Now, having become familiar with the images Close creates, I no longer remain certain that concentrating on a material process blinds a person to its product, and vice versa. That

■ PLATE 26
Georges Seurat (French, 1859–1891)
Woman Fishing, 1884
Conté crayon
12⅛ x 9⅜ in.
(30.7 x 23.8 cm)
The Metropolitan Museum of Art, New York
Purchase, Joseph Pulitzer Bequest, 1955, from The Museum of Modern Art, Lizzie P. Bliss Collection (55.21.4)

time-tested description of experiential incompatibility may be only a theory, and not such a good one. Close has stimulated a new kind of perception compelling me—as Peirce would put it—to "think otherwise." This is not his magic but his art.

Between magic and art as areas of expertise, Close chose art. Yet he retains magic as a central metaphor that guides his thoughts concerning artistic practice. This isn't because he rejects the logic of ordinary cause and effect. He clearly doesn't believe in "magic" of the supernatural kind, and his own magic is always made, crafted, matter-of-fact. Thoroughly pragmatic, Close couples his references to magic with metaphors of building: "I make paintings; I am building painting experiences for the viewer."[29] A building process is antithetical to a magic act; systematic and labor- intensive, it plays no tricks. Close resorted to both metaphors (magic and building) when asked in 1991 to comment on

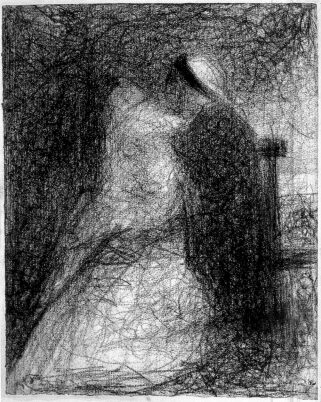

PLATE 27
Georges Seurat
Nurse and Child,
1881–82
Pencil
11¾ x 9⅜ in. (30 x 24 cm)
Musée du Louvre, Paris

Georges Seurat's drawing: "It's like seeing an illusion built for you by a magician."[30] He was marveling at Seurat's "device"—the technique of rubbing Conté crayon across the parallel or gridlike ridges of laid paper, to leave bits of sparkling white in the tiny valleys (Woman Fishing; plate 26). Seurat's device, Close implied, was both visible and invisible. Visible, it could be discerned as the elements of the material construction of the image: a dense accumulation of individual lines and strokes, hardly descriptive in themselves, that results in a general distribution of black and gray tones. Such a simple device, interchangeable with many others that produce a similar effect, seems inadequate to explain why Seurat's illusions are so much more impressive than most others. For analytical purposes, Seurat's device becomes invisible: it doesn't seem to determine how he made his "magic," and the viewer has no reason to fix on it. But pragmatically, the device is primary.

Although it may never have contributed to Close's techniques, Seurat's art set a relevant precedent. Seurat himself shifted attention from the magical illusion and figurative content of his image to his workmanlike, day-by-day practice of picture-making: "The writers and critics see poetry in what I do"—here, the artist might have said "magic"—"No, I apply my method and that's all."[31] The exceptional critic Félix Fénéon agreed, arguing that unlike those seduced by the cult of per-

sonalized style and expressive gesture, Seurat should be regarded as "a painter and not a prestidigitator."[32] If there was magic in his art, it wasn't a product of sleight-of-hand. Seurat's hand did only what other hands could do.

Among its actions, it scribbled. Many of Seurat's drawings employ loose, twisting lines that cross each other repeatedly to form composite masses of tone (for example, Nurse and Child; plate 27). Some lines track a contour, but many have no independent descriptive function.[33] Isolated, they would be mere scribbles: marks antithetical to attention, authorship, and even consciousness; marks any hand can make, absentmindedly; marks that may be conventional although they pass for natural. Is scribbling learned? Is it culturally specific? Or is it a physiologically naive response of the hand, given its range of movement and its capacity to grasp a stylus? I don't know. With his "scribble etchings" (Self-Portrait, plate 136; and Lyle, plate 111) Close takes this nominally useless mark, thought to record wasted time and energy, and he builds an illusion. Like Seurat, he applies the mark irregularly, at different lengths and densities. Unlike Seurat, his lines are colored, superimposed in sequence with an uncanny intuitive sense as to where each ramble in each hue should go. Although the scribble device is new, it must remind Close of airbrushing his color separations during the early 1970s: "When I get to the last color, yellow, you can't see the pigment come out of the airbrush—it's like waving a magic wand in front of the picture, and the purple [the previous combination of red and blue] becomes brown."[34] More magic.

Artists, Close has concluded, "see both the device that makes the illusion and the illusion itself."[35] This ability to divide one's perception may be required of all artists; but there are degrees of it, and Close, inventor of the scribble etching, is extreme. More intensely than most people, he has experienced a certain human truth: "Once you see the [three-dimensional] world flattened out, your vision is changed forever." Painting, he comments, was culture's first screen for flat projection.[36] As a device that changes perception, projection of any kind generates distinctive experience, not some mere derivative—it causes us to "think otherwise than we have been thinking."

So when Close states that he makes "experiences for people to look at," he refers to more than the illusion; he presents his experience of the illusion in relation to its device, his medium. With flat projection, he fixes an image spatially but retains a certain time-bound, imperfective aspect. The image he builds is active, set in motion between illusion and device, like the glint in Emma's eye: "I'm as interested in the distribution of marks on a flat surface . . . as I am with the thing that ultimately gets depicted. . . . [It's] shifting from one to the other that really interests me."[37] To keep the shift in view is something magical.

NOTES

For essential aid in research, I thank James Lawrence and Terrie Sultan; and for insight, Chuck Close.

1 On Close's childhood, see Lisa Lyons, "Expanding the Limits of Portraiture," in Lisa Lyons and Robert Storr, Chuck Close (New York: Rizzoli, 1987), 25. In conversation with the author, June 10 and November 2, 2002, Close offered additional details, mentioned here and to follow. Throughout this essay, statements, opinions, and factual information attributed to Close without further specification derive from these two conversations. Any information drawn from earlier conversations with the author or from interviews by others is footnoted.

2 One reason—his slowness and absorption in his medium: "How can you spend a year making something [a 'continuous tone' painting] and know whether it has anything to do with reality? I mean I'm so involved constantly with the artificiality of what I'm doing" (Kim Levin, "Chuck Close: Decoding the Image," Arts Magazine 52 [June 1978]: 146).

3 See Oswald Ducrot and Tzvetan Todorov, "Time," in Encyclopedic Dictionary of the Sciences of Language, trans. Catherine Porter (Baltimore: Johns Hopkins University Press, 1979), 305–13. Close sometimes uses the term apparition with the double sense of aspect. He has called the daguerreotype an apparition and also praised Jan Vermeer and Georges Seurat for creating that kind of magical effect: see Chuck Close, "Daguerreotypes," interview by Timothy Greenfield-Sanders (with Jerry Spagnoli), in Demetrio Paparoni, Chuck Close: Daguerreotypes (Milan: Alberico Cetti Serbelloni, 2002), 40; Chuck Close, "About Face: Chuck Close in Conversation with Elizabeth Peyton, October 3, 2000, New York City," Parkett 60 (2000): 32; Ann Temkin, ed., Chuck Close/Paul Cadmus: In Dialogue (Philadelphia: Philadelphia Museum of Art, 1997), n.p. An apparition is, first, an unusual or unexpected sight, and second, the act of becoming visible—both the illusion (the sight to be seen) and the device or process that generates it.

4 Kirk Varnedoe, "Chuck Close: Blood, Sweat and Tears," in Chuck Close: Recent Works, exh. cat. (New York: PaceWildenstein, 2002), 7.

5 Chuck Close, "Changing Faces: A Close Chronology," conversations with Lisa Lyons, October 1979 to May 1980, in Close Portraits, ed. Lisa Lyons and Martin Friedman (Minneapolis: Walker Art Center, 1980), 34.

6 Amy Baker Sandback and Ingrid Sischy, "A Progression by Chuck Close: Who's Afraid of Photography?" Artforum 22 (May 1984): 50.

7 Kirk Varnedoe, ed., Artist's Choice: Chuck Close, exh. cat. (New York: Museum of Modern Art, 1991), 7.

8 Robert Storr, "Interview with Chuck Close," in Chuck Close, exh. cat. (New York: Museum of Modern Art, 1998), 94–95.

9 Chuck Close, "Putting English on the Stroke," interview by Bice Curiger, Parkett 60 (2000): 63.

10 Jacqueline Brody, "Chuck Close: Innovation through Process: An Interview," On Paper 2, no. 4 (March–April 1998): 24.

11 Chuck Close, conversation with Roy Lichtenstein, in The Portraits Speak: Chuck Close in Conversation with Twenty-seven of His Subjects, Joanne Kesten (New York: A.R.T. Press, 1997), 619. Occasionally, where needed, Close would adjust fine details in an airbrushed painting by scratching or otherwise erasing the deposits of tone. In a black-and-white image, a scratch that uncovered the white ground of the support surface would amount to a white mark, although no white paint was used.

12 Lyons, "Expanding the Limits of Portraiture," 31.

13 Michael Shapiro, "Changing Variables: Chuck Close and His Prints," Print Collector's Newsletter 9, no. 3 (July–August 1978): 71–72.

14 Chuck Close, interview by Terrie Sultan (with Kathan Brown), August 18, 2002, in this volume, p. 49.

15 Shapiro, "Changing Variables: Chuck Close and His Prints," 70. See also Close, interview by Terrie Sultan (with Kathan Brown), August 18, 2002, in this volume, p. 51.

16 Chuck Close, "Chuck Close" interview by Lisa Yuskavage, Bomb 52 (summer 1995): 33.

17 Close's comment to the author on viewing his New York Museum of Modern Art retrospective in 1998.

18 Close, in conversation with Alex Katz and William Bartman, March 15, 1994, in Kesten, Portraits Speak, 316.

19 Ibid.

20 Concerned to establish precisely the right contour and the right amount of white within the grid unit,

Close made what may have been a final adjustment, adding a touch of white paint at the left corner of the existing reserve of white. This increased the irregularity of the grid unit (relative to the overall system), contributing to its instability and sense of movement. For further discussion of Close's tendency to construct situations of interference between image and mark, see Richard Shiff, "Chuck Close: Mark, Image, Medium, Interference," in Chuck Close (New York: PaceWildenstein, 2000), 4–15; and Shiff, "Raster + Vector = Animation Squared," Parkett 60 (2000): 44–49. I have set this issue into a general historical context in "Realism of Low Resolution: Digitisation and Modern Painting," in Impossible Presence: Surface and Screen in the Photogenic Era, Terry Smith, ed. (Chicago: University of Chicago Press, 2001), 124–56.

21 Julie L. Belcove, "Close Up," W 27 (February 1998): 206. See also Lyons, "Expanding the Limits of Portraiture," 30.

22 Close, "About Face," 28.

23 Barbara Harshman, "An Interview with Chuck Close," Arts Magazine 52 (June 1978): 143.

24 Close, in conversation with the author, April 24, 1997.

25 For a detailed account of the formative influences and the attitudes typical of Close's generation of artists, see Robert Storr, "Chuck Close: Angles of Refraction," in Chuck Close (1998), 21–59.

26 A similar argument was advanced by the nineteenth-century philosopher and historian Hippolyte Taine: artists become recognized as great when their natural vision agrees with all that defines the essence of their culture; in representing their own interests, they represent those of others better than the others themselves do. See Hippolyte Taine, Essais de critique et d'histoire (Paris: Hachette, 1866), vii–xxxii.

27 Richard Serra, "Weight," in Writings, Interviews (Chicago: University of Chicago Press, 1994), 185.

28 Close, Artist's Choice, 8. A similar statement appears in Sandback and Sischy, "A Progression by Chuck Close," 50.

29 Sandback and Sischy, "A Progression by Chuck Close," 50.

30 Patrick Pacheco, "Point Counterpoint," Art and Antiques 8 (October 1991): 73.

31 Charles Angrand, witness account of Seurat's views, quoted in Gustave Coquiot, Seurat (Paris: Albin Michel, 1924), 41 (author's translation). Of course, by saying such things, Seurat, known to desire privacy, may have been attempting to discourage critics from attributing ideas and feelings to him.

32 Félix Fénéon, "L'Impressionnisme" (1887), in Félix Fénéon: Oeuvres plus que complètes, ed. Joan U. Halperin (Geneva: Droz, 1970), 1:67 (author's translation).

33 Robert L. Herbert, in Seurat's Drawings (New York: Shorewood, 1962), 55–56, notes this type of line in Seurat, alluding to its imperfective nature: "Since it does not represent a real object, we are aware of its independent existence on the surface of the paper."

34 Lyons, "Expanding the Limits of Portraiture," 31–32. Close often compares his airbrush to a magic wand, marveling at, but also regretting, the loss of physicality that it represents: "Painting [with an airbrush] doesn't seem like a physical activity. It's more like waving a magic wand over the surface of the canvas" (Michael Auping, "Face to Face," Artforum 32 [October 1993]: 71).

35 Close, Artist's Choice, 8.

36 In conversation with the author, June 10, 2002; the context was Close's support for painter David Hockney's theory that lenses and other optical projection devices were critical for the development of Renaissance and Baroque painting. Close was recalling his participation in the first public debate over that theory, held at the National Gallery, Washington, May 3, 2000.

37 Storr, "Interview with Chuck Close," in Chuck Close (1998), 95–96.

Process and Collaboration

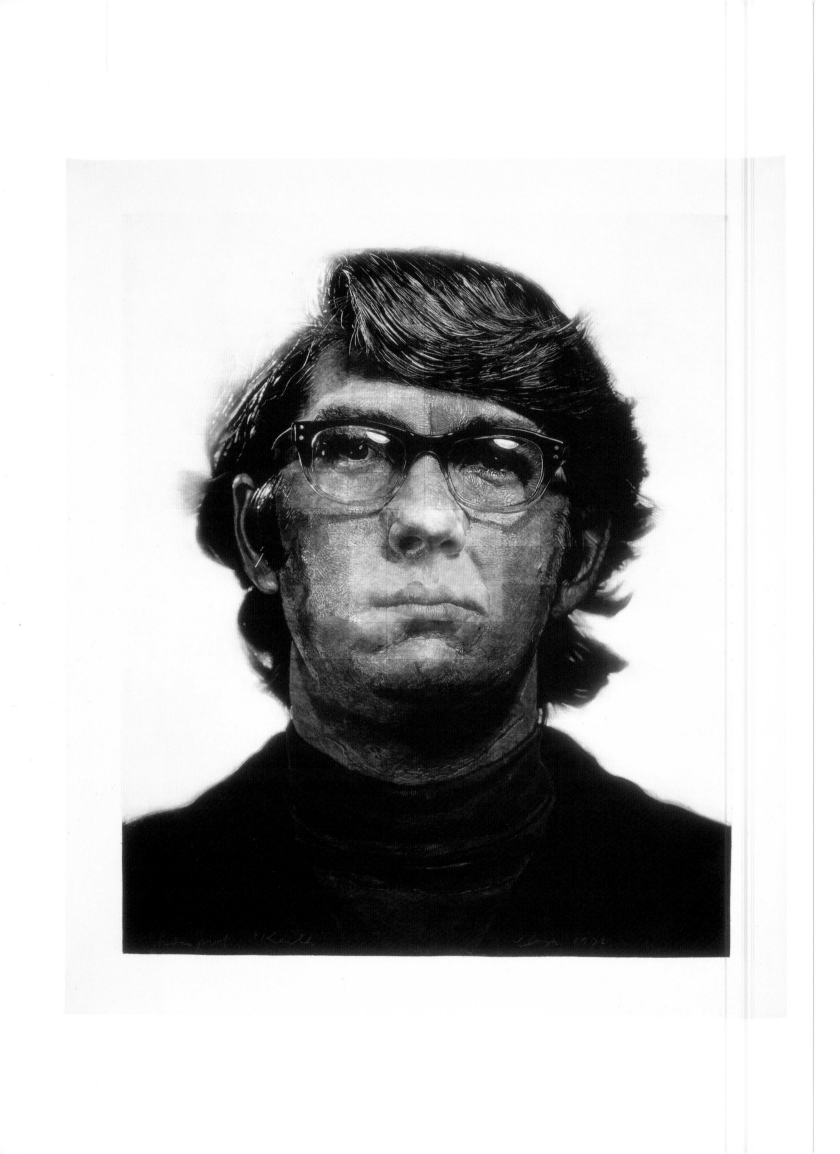

Mezzotint

KATHAN BROWN, CROWN POINT PRESS

THE MEZZOTINT TECHNIQUE was invented in the seventeenth century, becoming popular in the eighteenth and nineteenth centuries, especially for portraiture, but very few contemporary artists have tackled this difficult and time-consuming medium. Chuck Close and Kathan Brown of Crown Point Press, San Francisco, talked with Terrie Sultan on August 18, 2002, in Sag Harbor, New York, about the Keith/Mezzotint (plate 28) and the etching Self-Portrait (plate 32), both created at Crown Point Press.

TS: Keith/Mezzotint was the first print you made as a professional artist. How did it come about?

CC: Bob Feldman, of Parasol Press, invited me to try a print. I especially wanted to try an etching, and he arranged for me to work with Kathan Brown at Crown Point Press.

KB: This was in 1972. At that time, etching techniques were not as popular with publishers as silk screen or lithography. But we had already done etchings for Parasol with Wayne Thiebaud and Sol LeWitt. Bob really liked them, and he started sending other artists to us.

CC: You were basically a basement operation in those days.

KB: At first it was just me in the basement, with a very modestly sized press capable of printing a plate about 20 inches wide. When Chuck came to work with me in 1972, I had been in business for ten years, but I had just moved out of the basement to a loft in Oakland, and we were still using the small press.

■ PLATE 28
Keith/Mezzotint, 1972
Mezzotint
51 x 41½ in.
(129.5 x 105.4 cm)
Edition of 10
Crown Point Press,
Oakland, California, printer
(Kathan Brown,
Patricia Branstead)
Parasol Press, Ltd.,
New York, publisher

After Bob called to say that he wanted to send Chuck, I talked to Chuck on the phone, and he said, "I want to work big."

CC: That's always the operative word.

TS: So the print size presented a real challenge.

KB: Everything about the project was a challenge. I had always thought of etching as an intimate medium, and I still do, but the meaning of "intimate" has expanded for me. To accommodate Chuck's idea, we had to change our normal way of working. First, we had to find a place that could make very large copper plates. The biggest copper we could get allowed for an image width of 36 inches, so Chuck decided on 36 x 45 inches. We also had to order a new press, which had to be specially made. At the time no one was making such big presses, because no one was making such big prints. Now everyone does. Back then, it was practically impossible for me even to imagine doing a 3 x 4 foot etching. The size Chuck used for *Keith* is still our maximum size. And then there was the timing: Chuck wanted to come for three months, and it had to be during the summer, because he was teaching. The idea of an artist spending three months with us was amazing to me. Usually artists stay with us for a couple of weeks at the most. And we couldn't be ready by the summer. The press was delivered the same day that Chuck walked in the door, so we couldn't test anything in advance.

TS: Chuck wanted to do a mezzotint, which also presented a big challenge. Why was this technique so difficult?

KB: Mezzotint is a very old technique, a form of engraving, in which you start with a black ground. A traditional mezzotint plate is rocked with a hand rocker. The rocker's little teeth tear up the surface of the plate so that it holds ink uniformly. Rocking the rocker in various directions across the surface of the plate creates a burr, or tooth, that makes it hold ink. The artist then polishes down the burr to create an image that prints light against black.

TS: Why did you want to use this technique?

CC: The appeal of mezzotint was that no one had made one for a hundred years.

KB: Or if they had, it was very small by comparison to yours.

CC: My thinking was that I had been making black-and-white paintings using only black paint on a white gessoed canvas. The only color was black, diluted down when necessary to create tones. No white was used to make grays. And

I liked the idea of a mezzotint because it was the exact opposite of how I made the black-and-white paintings. Instead of starting with a white ground and working with black, I would be starting with something that printed black, and working backward to achieve white. I did absolutely nothing in my black-and-white paintings to achieve the white background. In the mezzotint, that would be where most of the time was actually spent, burnishing and polishing out the background. I had been an etcher in college; I knew how to make various kinds of prints. Also, I didn't want to go to a print shop where they would have all the expertise and would act as if I didn't have any, and where they would tell me that something had to be done a certain way, just because that was the way they did it. I wanted to do something that would require both Kathan and me to figure out how to do it at the same time. I love that kind of problem solving.

TS: What do you use to burnish out the places you don't want to print?

CC: First you scrape with a sharp triangular tool. Then you burnish, using a tool that is curved. With traditional mezzotint made using a rocker, burr is the part that sticks up and holds the ink, and since the burr is mostly above the surface, it is very soft and can be scraped and polished fairly easily. Because we were making something so big, which needed to be proofed a lot, we knew that this would be a problem, because the burr would wear out from being passed through the press so many times.

KB: We also knew that it would be impossible to manually rock this huge plate. I had been experimenting with photoetching in my own personal work, but I hadn't used it for Crown Point projects. I had a very fine dot screen, 300 dots to a linear inch, and I thought that with the dot screen we could photographically make all the little dots that the rocker usually makes. It wouldn't have the burr above. Rather, it would be little pits below. But it should still make that nice black. There was no burr, but because the dots were so close together it didn't need to etch very deep and could be burnished fairly easily.

CC: The problem was that instead of scraping and removing a raised burr, I would remove the surface and expose more of the holes. I would scrape, and I wouldn't get anywhere. Finally, it became more a process of burnishing the copper, caving in and filling the holes.

KB: All the fine work was done that way. But we also had problems with the photo screen. The plate was so big that we had a lot of trouble getting the ground on evenly. We used a photosensitive ground made by Kodak that we had to

apply by hand. That was what took the most time. If you think about it, what Chuck set out to do with *Keith* was so precise that basically it was impossible.

CC: Still, using the dot screen was a relatively traditional way to work. You evenly distribute the photosensitive ground on the plate. A screen with halftone dots is sandwiched on the plate, a carbon arc light exposes it, and then the screen image is washed out and the plate can be etched. It is easy to do this to an 8 x 10 inch plate. To apply it evenly on such a big plate presented a challenge.

KB: Eventually we did get close to a perfectly even, flat ground. But it took a couple of weeks, and we were all becoming discouraged. We kept making plates, and they kept failing. We discovered that the biggest part of the problem was how the plate was dried. It had to be absolutely, perfectly clean, and then if it wasn't dried rapidly it would tarnish and the ground would not stick. Finally, Chuck suggested that we dry the plate with squeegees and an airbrush. It took four of us to do it, and we were falling all over each other. "The Marx Brothers coat a plate," somebody said.

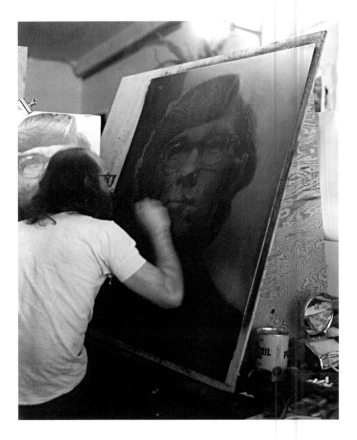

■ PLATE 29
Chuck Close working on the **Keith/Mezzotint** plate at Crown Point Press, 1972

CC: The blacks in this print are really amazing. You have to see a lot of blacks before you know what a velvety mezzotint black looks like. It's not a dead black, where the ink is lying on the surface so that light reflects off it, or a black made from crosshatched lines, or a black made from stippled dots. And mezzotint blacks give the whites a kind of pearly, active glow because the whites have been arrived at through the process of scraping and burnishing, rather than existing automatically as the white of the paper.

TS: You started in the center of the image, proofing that area so many times that the plate became worn.

CC: I started in the center because the center of the face is where the details are sharp, and I wanted to start where things were sharp. The image wore down because it took a long time to figure it out.

KB: The plate also wore down because of problems we had with the press. The bed was bowed out in the middle. Eventually we got another bed, but in the meantime we put newspapers under the center of the plate before printing. And that contributed to the breakdown of the plate. It was a technical comedy of errors.

CC: On the other hand, this print was really key for my future work. One of the things that came out of this, which directly led to most of what I have done since, was that the incremental unit remained apparent throughout the whole process. Keith's building blocks never meshed completely in the print as they had in the paintings. The individual grid units stayed as discrete areas. As those that were done first began to break down from printing, the grid became an essential part of the piece. After finishing Keith, I started doing dot drawings and other pieces in which the incremental unit was visible and ultimately celebrated in a million different ways. That all came from making this print.

TS: But you never did another mezzotint after that?

CC: It was really a onetime thing, and you don't necessarily want to try to go back and recapture that. This was a unique opportunity, and there was a kind of urgency or essential element to having done it at the time. But there is a tour de

PLATE 30
Installation view,
Chuck Close exhibition of
Keith/Mezzotint at The
Museum of Modern Art,
New York, 1973

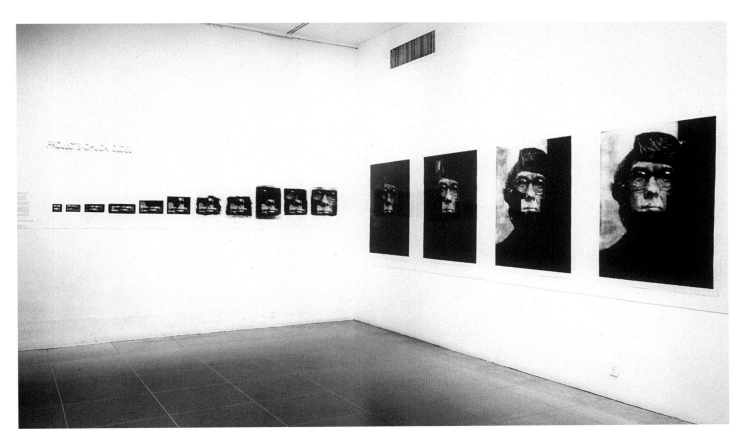

force quality to this print, and I am always suspicious of things that are technical tours de force, because I question why viewers respond. This print is now very valuable; it sells for what major paintings sell for. All of the ten Keiths that we editioned are in public collections.

Keith has been written about a lot, and was the subject of the Museum of Modern Art's first one-print show [in 1973]. A lot of people think it's a significant piece, but I remain suspicious of why. Is it just because it is the biggest mezzotint?

KB: Chuck had specific reasons for doing the mezzotint that were of a particular time and place. All of our successes came out of trying to satisfy his needs. Later, if we tried to do another, it could seem precious or pretentious.

TS: After completing Keith/Mezzotint, you subsequently printed other projects with Crown Point Press.

CC: After working on Keith at Crown Point, I made a lithograph of the same image at Landfall Press in Chicago. I was making drawings with dots in the individual squares, and I wanted to try to make a print that would be an extension of the dot drawings. I didn't like the unpredictable nature of the chemical reactions, so I decided that lithography was not the best medium for me. But I was still looking for something else to do in each individual square. I hadn't figured out a good way to do that in etching. Then I thought, "I'll do lines." The two self-portraits I did at Crown Point came out of this realization. I drew the plate for Self-Portrait (plate 32) entirely in my East Hampton studio, over the course of several months. When I arrived at Crown Point, the plate was ready to go. We just etched and printed it. The plate Kathan had sent me was not prepared with a traditional wax-based ground, because she knew I was going to be touching it a lot. The ground was a dark blue photographic ground. It was the same ground we used for the mezzotint. Only this time we didn't use it for a photographic process. It is very thin, uniform, and has a hard surface, and that is what I scratched through. That ground was very dark, nearly black, and the freshly exposed copper plate was very bright. As I was scratching, I had to think backward and in reverse. Where I wanted it to be dark, I had to scratch a lot of lines, which looked light. If I wanted a light area, I only scratched a few lines, and that looked dark on the plate. I realized that the plate looked familiar, like a photographic negative. It was dark where it was going to be light, and light where it was going to be dark. I had drawn as much as I could on the first round, and if I had been working at the press, we would have etched that and taken a first proof. Instead, I took a photograph

PLATE 31 (opposite)
Chuck Close working on plate for **Self-Portrait**, 1977

Page 54:

PLATE 32
Self-Portrait, 1977
Hard-ground etching and aquatint
54 x 41 in. (137.1 x 104.1 cm)
Edition of 35
Crown Point Press, Oakland, California, printer (Patrick Foy)
Chuck Close, publisher

Page 55:

PLATE 33
Self-Portrait/White Ink, 1978
Aquatint
54 x 41 in. (137.1 x 104.1 cm)
Edition of 35
Crown Point Press, Oakland, California, printer (Patrick Foy)
Chuck Close, publisher

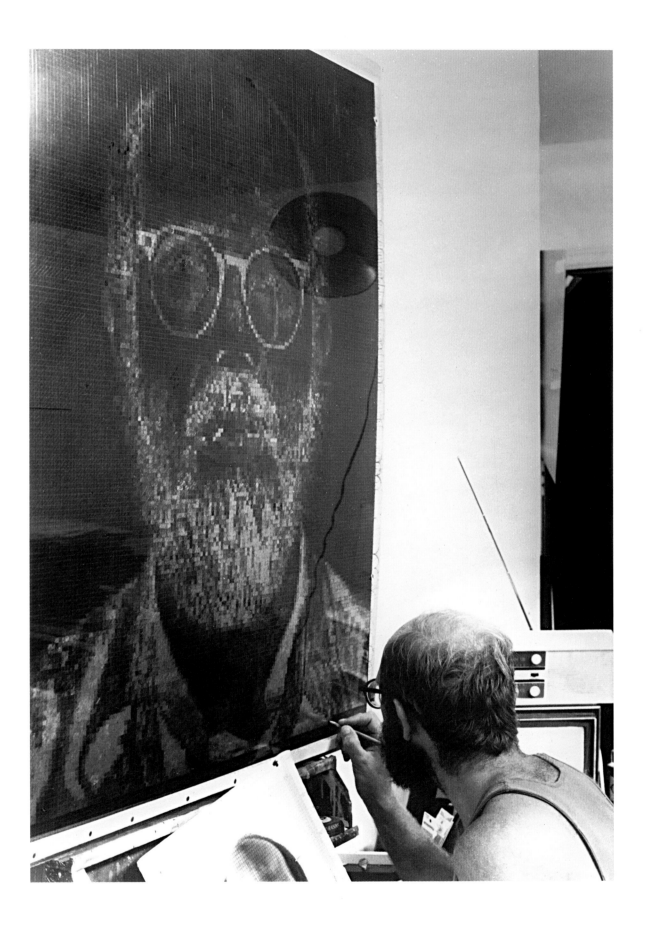

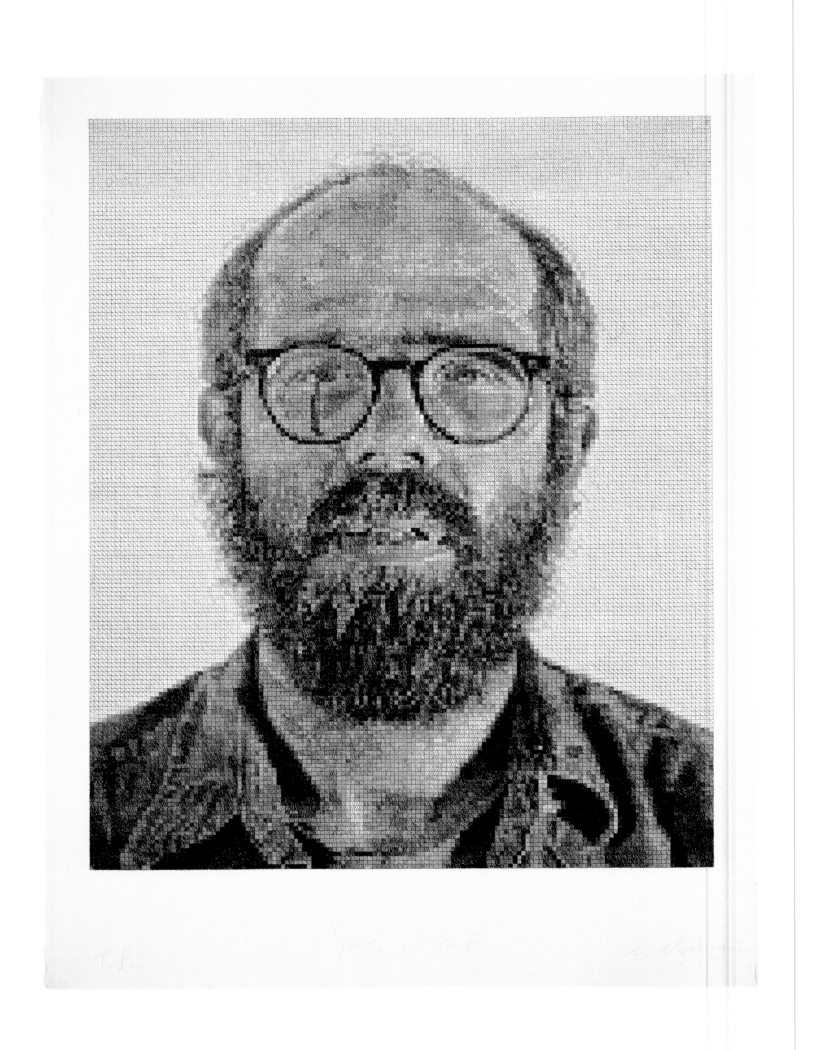

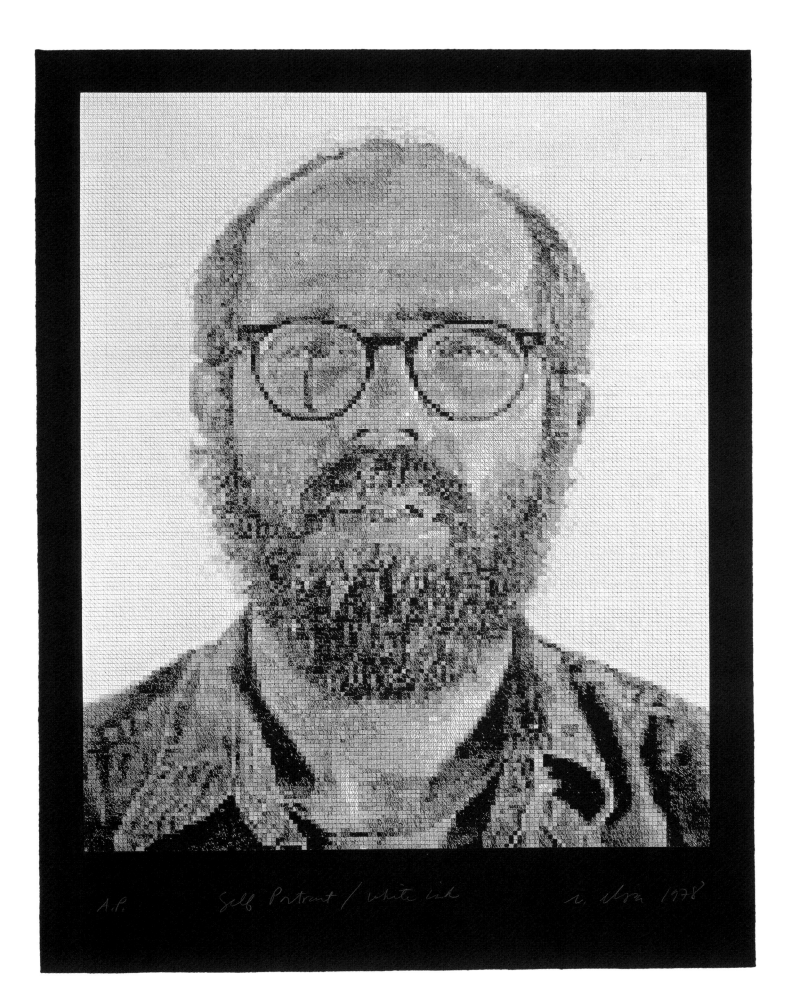

A.P. Self Portrait / White ink C. Close 1978

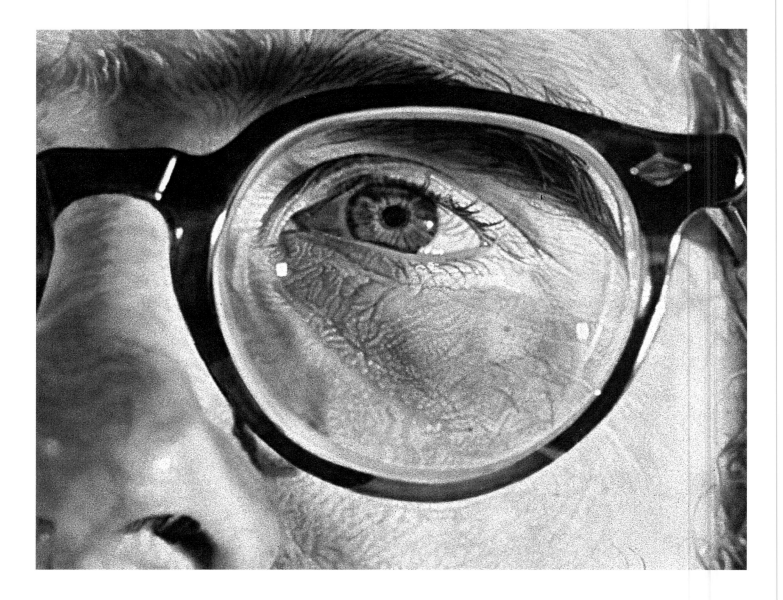

of the plate and made a contact copy negative. From that I made a reverse print so I could predict what the printed plate would actually look like. Based on the photographs, I was able to precorrect the plate before it was etched—essentially, I proofed the plate without proofing it.

TS: It seems that your process of engaging with even the most traditional forms of printmaking, like intaglio, is really about finding new ways to express an image.

CC: You have to understand the specifics of each working methodology. The history and tradition of graphic mediums is a vocabulary, and when you sign on to a process, it is with the knowledge of how that procedure has been used in the past. You may want to break with tradition, or you may want to use tradi-

■ PLATE 34
Detail, **Self-Portrait**, 1976–77
Watercolor on paper/ canvas
80½ x 59 in.
(204.5 x 149.9 cm)
Ludwig Collection, on loan to Museum Moderner Kunst, Vienna

■ PLATE 35
Detail of plate 32

tion. Or you might say, "This is the least likely way to make this image, and I want to see what will happen." I have always been interested in trying to change my experience rather than exploit it in some formulaic way.

 The path taken, the course chosen, influences how something looks. The particular decisions made are important to the product and make it different from other things.

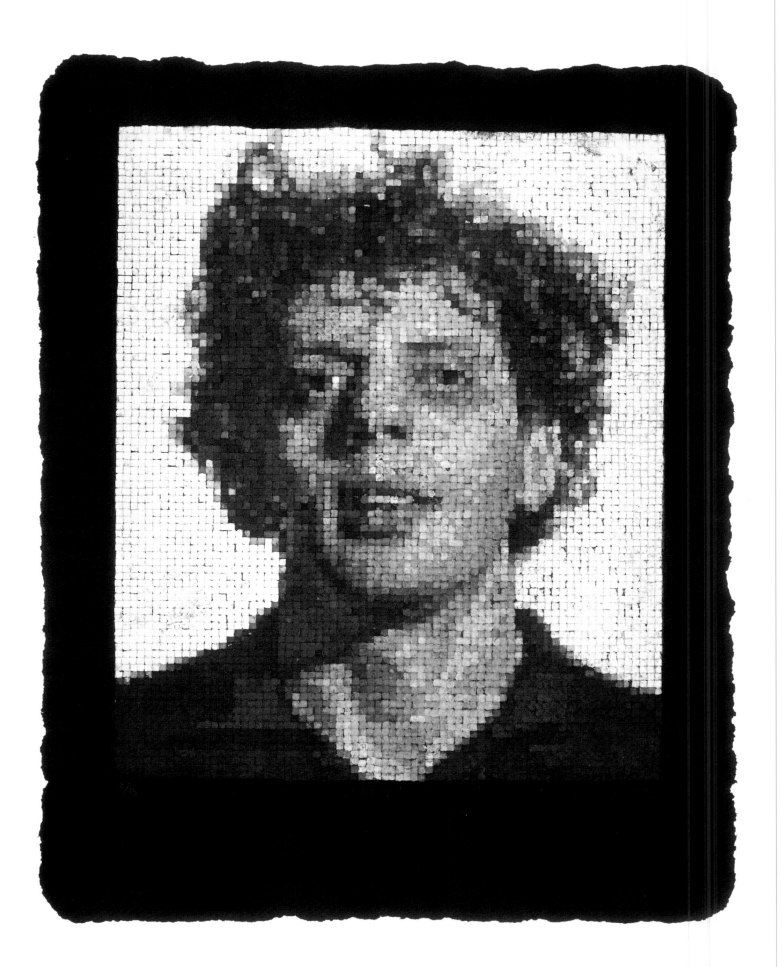

Pulp-Paper Multiples

RUTH LINGEN AND MAE SHORE, PACE EDITIONS, INC., AND PAUL WONG, DIEU DONNÉ PAPERMILL, INC.

PULP PAPER WAS A MEDIUM that Chuck Close approached reluctantly but now embraces with enthusiasm. On July 23, 2002, Terrie Sultan met with Close at the offices of Pace Editions, Inc., in New York to talk with Ruth Lingen and Mae Shore of Pace Editions, Inc., and Paul Wong of Dieu Donné Papermill, Inc., about the making of his pulp-paper multiples, including Phil (plate 36), Georgia (plate 45), and Self-Portrait/Pulp (plate 46).

TS: You have made a lot of pulp-paper multiples, which are rather different from your other prints. How did you get started?

CC: Joe Wilfer essentially conned me into it. Joe was the founding director of the Madison Art Center, and he taught printing and papermaking at the University of Wisconsin there, where he was known as the "the prince of pulp." Ruth was his student and his assistant. Later he was hired to direct the art program at Skowhegan School of Art. He immediately rubbed some people the wrong way and managed to get fired. I met him because I was a board member at Skowhegan. When he moved to New York, he visited me at my studio on West Third Street one day and said, "Let's make some pulp-paper pieces." And I said, "No." I hated pulp paper because I had never seen anything I liked in that medium.

PW: When Joe moved to New York, Dieu Donné hired him to bring artists to the paper mill, and Chuck was one of the artists he wanted to work with.

RL: Joe had also run the Upper US Paper Mill in Wisconsin. It was a commercial enterprise where he wanted to entice artists to make sheets of paper. He

worked with Alan Shields and Bill Weege and a lot of Chicago artists to publish editions in pulp paper and print.

CC: I had seen some pulp-paper work that Joe had done with Alan Shields that I liked, but not enough to pursue it. But Joe persisted. He kept asking, "Hypothetically, if you did want to make a pulp-paper piece, what would it look like?" I said I wasn't interested in big flat shapes and decorative stuff, and that I would need an infinitely controllable range of grays, say twenty-four to thirty grays that could be discretely placed. He did some tests at Dieu Donné that really didn't work for me. He made more tests, and he slowly got rid of more and more of my objections. Joe was probably the most creative problem solver I have ever worked with, and sometimes it is easier to agree to do a project than resist when someone is as insistent as he was. I did the first pieces with Dieu Donné at 3 Crosby Street [New York]. This is where Paul enters the picture.

TS: Paul, talk a bit about the process.

PW: Paper comes from cotton and linen fibers. At Dieu Donné we use pounds and pounds of new textiles, mostly clippings from the rag industry, to make the pulp. The pieces of cloth are cut into squares of about one inch. It takes quite a while to beat, using a machine called the Hollander beater. It generally takes the rags about five hours on average to disintegrate into pulp. This technique goes back to the traditional manner of how paper was made before the Industrial Revolution. But with Joe, we often used an old washing machine with cotton linters, very low-tech.

TS: Just water and action? No chemicals?

PW: It's a mechanical process and very labor-intensive. We add calcium carbonate to buffer any acidity in the materials. We can add pigment at the end of the pulping process, and usually the pulp is sized with a liquid sizing. That is the raw material. Then you form a backing sheet on a mold by dipping it into a vat of pulp. You pull up a layer of pulp, and while the water drains out you shake it so that the fibers are evenly distributed on the surface of the screen. Once it's drained, you flop the whole layer over onto a felt and lift the screen off—that's called "couching"—then stack and press the layers.

RL: We work wet on wet. When you put colored pulp on top of a wet, freshly couched sheet and press it, it bonds together to make one integral sheet of paper. If you pressed the sheet first, for example, and then tried to go back over and work on it, it would create only a superficial attachment. While the pulp is

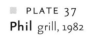 PLATE 37
Phil grill, 1982

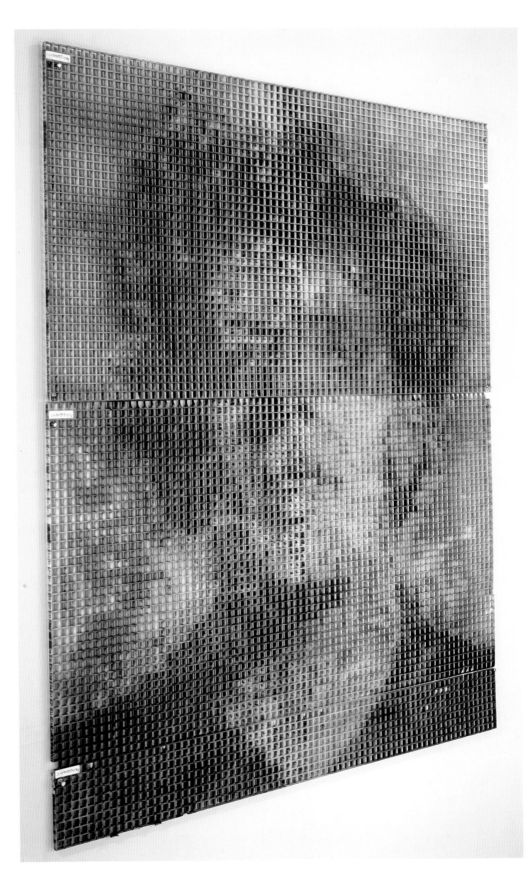

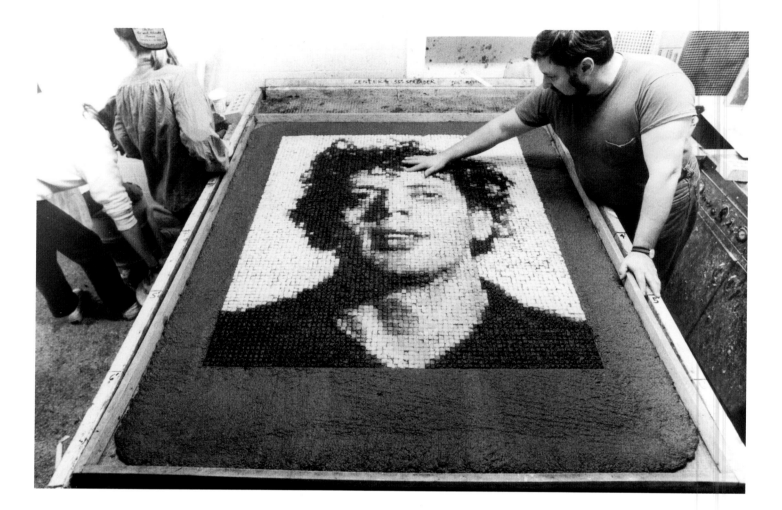

PLATE 38
Joe Wilfer working on **Phil**,
c. 1982

wet, it is malleable. Placing it on felt helps the water drain away from the fiber. Eventually you stack up a bunch of pieces and press them.

PW: For Chuck's first piece, Joe devised a grid system we could use, using grills that are used commercially as covers for fluorescent light fixtures. One was aluminum, the other plastic. The plastic one had thicker walls, so the deposits of pulp were more separated. The aluminum had much thinner walls, so the pulp deposits were right next to each other.

CC: We came up with a grill in the first place because pulp runs and bleeds. We wanted something that would form an occlusive seal to keep the watery gray pulp from seeping into adjacent areas.

TS: Your first pulp-paper piece was Keith. Why did you select that image?

CC: I always recycle images. I had used Keith for the mezzotint (plate 28) and the lithograph *Keith/Four Times* (plate 2). For the pulp-paper piece, we had to figure out the arrangement of grays, so we worked with an image that already ex-

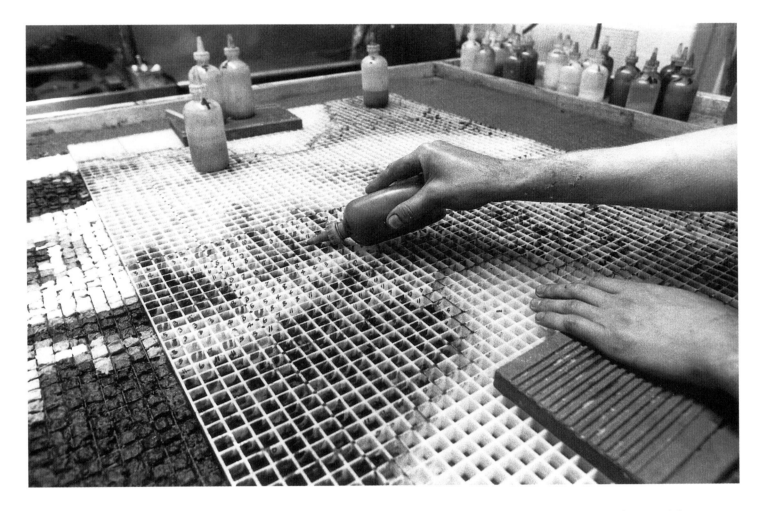

■ PLATE 39
Filling the **Phil** grill with
pulp paper, c. 1982

isted. I took a watercolor of Keith that I had done in square strokes, and by punching holes on a Kodak gray scale, which ranges from white to black, I could slide the scale over the watercolor and see the value of each part. Using this as a template, we assigned a number to, in effect, digitize the image and give us a string of numbers that established a tonal gradient. Those strings of numbers in the rows were attached to the grill. We pushed the pulp through the grill into the carrier sheet. Both Keith and Phil, which I had done as watercolors, were images I could digitize that way.

PW: Every single opening in the grating was numbered according to a corresponding grade of pigmented pulp. Basically, it was a lot like color-by-number. You would fill in the appropriate gray in that appropriately numbered slot. We ended up using a total of twenty-four different grays.

CC: We found that the Kodak gray scale didn't seem to have equal steps. So we established halfway marks, something like 3.5 halfway between Kodak's 3 and 4, to make the scale continuous.

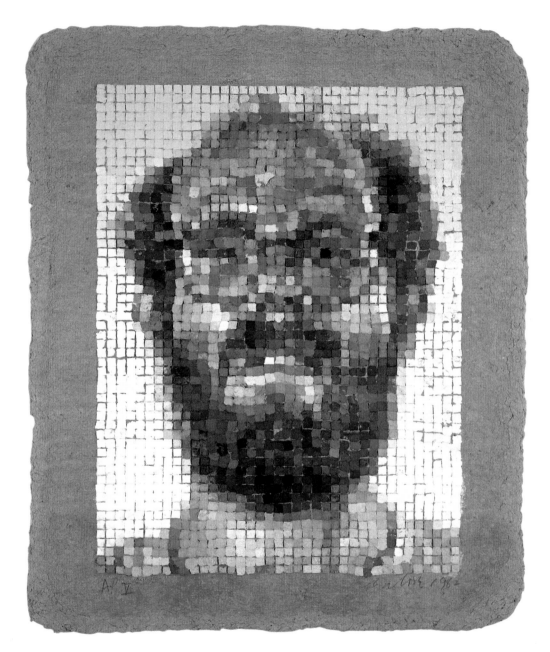

PLATE 40
**Self-Portrait/
Manipulated**, 1982
Handmade paper in
24 gray values
38 x 30 in. (96.5 x 76.2 cm)
Edition of 25
Joe Wilfer, printer
Pace Editions, Inc.,
New York, publisher

PW: There was a lot of fine-tuning. Chuck had determined certain squares to be a certain gray, and if it wasn't visually quite right, he would change that square. We would make him a proof with those colors, and then if there was something off, he would tell us.

RL: He could zero in on just the one wrong gray. When you had it just right, you would never see a jump.

TS: How long did Keith take from start to finish?

PLATE 41
Self-Portrait/String,
1983
Handmade paper in
24 gray values and string
33 x 23 in. (83.8 x 58.4 cm)
(variable)
Uneditioned, 3 TP
Joe Wilfer, printer
Pace Editions, Inc.,
New York, publisher

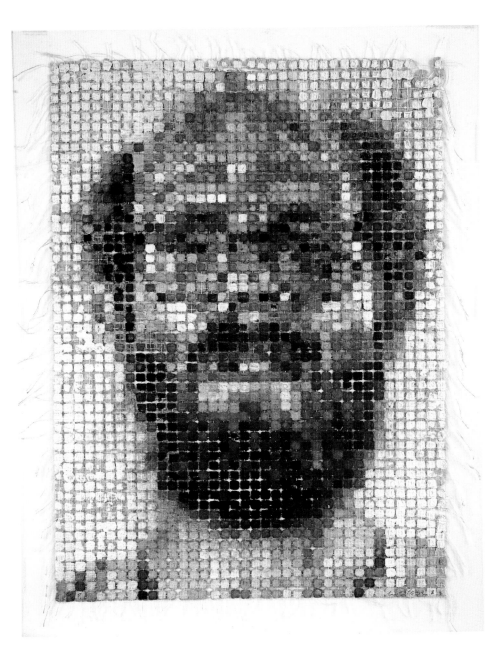

PW: Probably a year. But many different variations were editioned, too. One was hand manipulated. We would edition everything wet, and then Chuck would come in at the end of the day and start manipulating it by mushing it around.

RL: The manipulation was to give a certain kind of expression and surface texture that wasn't inherent in the piece. It gave it more depth in a way that is similar to hand coloring, to show the artist's hand. In this case, it was Chuck's all-seeing eye. It became more about perception, about seeing the whole thing work.

CC: There is a real interdependence between the unique works and the prints and multiples, a constant dialogue back and forth. For example, while we were making the early pulp-paper pieces—Keith, Phil, and Robert—I would drop blobs of pulp on the floor, and they would harden into miniature meadow muffins the size of Pringles potato chips. Eventually, there were hundreds of little chips in all the various shades of gray we had been using. I picked them up and kept them in a cigar box. I started stacking them up on top of each other. The edges of these little chips were beautiful—natural, irregular outside edges formed by gravity, not by artistic decision. So I went into the chip-making business. We had trays filled with the various grays. I started making collages with them, gluing them on a canvas. At a certain point I did a collage of *Georgia* (plate 42), and I decided I wanted to go back and make a multiple again. I traced out the collage, simplifying it and changing it some to make it more possible to do. For this one, we couldn't use a gridded grill. Joe had to make a new, eccentrically shaped one from bent strips of brass and silver soldered together.

TS: *Georgia* is almost a tracing of the painting, but the grill is a work of art too (plate 43).

RL: It took Joe almost four hundred hours or about ten weeks of work to make the grill.

TS: Talk more about *Self-Portrait/Pulp* (plate 46). How has working with pulp evolved over time, from the ready-made grill you used for *Keith* to the eccentric grill you used for *Georgia* to this new one, which is made mainly with stencils?

■ PLATE 42 (below, left)
Georgia, 1982
Pulp-paper collage
on canvas
48 x 38 in. (121.9 x 96.5 cm)

■ PLATE 43 (below, center)
Brass shim grill for
Georgia, 1984
48 x 38 in. (121.9 x 96.5 cm)
Created by Joe Wilfer

■ PLATE 44 (below, right)
Detail, **Georgia** brass shim grill

■ PLATE 45 (opposite)
Georgia, 1984
Handmade paper, air dried
56 x 44 in. (142.2 x 111.7 cm)
Edition of 35
Joe Wilfer, printer
Pace Editions, Inc.,
New York, publisher

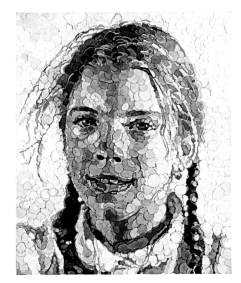

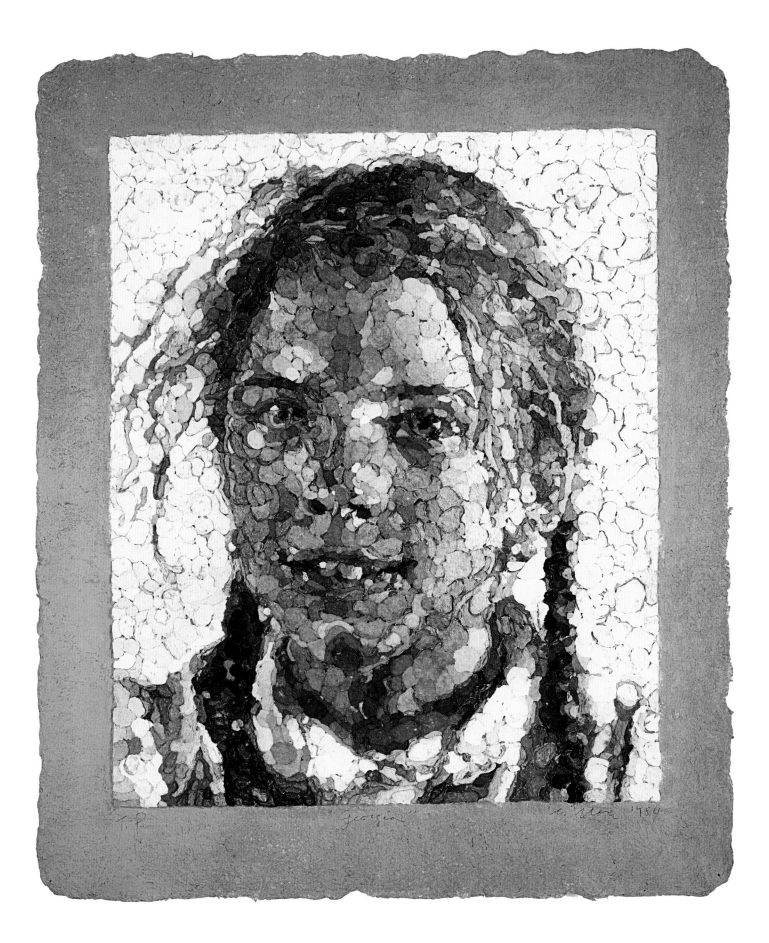

T.P. "Georgia" C. Close 1984

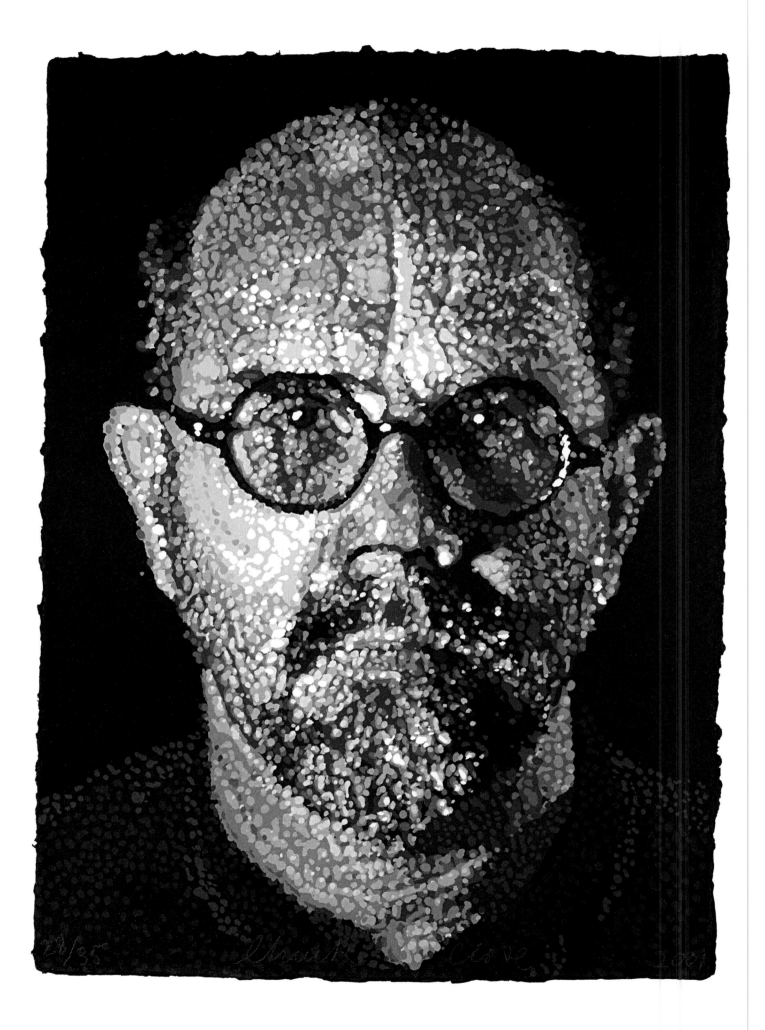

RL: The big *Self-Portrait/Pulp* idea came about from the states for the reduction linoleum cut of a small self-portrait (1997). We had the states, and they were very clear. And I kept thinking, "There should be a way to make that in pulp paper."

CC: We had pulled Mylars from each state of the reduction linocut, which we simplified to make a small self-portrait pochoir. I wasn't as thrilled with it because we had reduced the steps and so didn't have a broad enough range of lights to darks. We decided to try it much bigger, and put all the steps back in. In fact, we added steps, because we added corrections and highlights. At first we tried Plexiglas for the stencil because we thought we had to have a thick wall. We worked the marks with a router.

RL: But the Plexi was too thick, and there was too much suction. By the time we would pull up the stencil, everything was mush. So we tried making the stencils out of Lexan [a commercially available plastic sheeting], which was stiff but thinner than the Plexi, and that worked beautifully.

CC: We never would have guessed it, but with the really thin stencil the pulp stayed perfectly placed.

RL: It repels it and pulls it in a perfect way. We got incredible detail.

PW: We had to acquire new skills in filling these stencils, too.

MS: After testing different ways of applying the pulp to the stencils, we discovered that regular cake-decorating tools were perfect for applying the pulp. They gave us control, and there were different tips we could use on different areas as needed. We had a number of layers, and we would use a pellon on each new stencil when we put it down to blot it. Otherwise it became too mushy.

TS: What is pellon?

RL: It is a thin synthetic fabric, like the slightly stiff interfacing you would use in sewing clothing, for collars and lapels. We would put it down and smooth it out over each step, and it would pull off the surface water, so the next stencil was sitting on something not too wet.

MS: Then we had to push down each air bubble to make sure the fibers were in contact with the stencil. We called this process "happy fingers." It eliminated pockets of air that could cause leaks and the pulp to bleed. We needed each layer to be in perfect contact with the previous layer for crisp registration.

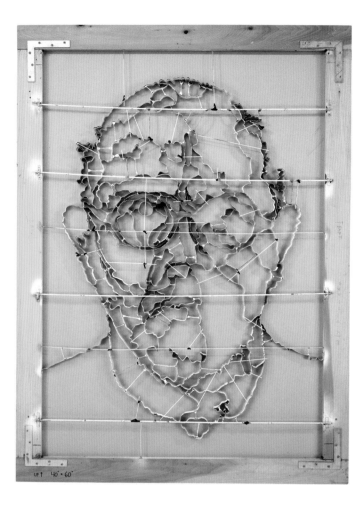

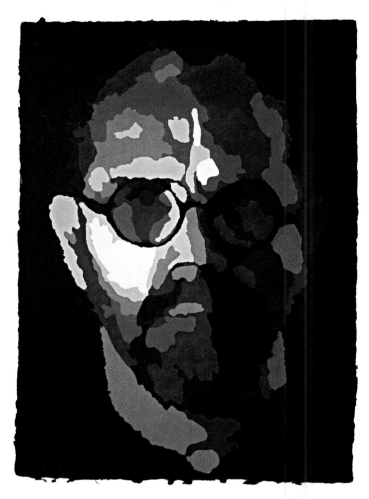

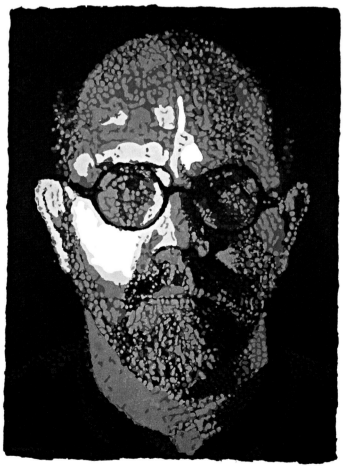

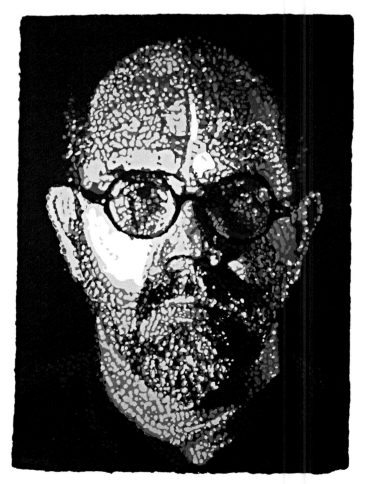

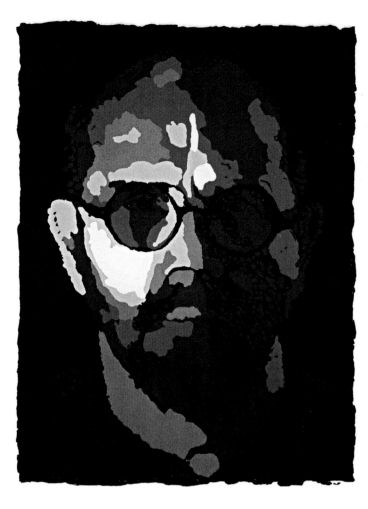
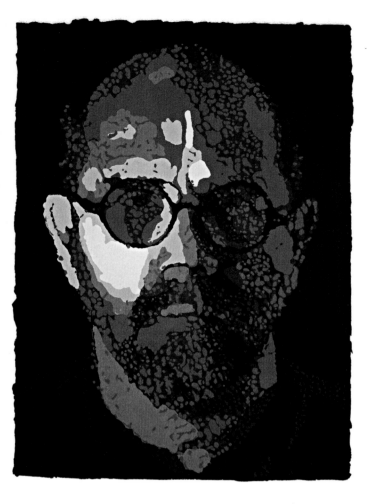
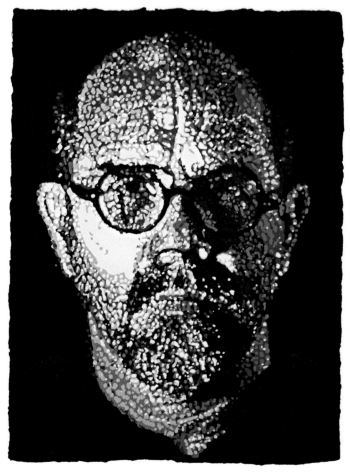
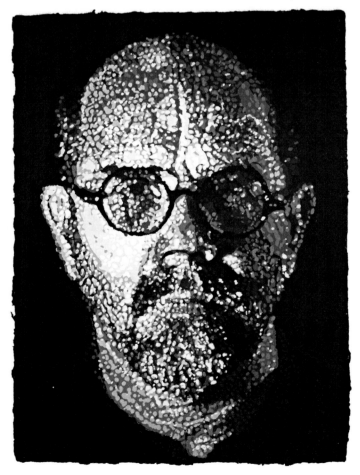

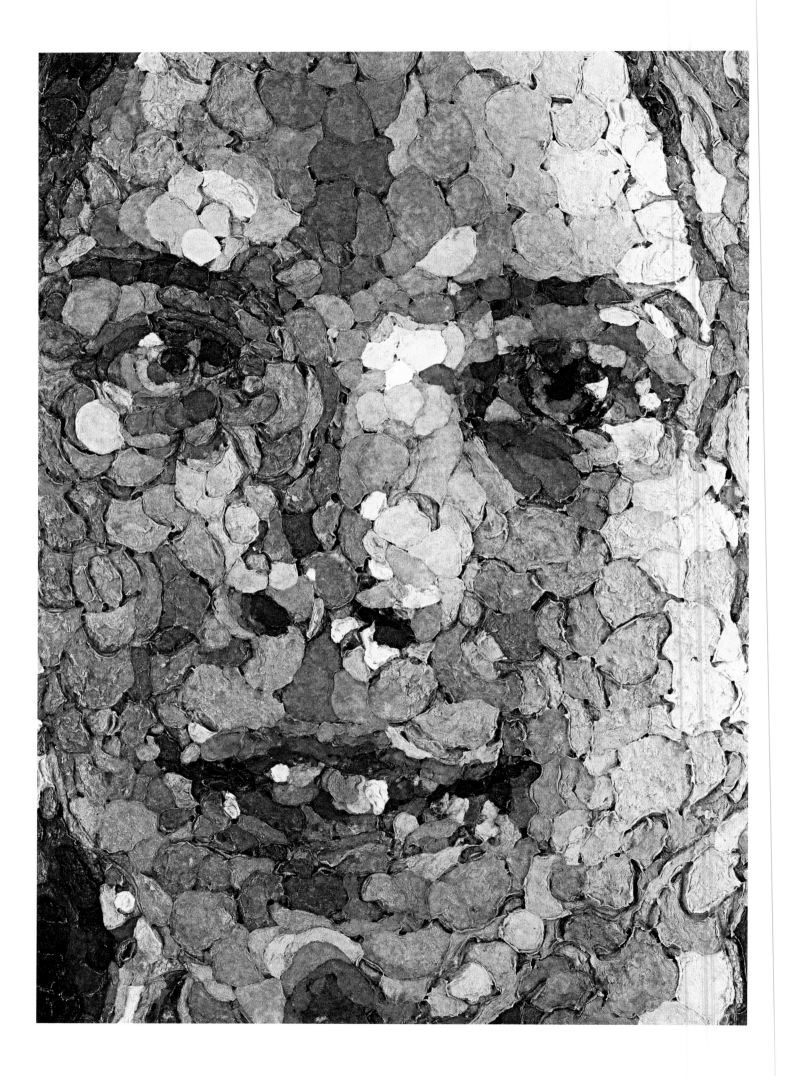

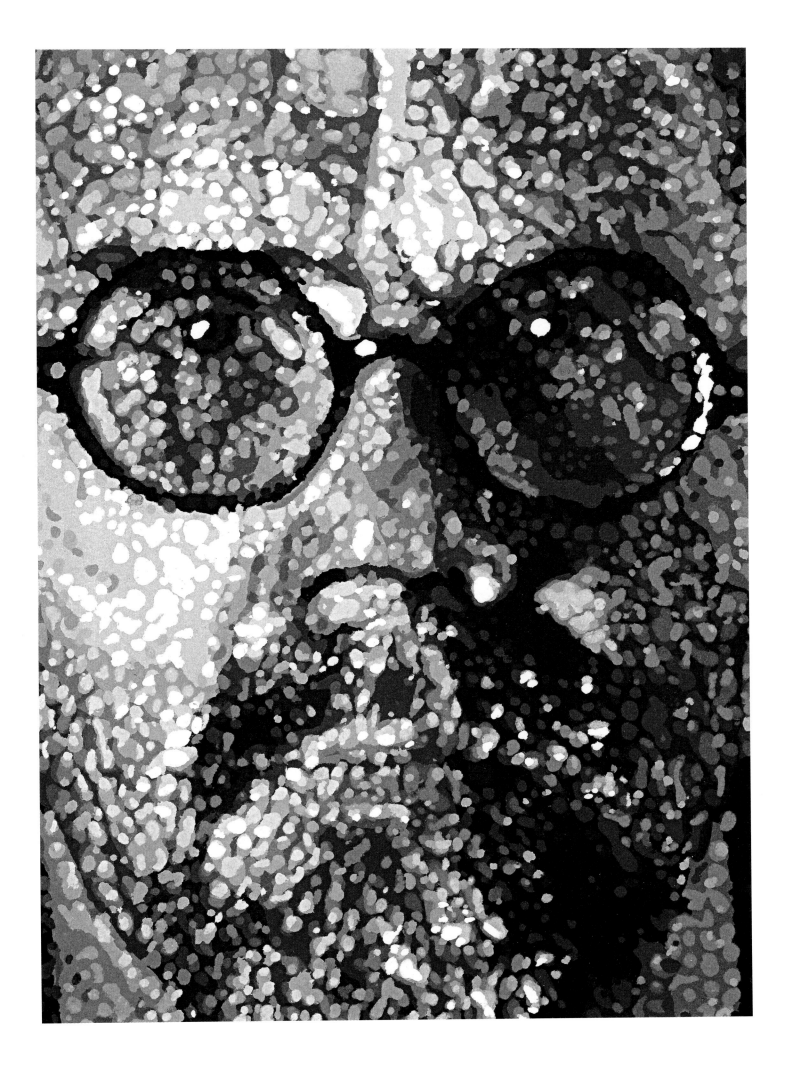

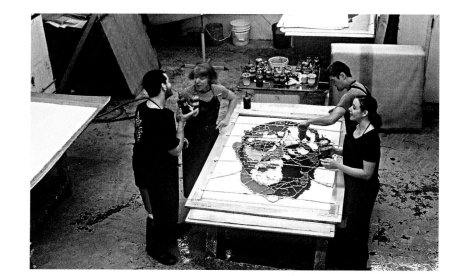

■ PLATE 57 (left, top)
Self-Portrait/Pulp
Filling the grill, 2001

■ PLATE 58 (left, center)
Self-Portrait/Pulp
"Happy fingers," 2001

■ PLATE 59 (left, bottom)
Self-Portrait/Pulp
Stencil, 2001

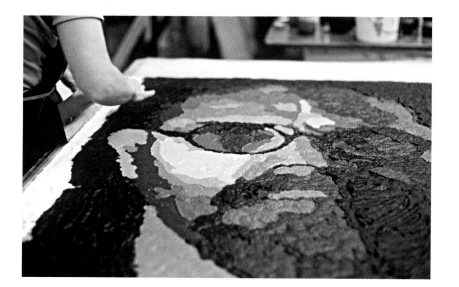

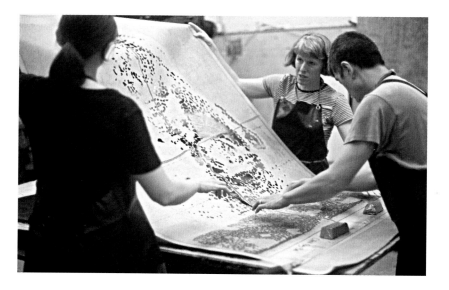

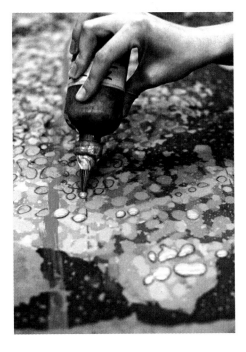

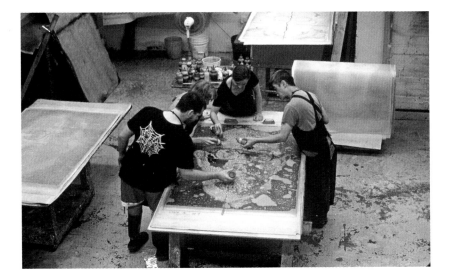

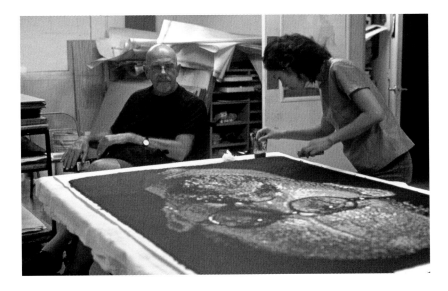

■ PLATE 60 *(above)*
Self-Portrait/Pulp
Detail, filling the stencil
using cake-decorating tip,
2001

■ PLATE 61 (right, top)
Self-Portrait/Pulp
Filling the stencil, 2001

■ PLATE 62
(right, bottom)
Self-Portrait/Pulp
Chuck Close checking final
image, 2001

CC: In the end the whole sheet looked like a huge, beautiful sheet cake with fluffy frosting.

MS: Some of the stencils have pretty large holes, and we had to put in a lot of preliminary work on this, before we did any proofs, just to see if it would work, registration wise.

CC: As always we did about half the edition, and then I decided that I didn't like the steps of the grays, because I thought that the jumps between them were too big.

MS: We did nineteen pieces before we had to change all the dark colors. We had to throw many of them away.

CC: The rest became printers' proofs because you guys liked them.

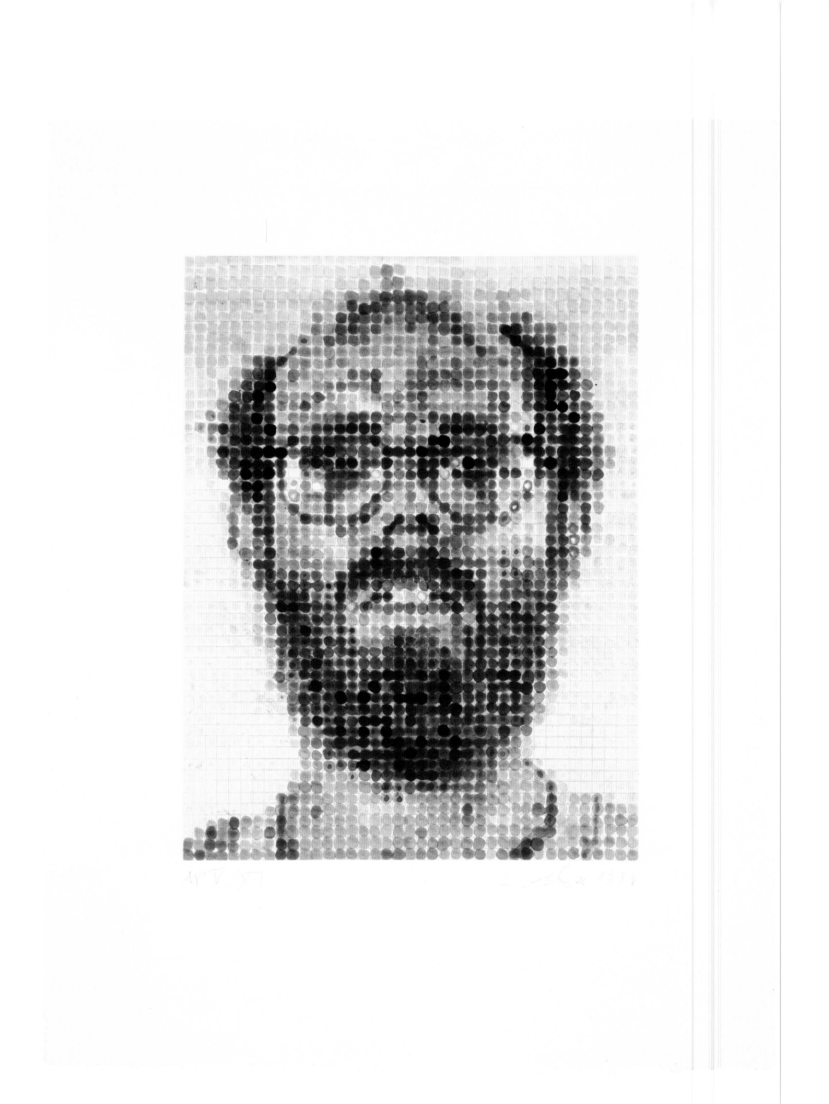

Spitbite Etching

BILL HALL AND JULIA D'AMARIO, PACE EDITIONS, INC.

SPITBITE ETCHINGS AND AQUATINTS are types of intaglio prints, and Chuck Close has made several in this medium. A spitbite etching is basically an aquatint, but rather than putting the entire plate in an acid bath, the acid is painted on, allowing for more nuances in grays. Spit is used to add viscosity, holding the acid in place. On July 23, 2002, Terrie Sultan talked with Close and Bill Hall and Julia D'Amario of Pace Editions, Inc., in New York, to learn about this process and the projects *Self-Portrait* (plate 63), *Phil Spitbite* (plate 66), and *Self-Portrait/Spitbite* (White on Black) (plate 67).

TS: In 1988 you made *Self-Portrait*, your first spitbite aquatint. Explain the difference between a spitbite and a regular aquatint.

CC: For an aquatint, an etching plate is dusted with rosin, sometimes from a bag, or now applied by placing the plate in an aquatint chamber in which the rosin dust is blown in the air and settles onto the plate, after which the plate is taken carefully out of the box. The plate is then heated with a torch, and little beads of rosin melt and adhere to the plate. When the plate is etched, the acid etches around each one of those dots, giving you a kind of random halftone and, more important, giving the plate a tooth to hold the ink. To make a normal aquatint, you put the rosin on the plate, you heat it, you stop out the areas you don't want the acid to bite, and you drop the plate in the acid to flat-etch those areas that are not protected by stop-out varnish. It tends to bite the whole area like a flat tone.

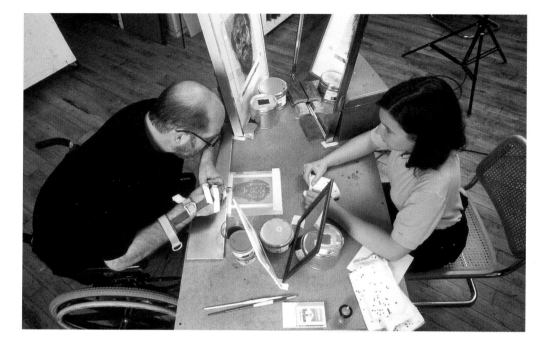

■ PLATE 64
Chuck Close working on **Self-Portrait** with Julia D'Amario, 1992. Note photograph and mirror setup, to facilitate working in reverse on the plate

JD'A: You have to be careful when you heat it that the dots don't run together. Rosin has a relatively low melting point, 250 degrees. If you heat up the plate too much, the rosin turns into little pancakes instead of little beads.

TS: Where does the spitbite part come in?

CC: The beauty of spitbite is that instead of biting the whole area in an acid bath, you apply the acid directly onto the aquatint ground, with a brush dipped in acid mixed with saliva to control the acid flow. This allows for a soft edge, which to me looked very much like the drawings I made with an airbrush. I made *Self-Portrait* with the renowned French printer Aldo Crommelynck, who was Picasso's and Matisse's printer. I had Aldo spit in the acid for me. I thought that French spit was better suited for this process. I think it was all those Gauloise cigarettes Aldo smoked. My spit never seemed to work as well. With spitbite, you can bite in differing intensities on small sections of the plate.

BH: In the proofs you can see the methodology Aldo developed for the first self-portrait, which we expanded on for several other prints. We used the same gray scale that was used for the pulp-paper self-portrait (plate 46), and we did timing tests to determine corresponding aquatint times from light to dark. On a gridded piece of paper we had numbers from 0, which was basically white, to 24, which was black. With testing, these numbers became times for applying acid.

CC: It is hard to believe that I made these [Phil Spitbite and the spitbite self-portraits] without the use of a computer program. In fact I was doing something that is really very similar: averaging things together and finding marks that stand for that number. Digitizing tones and values and leaving them as a stream of numbers is very close to how computer scanning works. But we don't use any labor-saving devices. We make art the old-fashioned way, very much by hand. And everything is coordinated by eye, by me, putting a gray scale across the image and deciding that one part of the scale had to be 3.5 or 4.5 and that to arrive at that number you guys had to decide how to print that color, how to etch it in a different way.

BH: Through experimentation we had to calculate exactly how long the acid had to be on the plate [of *Self-Portrait*] to give a particular value. For instance, if the value for a square was number 1, it may have been a two-second bite. Number 2 may have been five seconds, and so on. The darkest value, the longest bite, was perhaps sixteen minutes. To begin, a soft-ground grid was etched on the plate. Using a soft brush, the acid was applied within a square and then after three or four seconds, if that was the length of time, it would be blotted with a small cloth—actually diapers, because they were so absorbent. We used a photographer's clock for the longer times.

CC: The lightest ones were a split second, and for those we used the ticks of a metronome. It would go, "tick, tick, tick," and we would say, "Put it on two ticks and blot, three ticks and blot." At least for the first one, I was painting the acid on, and Kathy Kuehn was blotting.

JD'A: We kept a detailed notebook to track the different applications. It required a lot of hitting the plate with acid, blotting it off, and reapplying. Keeping track of how many minutes the first application had been on and how many the second, and so on, was the real key. It was a job for three people: a timer, a person putting on the acid, and a person blotting. In order not to have a row take half a day, we needed to figure out the highest number and then work down, adding as we went. It was sort of like being an air-traffic controller; you could very easily lose your focus in the middle of the row. For example we started with the longest bite in a row, applied acid, and at the appropriate interval applied acid to the squares needing the next longest bites and so forth, until all the squares on the row had acid on them for the right amount of time. Then we would move down to the next row.

BH: As clever and together as it seems, it had to be done twice to get it right. We

had to analyze exactly which square needed to be hit with more acid. Chuck came in at the end and used an electric architect's eraser to bring out the highlights. The big Phil was done the same way. On the chart for Phil, we had codes written in both red and gray pencil. The red marks indicated second bites, and the regular pencil marks show anything over one minute. Phil was a challenge for size, too. We divided it into quadrants, with numbers for each quadrant. But it is all one plate. That is, one plate with over 6,800 squares.

CC: I would work all over in big washes on top. Sometimes the little spaces between the dots were too white. I wanted to give it tone, so we put another aquatint on the plate, and I brushed over the top to kill certain areas, or to run dots together. It's not an accident that one little spot is bright and one dull. Each tone is the result of a conscious effort.

TS: Why did you decide to do a white-on-black print [Self-Portrait/Spitbite]?

CC: Years ago I had done drawings with black ink on white paper, and then I got black paper and decided to spray it with white ink. Making a reverse image is not so easy. What takes no time, like a background, in one becomes a time-consuming and complex problem in the reverse.

BH: It wasn't just a matter of reversing the numbers on the first one, because to get a white to print well, you have to bite the plate very differently. We reversed

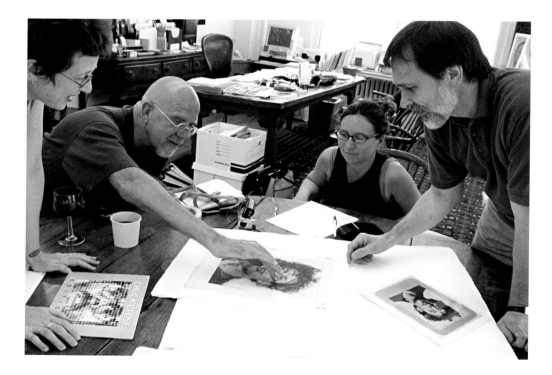

■ PLATE 65 (left)
Terrie Sultan, Chuck Close, Julia D'Amario, and Bill Hall discussing **Phil Spitbite** at Pace Editions, July 2002

■ PLATE 66 (opposite)
Phil Spitbite, 1995
Spitbite etching
28 x 20 in. (71.1 x 50.8 cm)
Edition of 60
Spring Street Workshop, New York, printer (Bill Hall, Julia D'Amario, Ruth Lingen, Pam Cooper)
Pace Editions, Inc., New York, publisher

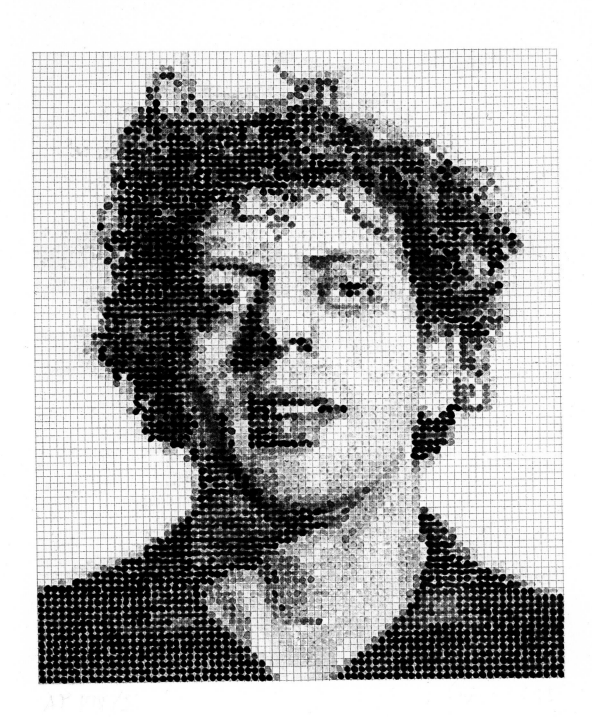

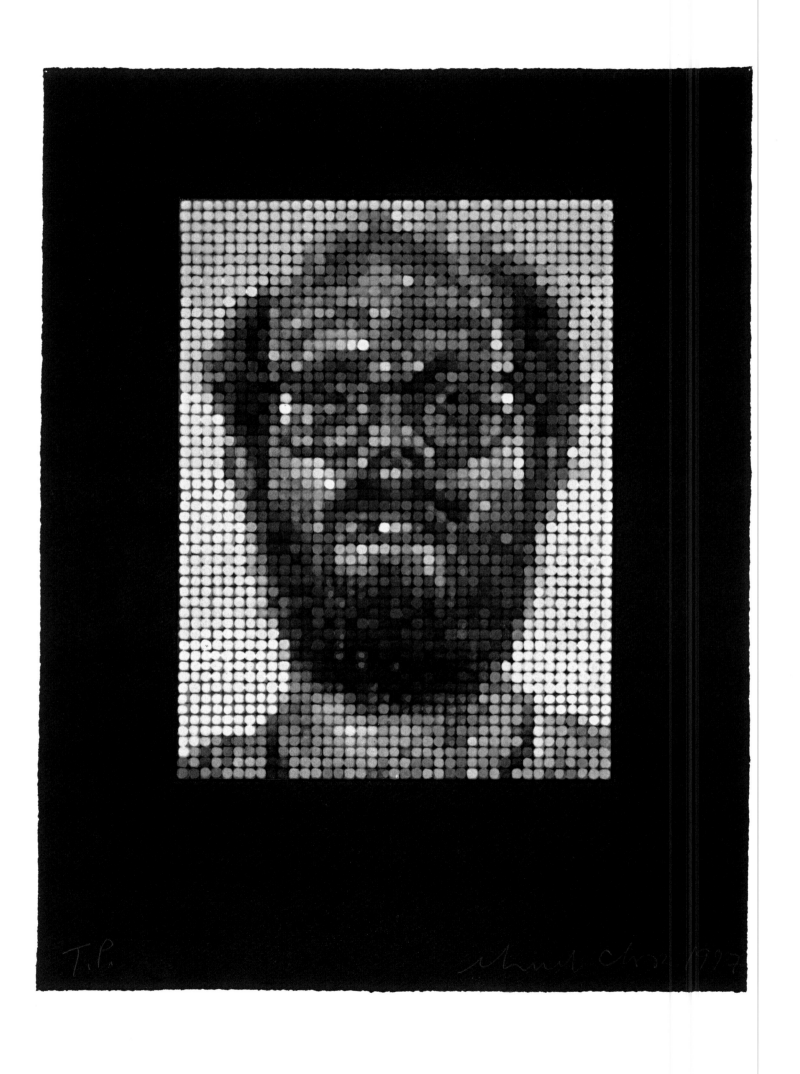

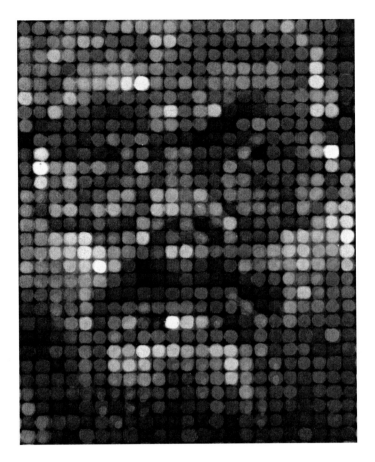

PLATE 67 (opposite)
**Self-Portrait/Spitbite
(White on Black)**, 1997
Spitbite aquatint
20½ x 15¾ in. (52 x 40 cm)
Edition of 50
Spring Street Workshop,
New York, printer (Bill
Hall, Julia D'Amario)
Pace Editions, Inc.,
New York, publisher

PLATE 68 (above, left)
Detail of plate 67

PLATE 69 (above, right)
Detail of plate 63

them and then adapted them for three plates. We made a coarse aquatint for the whites that had to be etched the longest. Then we did a fine aquatint plate for the shorter bites and to enhance the whites on the first plate. Then Chuck etched a third plate with broad spitbite washes, which was printed last and effectively pulled the image together.

TS: Did you print black ink first?

BH: Yes. We printed a solid, flat aquatint over the whole sheet of paper, so it looks like a black sheet of paper. Then we printed all the plates in white. It was a complicated process.

CC: Nothing is ever quite what it seems. It isn't simply white ink on a black sheet of paper. It is usually several plates to accomplish it. My belief in process is that if you follow it, it will take you somewhere. But it's not the process itself that is important. I'm not just displaying what the process does. If the process doesn't make something interesting, then throw out the process altogether or alter it by intervening somewhere in the process, with correction plates, or layering, or something else.

Reduction Linoleum

RUTH LINGEN, PACE EDITIONS, INC., AND ROBERT BLANTON AND THOMAS LITTLE, BRAND X EDITIONS

CHUCK CLOSE MADE HIS FIRST reduction linoleum cuts in 1988. These were small prints, such as *Lucas* (plate 70). Several years later, he tackled the monumental *Alex/Reduction Block* (plate 72). On July 23, 2002, Terrie Sultan, Chuck Close, and the master printers Ruth Lingen and Julia D'Amario of Pace Editions, Inc., met at Pace Editions, Inc., in New York to discuss these projects and *Self-Portrait I (Dots)* (plate 71). The group was later joined by Robert Blanton and Thomas Little of Brand X Editions to talk about how *Alex* began as a reduction linoleum cut and finished as a silk-screen print.

TS: How did you become interested in making reduction linoleum cut prints?

CC: Joe Wilfer brought me a book from the Museum of Modern Art about Picasso's reduction linocuts. Two things appealed to me about his process. One was that there were no registration problems, at least for the artist. All the drawing and cutting is done on the same block, progressively cutting away until there is virtually nothing left. Picasso invented this process, and his technique was absolutely brilliant. He was having trouble getting printers to accurately register his blocks, so he came up with the idea of nailing the block to the table, then carving away parts of the block for each successive stage. Say you are making a landscape image, and you want white puffy clouds in a blue sky. The white is the paper, so you would carve away the areas you want in white, leaving the rest of the block to be inked up in blue. Then you would print the entire block in blue. That would be the sky. Then, perhaps the next color would be the green grass. You would carve away all the areas you wanted to remain blue, and then print the whole block in green. The image builds slowly this way.

■ PLATE 70
Lucas, 1988
7-step reduction
linoleum cut
31 x 22¼ in. (78.7 x 56.5 cm)
Edition of 50
Spring Street Workshop,
New York, printer
(Joe Wilfer, Ruth Lingen,
Kathy Kuehn)
Pace Editions, Inc.,
New York, publisher

Picasso's reduction linocuts had such impeccable logic, yet were totally unpredictable. In some ways it is similar to how I made the three-color paintings. It is the least complicated way to build a full-color image using only a few colors, but it is in fact very hard to do with just three colors. You have to get them all just right. There is something about this economy that really interests me. The fewest number of colors, least number of steps, letting the steps show, laying it out for the viewer. It is a simple, direct process, but complicated on another level.

RL: I checked our journal and saw that you first came to the shop to discuss doing a reduction linoleum cut in October 1988. We made Lucas and Janet then, over the course of about two weeks, using an electric chisel and an electric Dremel. And this was the first time you used a projection to draw the image on the linoleum block. I remember we fixed a projector to the ceiling to beam the image onto the block.

CC: It was very low-tech. Someone would have to go up there from time to time and shove the slide around because it would get out of register.

TS: Talk about how you conceptualized the Lucas and Janet prints.

CC: I devised a way of printing light to dark in seven steps in seven successively darker grays. Anything I wanted to appear white on the finished print I carved out of the block, and then printed the lightest gray. The next step was to carve away the places I wanted to appear in the lightest gray, and so on until we built up to the darkest value.

RL: Reduction blocks are very different from a traditional woodblock in that the carving process is subtractive rather than additive. The end has to be in sight from the very beginning, but you have to visualize the steps in between. You have to know what it is going to look like at the end before you start, and you have to work backward. It's very risky that way.

CC: I always know that a finished print is going to look a lot like the photograph I work from. An art historian once said that the difference between my work and, say, Jackson Pollock's was that Pollock didn't know what his next painting was going to look like, but he knew what he was going to do in the studio that day. I know what my painting is going to look like, but I don't know what I am going to do in the studio. My art is an invention of means rather than an invention of interesting shapes and interesting colors. It is a belief that ideas are generated by activity.

■ PLATE 71
Self-Portrait I (Dots),
1997
Reduction linoleum cut
24 x 18 in. (60.9 x 45.7 cm)
Edition of 70
Spring Street Workshop, New York, printer (Ruth Lingen, Jona Markgraf)
Pace Editions, Inc., New York, publisher

AP XX/XX S.P.I c. close 1997

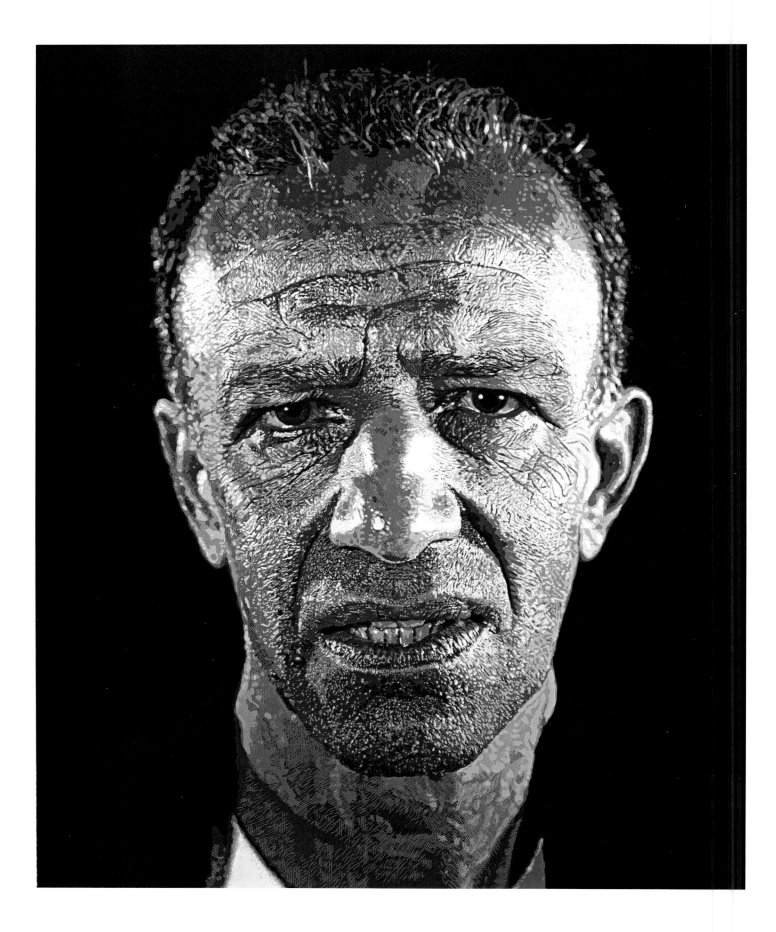

■ PLATE 72
Alex/Reduction Block,
1993
Silk screen from reduction
linoleum cut
79⅜ x 60⅜ in.
(201.6 x 153.3 cm)
Edition of 35
Brand X Editions,
New York, printer (Robert
Blanton, Thomas Little,
Jason Engelhard, Joseph
Stauber; original reduction
linocut, Tandem Press
with Bill Weege, Joe Wilfer)
Pace Editions, Inc.,
New York, publisher

RL: For *Lucas* we had to do a correction block. Do you remember that, Chuck? The color had gone too far at number six; there was too much cut away from the block. Here's the quote from our journal, "Chuck in, worst day of his life."

CC: I've had a few worse days since then.

TS: The three self-portraits are relatively small prints.

CC: I made *Lucas* and *Janet* before I was paralyzed, and the three self-portraits afterward. The plates are smaller because that was as far as I could lean over to carve.

RL: Yes, and for the self-portraits you were just getting back into linocuts and using a different tool, and that is why the cutting looks so different.

CC: That's right. I had to use a finer electric rotary tool because I could no longer carve the way I had before. But I still made every mark myself.

JD'A: What impressed me watching Ruth edition those linoleum cuts is just how stressful making that kind of edition is. In etching, it's a shame when we ruin a print at plate ten. But that's one print, not a stack of sixty pieces of paper. The edition size depends on how many good sheets you have left.

TS: You could make a smaller edition. But isn't the goal to plan correctly and end up with the right number?

RL: The idea is to establish the number of prints and hit it. Sometimes you end up ahead. Sometimes you end up far ahead, like in Chuck's three small self-portraits. We did them all at the same time. Each was based on a different mark. Chuck was using the power tool, doing all three blocks at the same time, not knowing how they were going to come out.

CC: Why did you let me do three self-portraits? Why didn't you talk me out of that?

RL: It was like a controlled experiment. I thought that a couple would fall by the wayside. But they all worked out. These were planned to be huge editions, so we started with an amazing number of sheets of paper. We had three piles of prints on three different carts. And when you start with those ghostly states, they all look the same. We started printing one state on the wrong one. Because we always register by the whites of the eyes. I said, "Well, the eyes are right, but something is weird." It took us the longest time to figure it out. That's how similar they were. Everything was so perfectly registered.

TS: Alex began as a reduction linoleum cut and ended up as a silk screen. Isn't it a special case to have a project cross the boundaries of such distinct print processes?

CC: It's an interesting story. I was planning to make a big reduction linocut with Joe Wilfer at Tandem Press in Wisconsin. We were going there specifically because Tandem had a press big enough to handle the print size, around 6 by 12 feet. We had arranged to acquire a beautiful, large piece of real battleship linoleum, special because it was difficult to get it in such a large sheet.

TS: Why is it called "battleship linoleum"?

CC: Battleship linoleum was made to cover huge areas on battleships. Also, it's gray. It is made with linseed oil and sawdust with a canvas back, and it cuts like butter. You can cut like you are making a woodcut, but your knife is free to go in any direction, because there is no grain. So we went to Wisconsin in February, and it was very cold. The big roll of linoleum was on a loading platform, and unfortunately the workmen put a forklift right through the roll and cracked it. We couldn't get any more battleship linoleum on such short notice, but I still had a crew waiting to work. So we went to the local flooring store and got vinyl flooring, which we mounted on Plexiglas. It was really hard to carve. I didn't have the physical strength to carve it; even the electric Dremel tool I was trying to use chattered across the surface, jumping across instead of digging in and making a mark. We had a big crew and only nine days to try and pull off a print. So we changed tactics. We set up the projector, and I drew on the vinyl with a Sharpie, and then people carved. I drew for eight hours, they cut for eight hours, and then we printed for eight hours. We went around the clock. We did one color a day for eight days. We had this big block on the table, with everyone sitting around it, carving. But everyone had a specific cutting style. So we blew a whistle every fifteen minutes and rotated the block, so the various carving styles became homogenized.

PLATE 73
Chuck Close and projection of **Alex**, 1991

90

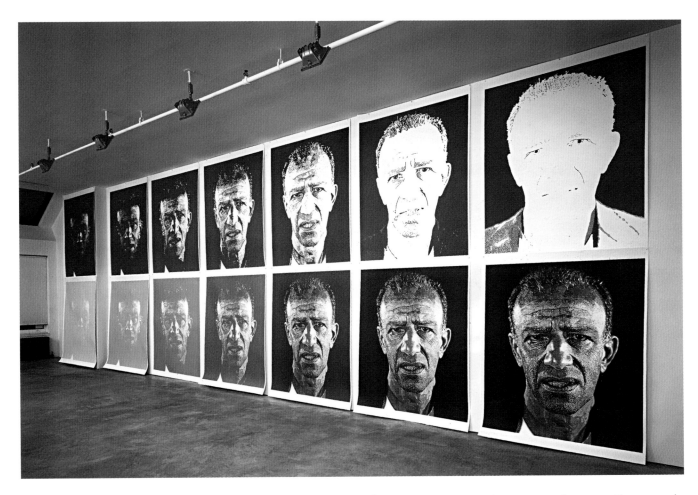

■ PLATE 74
Alex/Reduction Block,
1993
7 state proofs and 7
progressive proofs

We had custom-made Japanese paper that cost a fortune. The sample they sent us was great, but the paper they sent us bore no resemblance to the sample. It was like leatherette, and it printed really badly. There was a seam down the middle. It was just awful. Joe and I knew we were going to have problems from the very beginning. Just to be sure we didn't truncate all possibilities, we decided to pull a Mylar of the block at every stage. When we got done printing a gray, we would roll up the block in black and print it on Mylar, saving a record of the block at every stage. We knew that the prints themselves would not be usable, but they would give us an indication of how it was going. All we really had at the end was the set of Mylars. The question became, "How are we going to make a print out of this?" Joe thought that it would be perfect for a silk-screen project. And so we went down to see Bob Blanton and Tom Little at Brand X [in New York] and printed them up. It was pretty straightforward.

TL: The timing couldn't have been better, because we were involved with other artists who were using transparent grays and working to mix different colors

into the black to provide depth, presence, or color to a gray. Also, there was a history at Brand X of printing relief plates to look like reduction prints from other previously printed projects. But the size of Chuck's print was a bit of a shock.

TS: How did you get the color of the grays right?

CC: We had the inks we had used on the linoleum proofs.

RB: I think we did three or four proofs to balance the values. We also had two or three of the prints that were pulled directly from the linocut. We discussed the proofs with Chuck, and he would say, "Well, these colors are pretty much okay here." We would go through and make our first proof based on this. After that it became a matter of always referring back to the first proof. We would say, "Make this lighter or darker." We had the reference of the original print, and we had color swatches.

CC: It is confusing for people to see a reduction linoleum cut as a silk-screen print. That is one of the things about collaboration. Everybody's ideas add to the process. Always something goes wrong. Always, always. And there is always a solution. It just may not be the preconceived route. So what was meant to be a reduction linoleum cut ends up as a silk screen. But it is better as a silk screen than it was as a relief. You ask, "Am I going to be a purist" and show the bad prints that were actually pure linoleum cut? No, I want them to look as good as they can possibly look. We reinterpret it as a silk screen, and it makes a better print. Why not?

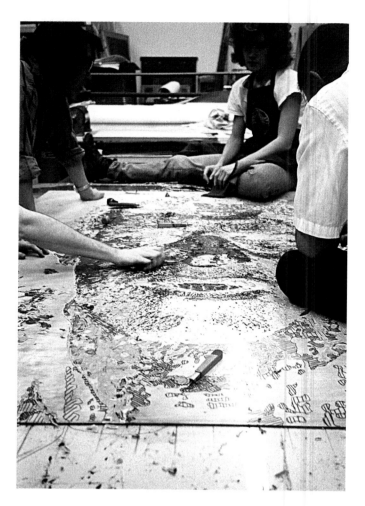

PLATE 75 (above)
Team of workers cutting on **Alex** linoleum block at Tandem Press, 1991

PLATE 76 (opposite, top)
Joe Wilfer and Andy Rubin inking the linoleum block for **Alex** at Tandem Press, 1991

PLATE 77 (opposite, bottom)
Chuck Close checking silk-screen print of **Alex** at Brand X Editions, 1993

Pages 94–95:

PLATE 78
Detail of plate 72

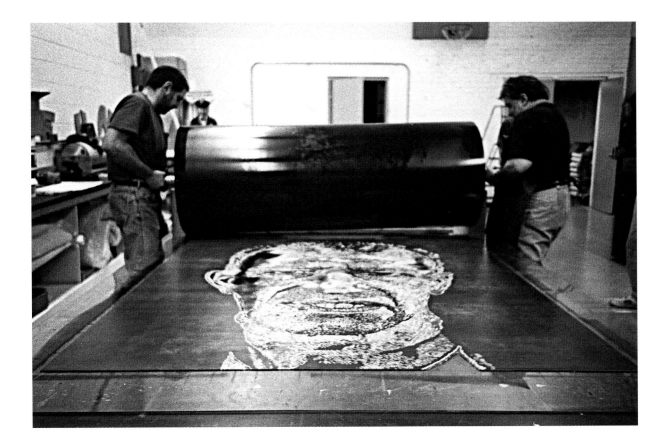

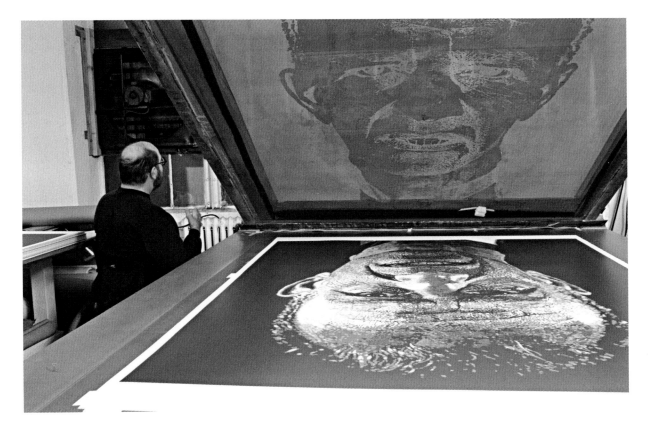

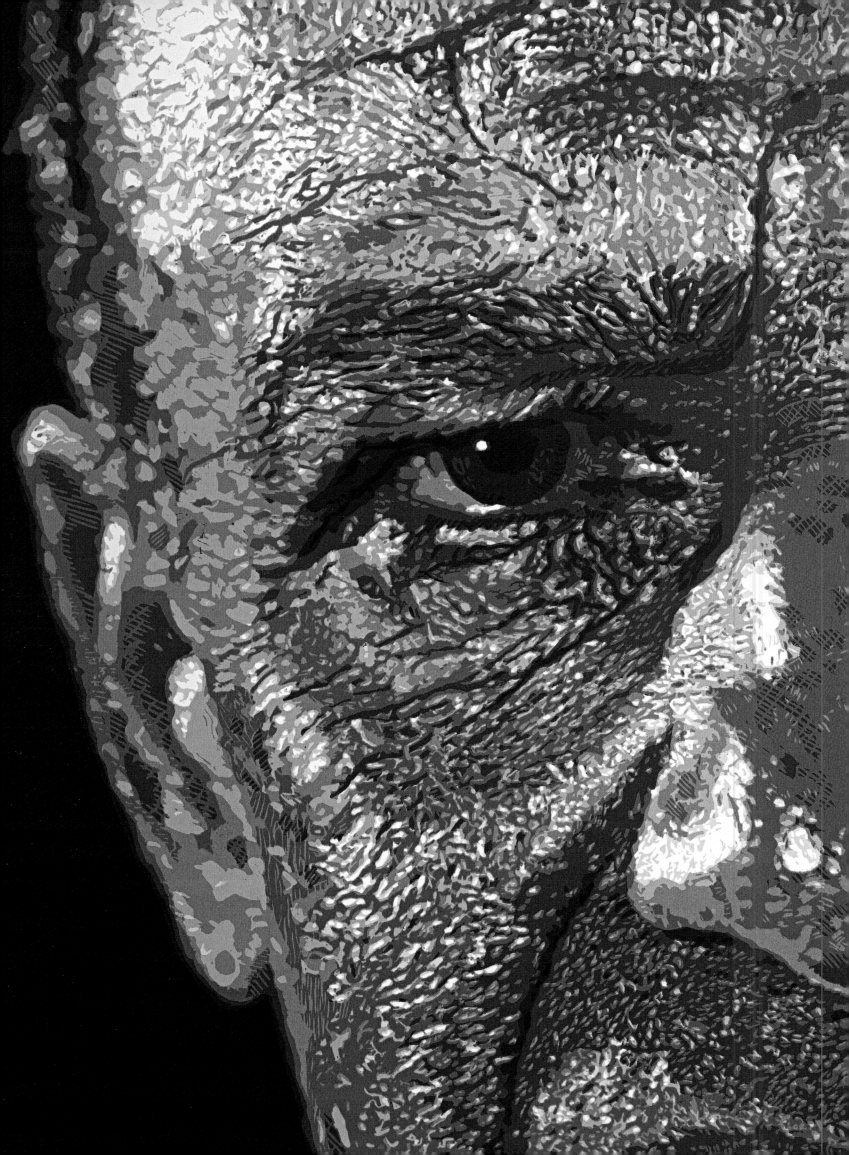

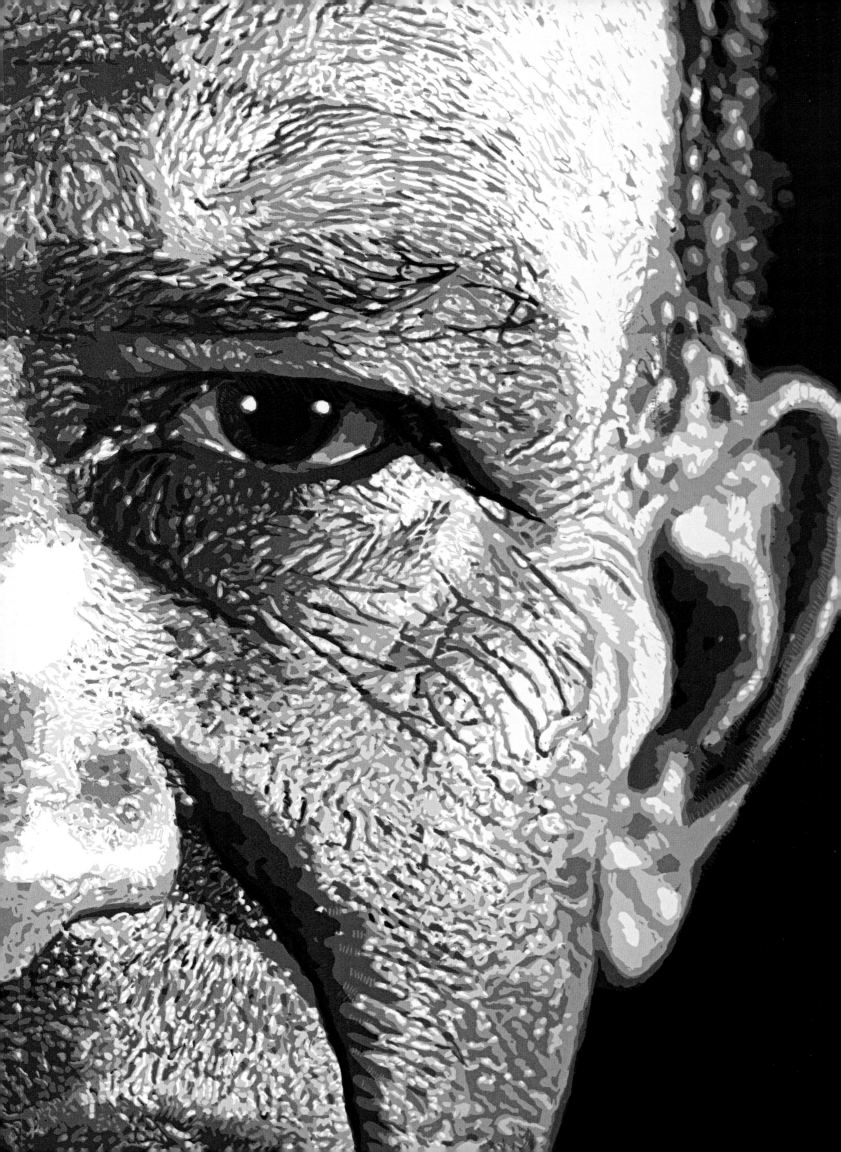

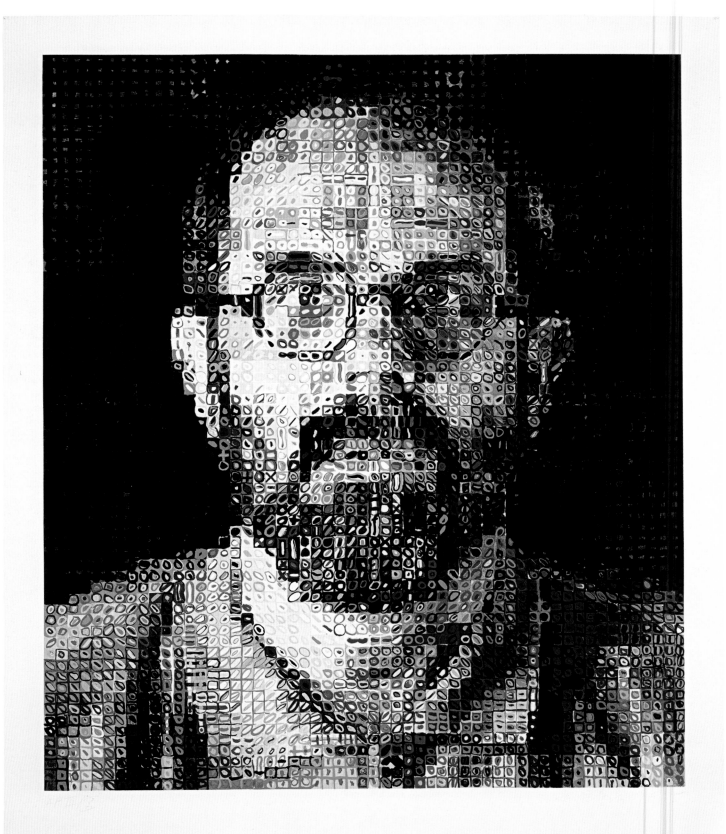

Silk Screen

ROBERT BLANTON AND THOMAS LITTLE,
BRAND X EDITIONS

UNTIL THE MID-1990S Chuck Close had not worked with the silk-screen technique, thinking that the process would not be appropriate for his images. But after seeing the results of the silk-screen print from *Alex/Reduction Block* (plate 72), he became interested in pursuing more projects. On July 22, 2002, Terrie Sultan interviewed Close with printers Robert Blanton and Thomas Little of Brand X Editions, New York, about *Self-Portrait* (plate 79), *John* (plate 80), and *Lyle* (plate 93).

TS: Most people associate silk screen with a photomechanical process, but these marks were hand-drawn.

CC: We don't use any photomechanical processes to reproduce the drawing in the silk screens. There is not a print of mine in any medium that has used a photo process to translate the marks from a painting to a print. We are not trying to make reproductions.

TL: Once it was decided that we would work on *Lyle*, I went to see the painting. I had my Pantone color guide, the book that most printers use for color matching and mixing, and we spread out the pages and began to look at color. We planned to go from light to dark, warm to cool, yellow to purple. Then, from a transparency of the painting, we generated a Duratrans, which is like a big 35-millimeter slide. It's translucent and gives a good representation of the mark, which is very important in Chuck's work. From the Duratrans, we made decisions about color separations, and then I hand-drew the many layers of Mylars that we needed for the print. From there we made the screens.

■ PLATE 79
Self-Portrait, 1995
80-color silk screen
64½ x 54 in.
(163.8 x 137.1 cm)
Edition of 50
Brand X Editions,
New York, printer
(Robert Blanton, Thomas
Little, Joseph Stauber)
Pace Editions, Inc.,
New York, publisher

TS: So Tom's drawings are basically an interpretation of your mark, not a copy.

CC: It is essential that the spirit and speed of the mark, which was made quickly, be arrived at by a slow, painstaking process. But it has to have that same spirit, it has to look like it just happened. To make it look like my stroke, Tom has to make everything but the stroke. He has to work around it. How can a stroke still seem like a stroke when you did everything but paint it? On the print, these marks are somewhere in between. The printers know what the end product has to look like; they know the destination, but they have to find the right route to take. The route will be different for each print.

TL: Making the screens does have something to do with a light-sensitive process. We place an emulsion on a screen, and when it dries, it is light sensitive. Then a hand-drawn separation on Mylar is placed on a glass, and the screen is placed over the separation. A vacuum pulls out the air, bringing the separation and the screen into perfect contact. The light solidifies the photo emulsion where it passes through the Mylar. The light is blocked by the marks of the drawing so that the emulsion does not harden in those areas. Thus the emulsion under the marks dissolves when sprayed with water, and the marks become the holes we push the ink through. Each hole retains the character of the mark that was made on the Mylar. For every color, we make a Mylar, then a screen. After we produce each screen, we make a proof, which is documented in terms of sequence and color and then filed away. The screen is erased, and we do the process over for the next color.

We do it all over again when we do the editioning. We use the same frame and the same screen over and over again. We print all the first color, then print all the second color, and so on. With Chuck's prints, we have to print by hand, rather than by machine, because they are so big.

TS: Chuck, I understand that you were resistant initially to making a silk-screen print.

CC: I never wanted to do one. I had a notion that it was something either for commercial purposes or for art that reflected the commercial purposes of Pop culture, like Andy Warhol or Roy Lichtenstein.

TS: What convinced you?

CC: A lot of my misgivings about silk screen vanished when I saw that silk screen didn't have to be flat and opaque, that it was possible to get tremendous watery transparencies, and to make something that had an open, brushy quality where other colors flickered through. I realized a silk screen could have the spirit and touch of the paintings.

TS: Why did you decide that John should be a silk screen?

CC: A lot of that decision making is practical. I think about how an image that big can best be realized. I think about the incremental size of the marks of the painting. How much smaller will they be in the print? Will we still have enough room to combine enough colors to make it happen? Will it have to become too finicky and fussy? We use photostats to see what the marks will look like at a certain scale. I always want to make them bigger, and Bob and Tom always want to make them smaller.

TL: Let's not forget Joe Stauber, who was involved with John. He was the chromist for the black-and-white self-portrait, and he did John as well.

TS: Explain "chromist."

TL: A chromist is the person who makes the individual drawings that separate out each color from the original painting, who makes the decisions about the number and sequence of the colors. I mixed a lot of the colors for John and was involved mostly in production of both the self-portrait and John.

TS: Do you always print the colors in the same sequence?

TL: Generally speaking we print from light to dark, warm to cool. The first self-portrait (plate 79)—the black-and-white one—was done light to dark because it was easier that way. You don't want to commit to paper the darkest dark because you would have to work backward from the darkest dark to the lightest light.

CC: There would be trouble with opacity.

RB: For the black-and-white self-portrait, Joe and I spent half a day in front of the original painting, estimating colors. The best we could come up with was thirty light, thirty medium, thirty dark. We broke those in half, so that each section—light, medium, and dark—was half warm and half cool. John had so many more colors, it was impossible to count them. We just gave it a shot, and it ended up being more colors than we planned. On the first self-portrait, we started doing more layering of color, putting down color and becoming more transparent on top as we began to correct. On John, Joe was drawing more specifically.

CC: That means drawing for a color that will stay the color it's printed, instead of putting down a yellow that a blue will go on top of later to make green. He would have to decide at the outset that an area was going to be green.

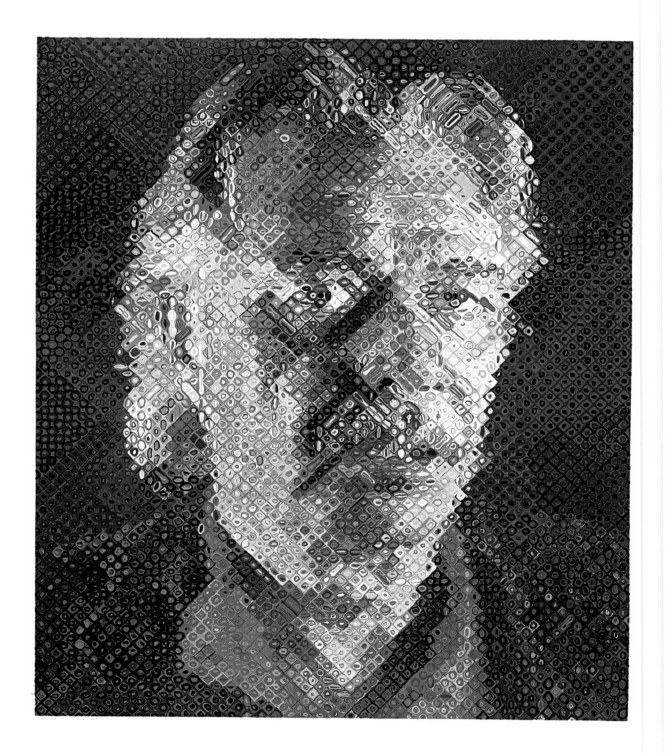

■ PLATE 80 (opposite)
John, 1998
126-color silk screen
64½ x 54½ in.
(163.8 x 138.4 cm)
Edition of 80
Brand X Editions,
New York, printer (Robert
Blanton, Thomas Little)
Pace Editions, Inc.,
New York, publisher

■ PLATES 81–82
(below, left to right)
John, 1998
States 1 and 2

Pages 102–3
(left to right, top to bottom):

■ PLATES 83–90
John, 1998
States 3–10

TS: When you did John, did you match colors with Pantone chips?

TL: No, Joe would indicate a needed color. He would say, "This is what the color has to be," and Bob or I would mix a color on a swatch to help him as a color aid in finding that color across the painting. He was also checking the transparency.

CC: For John, we didn't just move from light to dark. Relatively early in the print, we established some lights, middle colors, and darks, so that we knew the range we were dealing with.

RB: At various stages we give up on the system, and I have to admit that I can't see it anymore. We had to add a darker value to give us a reference to start establishing the space and the value relationships.

TS: So it is an organic process, not a formulaic "step one, step two." Every time you do something, you have to assess it.

RB: Making the print is a very collaborative effort. We'll have the painting to discuss, or maybe not. We'll meet for an hour. We'll talk about this, and Chuck will explain mark making on his paintings. Out of that hour there will be a small percentage of conversation about something that is not working.

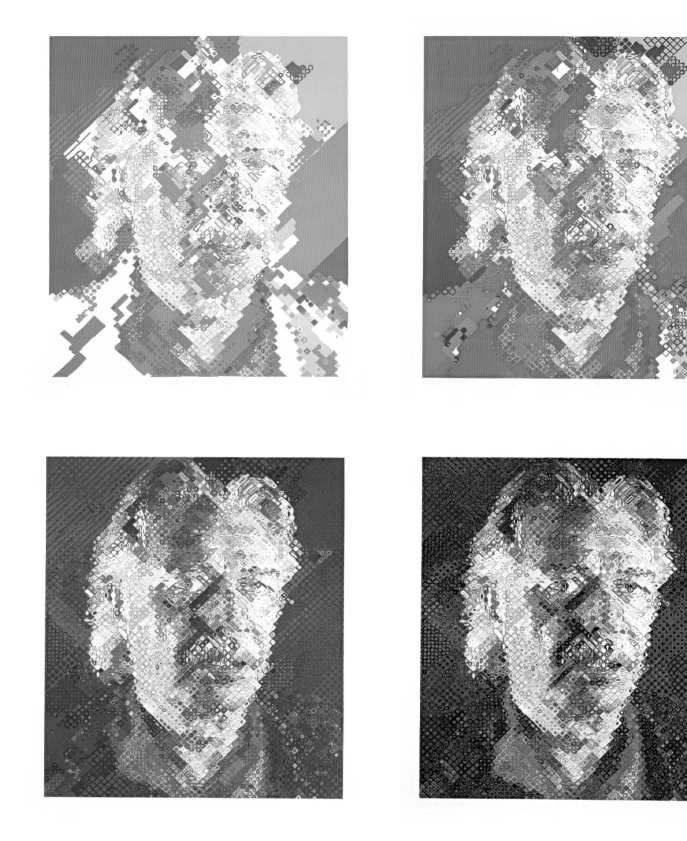

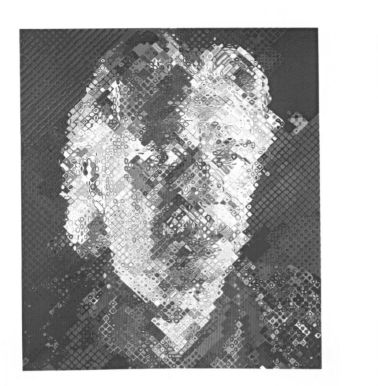

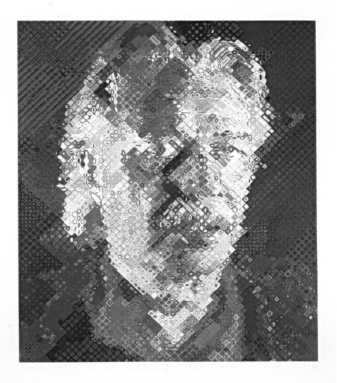

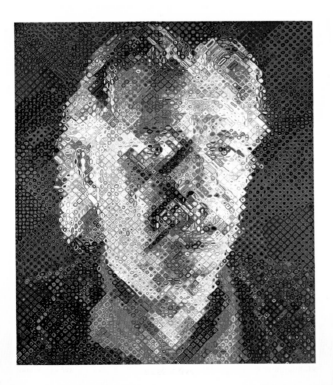

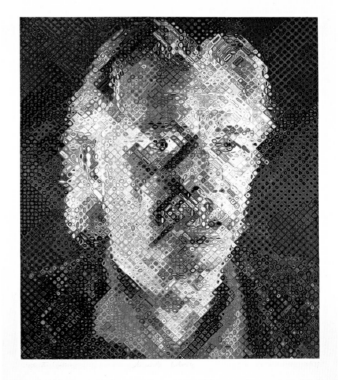

CC: That is because I can't impose my system on people who are deeply involved in their own system. The print has its own internal logic. You can throw a monkey wrench in the machinery very quickly if you insist on changes when you don't fully grasp the internal system. The way I work, I sneak up on what I want by making a series of corrections. What I want in my paintings is the purest intensity, the purest saturation. Every piece of the painting is made from full-intensity, full-saturation color. I want the print to have that same chromatic intensity.

TS: Do you follow the same color system that Chuck uses on his paintings?

TL: Yes, we gray with complements, meaning that we use complementary colors to reduce intensity in other colors.

RB: It is a classic color system, and it works.

TS: Chuck, talk about scale a bit. What drives your decision-making process? How does a print correspond to painterly scale?

CC: When I started doing the self-portraits and portraits, they were essentially as high as my ceiling. I always used to say, somewhat facetiously, that the bigger they are, the longer they take to walk by, therefore the harder they are to ignore. The goal is to achieve a Brobdingnagian scale, where you lose track of the whole and get lost in details. I always want to make the prints bigger, usually as big as the press will take. The first thing I ask is, "How big are your screens," or "What size does the paper come in?" I want the print to approach the scale of the paintings. I am interested in extremes, so I also like to make diminutive pieces. Some of the spitbite etchings and other things are quite small. It is about the relationship of the scale of the mark. It's also about being able to make it comfortably without it being finicky. The prints have to have the same aggressively confrontational relationship that the paintings have. I want to bring the viewers right up to the painting or the piece of paper so they can see how the image is built or see what the marks are like.

TL: It is interesting to hear you describe the intent of some of these things in relationship to the painting size and scale. I think that sometimes people are surprised at the scale of the prints. Especially since we are averaging the color. Our prints do not have the same number of colors as Chuck's paintings. There is a point at which we do step back to see the contrast. To see how that color is interacting with previously proofed color.

PLATE 91 (opposite)
Self-Portrait, 2000
111-color silk screen
65½ x 54 in.
(163.8 x 137.1 cm)
Edition of 80
Brand X Editions, printer
(Robert Blanton,
Thomas Little)
Pace Editions, Inc.,
New York, publisher

Pages 106–7:

PLATE 92
Detail of plate 91,
actual size

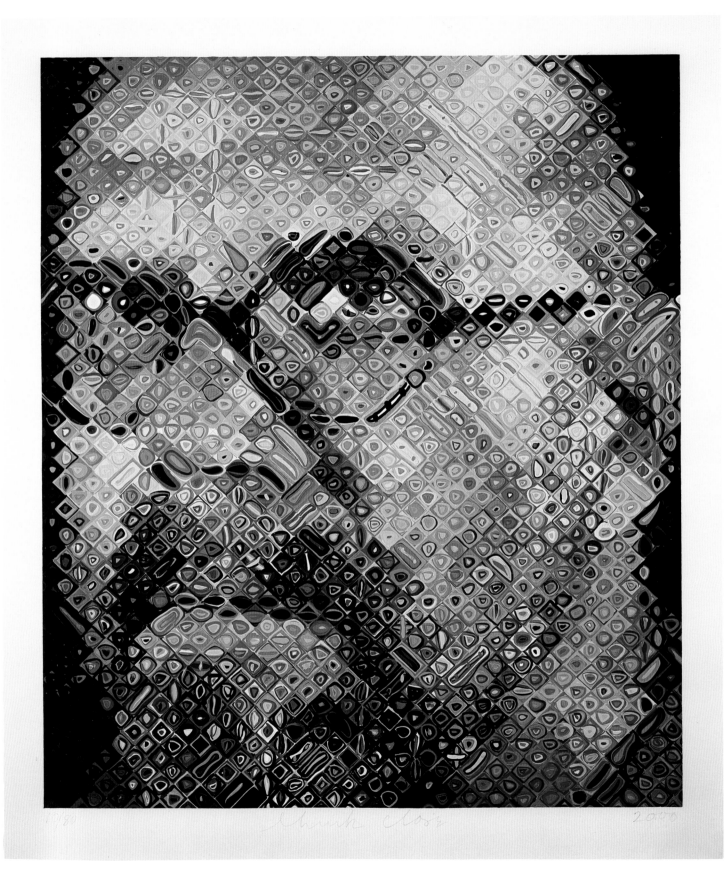

TL: Lyle is our fourth project with Chuck, and we are approaching it somewhat differently than the previous projects. We have been more intent in the color-matching process. For me, the background, the darkest darks of the skin tonality, and the highlights defined as a twelve-color resonance are key. I was specifically trying to match seventy-five colors or so at first, to establish a chromatic armature.

RB: Lyle is a very large painting and well suited to this process. Chuck saw the proofs when we had printed thirty colors. As we started to edition, we decided that we could get more out of the colors. So we started adding colors, and Tom took the plates and started drawing underneath some of the marks to give them richer surfaces.

TL: The choice of colors affects the number of colors. One thing we talk about is the difference between having more colors and getting the most out of less. Sometimes we can best express something graphic in the least number of colors.

RB: We bring every print to Chuck after every ten colors for discussion. When we have about eighty colors, that is when the final corrections and the fine-tuning happen. At that point we are dealing not with what might be, but with what is already there. Often we add twenty or thirty colors; in this case we added forty.

TS: What is the discussion like at the eighty-color review?

RB: At eighty colors, we feel that we are done with our part; now we rely on Chuck's input. We always expect him to add a few more colors.

CC: Sometimes colors are too bright, too dark, too light, or an area will be too spotty, or we have to get an area of the forehead to read as if it was part of the same family.

TL: Sometimes it will have to do with a point of transition. He'll see something that doesn't work, like a solid square that shouldn't be a solid square. It should have a lighter center or a ring.

CC: It's similar to what my paintings are like when they are 80 percent finished. At that point I am no longer working from top to bottom, left to right. I am working all over, making corrections where I need them. With the prints, I am no longer looking at the painting it's based on, but at how we can take this thing that exists in this state and take it the rest of the way. The fine-tuning is always the most fun.

PLATE 93
Lyle, 2002
149-color silk screen
65½ x 54 in.
(166.3 x 137.1 cm)
Edition of 80
Brand X Editions, New York, printer (Robert Blanton, Thomas Little)
Pace Editions, Inc., New York, publisher

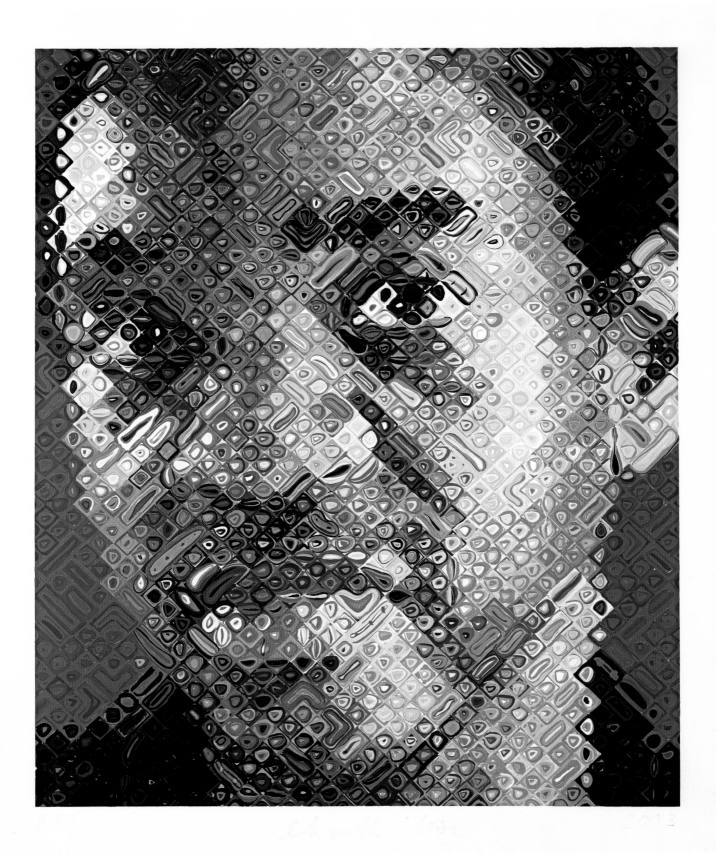

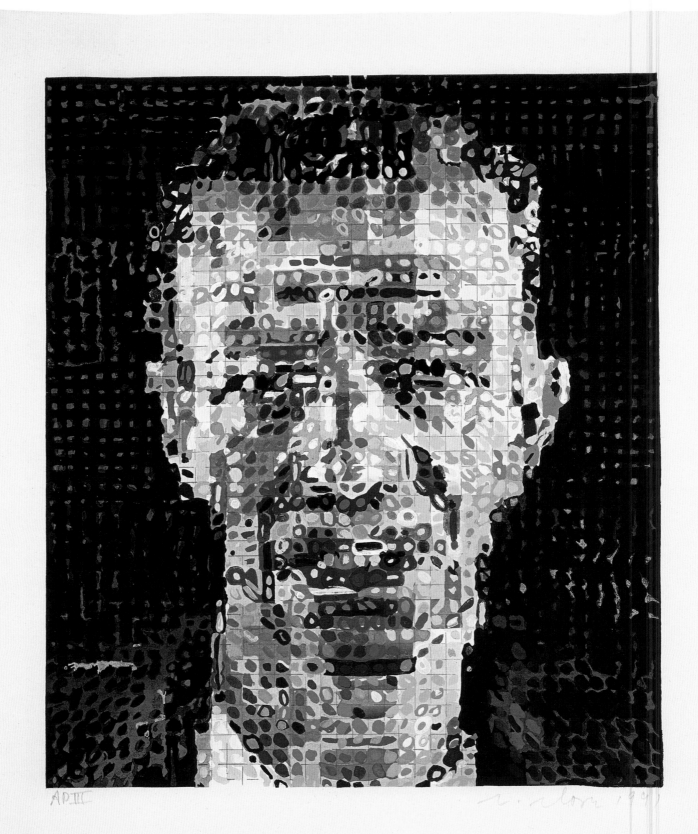

AP.III ~~~~~ ~~~~~ 1991

Japanese-Style Woodcut

YASU SHIBATA, PACE EDITIONS, INC.

CHUCK CLOSE MADE HIS FIRST Japanese-style woodcut, Leslie (plate 3), in 1986. Since then, he has completed several, including Alex (plate 94), Self-Portrait (plate 96), and Emma (plates 20 and 97). Terrie Sultan met with Close and master printer Yasu Shibata at the offices of Pace Editions, Inc., New York, on July 23, 2002, to discuss the making of Emma.

TS: You said that making your first Japanese-style woodblock print in Japan was a defining moment for you in terms of your subsequent print projects. What happened?

CC: I am used to making every mark myself. I like to make every decision, carve everything, draw every line. It wasn't until I went to Kyoto in 1986 with Kathan Brown from Crown Point Press to make a Japanese woodblock print that I ever gave over the responsibilities for separating the image out to anyone else. I had sent a watercolor gouache over to Japan for the master printer to work on it ahead of time, and I was shocked to see when I got there that it had become his piece. Then I had to wrest it away and make it mine again. The printer I was working with, Tadashi Toda, is very highly regarded in Japan. With us also was Hidekatsu Takada, a printer who had spent the first twenty-one years of his life in Kyoto working with a printer, and another twenty years working with American artists in California as an etching printer with Crown Point. He was acting as translator. When we arrived, a lot of work had already been done. I pointed to a specific shape and said to Takada, "Tell him it is too green." He started talking and talking, and there was an intense reaction from Mr. Toda.

PLATE 94
Alex, 1991
95-color Japanese-style
ukiyo-e woodcut
28 x 23¼ in. (71.1 x 59 cm)
Edition of 75
Keiji Shinohara and
Bruce Crownover, Malden,
Massachusetts, printers
Pace Editions, Inc.,
New York, publisher

Finally I asked, "Why is it taking so long?" Takada said, "You don't understand, what I have to say is, 'Chuck is thrilled with what you have done, he thinks you are a genius. He thinks it is perfection. Beyond his wildest dreams. Nothing could be done to improve it. However, in the interest of intellectual curiosity, not that it would be better than what you have done, just to see what would happen, could you possibly make it a little less green?'" We had to go through this process every time. I needed to be positive about any correction I wanted to make. I found it strange yet interesting to let someone interpret the work, to make decisions about color and separations. I realized we had to work together to get a good print.

▓ PLATE 95 (above)
Chuck Close working with master printer Tadashi Toda in Toda's Kyoto atelier to create the Japanese-style woodcut **Leslie**, 1986

TS: How did you decide that Emma should be a Japanese-style woodcut print?

CC: Emma is a small painting, and I thought that if we could make a big enough woodblock, we could get the print up to the size of the painting or at least as close as we could. By choosing a woodblock, we had the opportunity to keep the mark size in the range of something that could be cut by hand. And also there was very little change in the baby's face in the painting. It is all pretty much the same pink. I thought it would really lend itself especially to the peachy color washes of the water-based inks.

YS: This technique is three hundred years old. Traditionally, it takes two people to make such a print. One person decides about the colors and the color separations, draws on the blocks, and prints. The second person just does the carving. That is the way it works in Japan, even today. When I started at Tyler Graphics in 1991, I was the only printer for woodblocks, and so I had to cut the block and print it too. This is how I worked on Emma.

▓ PLATE 96 (opposite)
Self-Portrait, 2002
43-color woodcut
31 x 25 in. (78.7 x 63.5 cm)
Edition of 60
Karl Hecksher, New York, printer
Pace Editions, Inc., New York, publisher

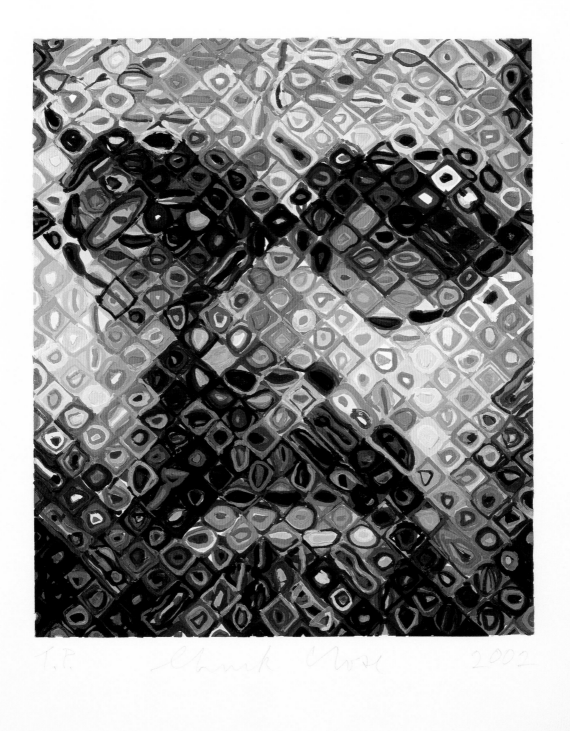

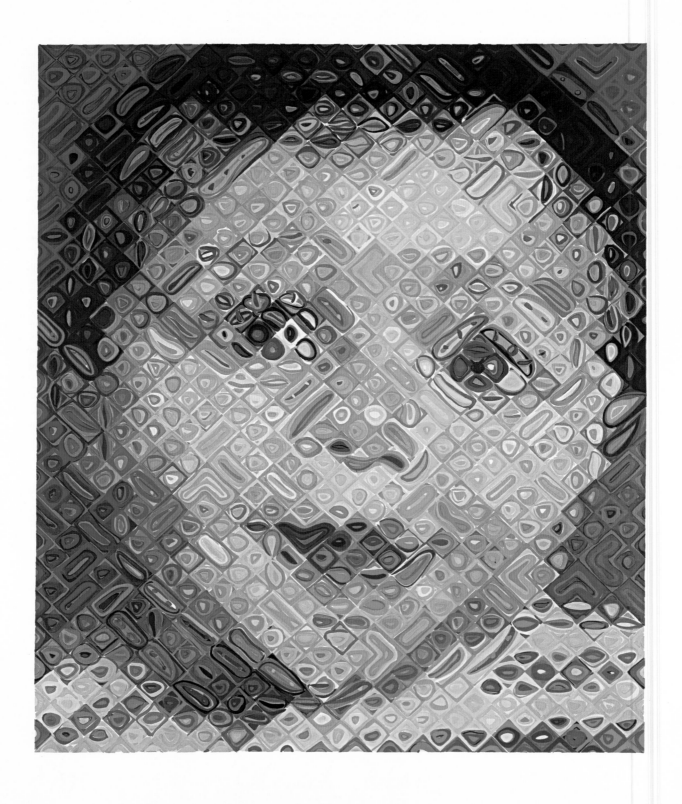

TS: Does the fact that you can draw, carve, and print give you more control?

YS: I like doing both because as I print I can see clearly how I should proceed in cutting the blocks. Taking proofs along the way helps guide me in the cutting of the next blocks.

TS: How did you get started on Emma?

YS: I went to Chuck's studio and studied the painting. I looked at the paint on the palette and the underpainting. I saw how he painted. I thought that I should follow the same process. I actually mixed color samples in his studio, with pigments I brought from the shop. I made about fifteen color samples per day for several days. I didn't make all the samples in the studio because there were too many, but I created a solid base. Then I made notes and numbered each color.

TS: What happened next?

YS: I went back to the shop, began identifying color areas for separation, and began carving the blocks.

TS: Did you work from a transparency of the painting?

YS: I did have a transparency and a color photograph as references as I began drawing. It was very difficult to start. For each color, I traced the Mylar, mixed the color, and started cutting the block. I started from the light colors first—yellows, pinks, and blues. After I traced eight Mylars, I got so confused that I had to start cutting and printing to make a map. Then, after the second proof, I realized that was not the way I should do it. I printed the first layer a light transparent color, and then I printed the stronger color to cover the first layer. But it didn't cover. At that point I had to change my whole approach. After I printed a few more proofs, it became clear how I should proceed. You have to know which inks are going to cover, which inks are going to be translucent, and make a decision about what goes over what, pretty much at the beginning. I showed Chuck the proof from the first eight blocks. He didn't say much really, because it was too early to say anything.

CC: I remember saying that I liked the opacity, the transparency, the way the ink was lying on the paper, and the way the shapes were cut. I didn't say much about the direction, the route.

YS: I didn't really get direction from Chuck until the third proof. That was nineteen blocks and eighty-eight colors.

TS: You were almost halfway there at that point. You talked about corrections then. Chuck, do you remember your response?

CC: Basically that the color was too strong, too bright. We needed to get some darker colors on the print so that we could see what the light ones really looked like. It was really more theory. I explained to Yasu that in a given square, if you have a bright blue, you will need something equally bright to neutralize it. And it could be two or three different colors. You can't just take the bright blue and put dull browns on top of it. That won't work. You have to really see that if you have a blue, you have to have an equally bright orange somewhere, or a yellow, blue, or red, so that all together they have to balance each other out. I was pointing out places where I thought colors popped off. My main concerns were about the color world we were building; how the image had translated into something so much more transparent than the painting.

YS: Each time I corrected the blocks and added more color to show Chuck, I started over with an entirely new proof. I didn't want to print over the print I had shown him. If you overprint on the print, it never looks like it is going to look in the edition. Some places I had to patch it where I was missing a color. Every time I showed him proofs, I found that there were so many places I was missing.

TS: How did you patch a block?

YS: It is like inlaying a piece of wood. I routed out just a little and glued in a square shape, and then traced the design and cut it again. There were a lot of places like that.

CC: It is very different than making a silk screen. With that process, they make one screen for one color, and they print that color a thousand different places around the image and alter it later with colors printed on top. So you end up with 110 colors and 110 screens. Here, there are a total of only 27 blocks and several colors on each block.

YS: I think we have more than 110 colors.

CC: We also had problems with paper shrinkage from the very beginning.

YS: I have to keep the paper damp, because I am using water-based color, which prints best with damp paper. If I print on dry paper, the paper will expand where I have printed, and then later, it will shrink. If that happens and I try to print the next block, it will never register. The paper has to be consistent. With big paper it is harder to control. That's why the traditional ukiyo-e prints by such

artists as Hokusai are pretty small, say 16 x 11 inches. That is really the limit to get the registration perfect. I remember the day I met Chuck and he asked me if I could make *Emma* as a woodblock. Right away I wasn't sure I could do it because of the size. It is really way too big for this technique. I think *Emma* is the biggest Japanese-style woodcut ever made.

TS: Talk about *ukiyo-e* style. I thought *ukiyo-e* related to imagery or content, rather than technique.

YS: Historically *ukiyo-e* did refer to pictures of the floating world, and it included both paintings and prints. It is a style of late-seventeenth-century Japanese art that depicts images related to the theater and the pleasures of urban life, and also beautiful images of nature. The prints became quite famous around the world, so now *ukiyo-e* is commonly used as a general term for water-based woodblock printing.

TS: How do you know that the paper is the right dampness?

YS: I check the registration marks constantly. I put a pencil mark on the back of the paper, so I can see if the paper is too much this way or that way, and I don't want to print if the paper is off. Sometimes the paper is not damp enough and I have to stop and rehydrate the paper.

TS: You are printing by hand, laying the paper on top of the block.

YS: Yes, using a *baren*. I apply the ink with special brushes. They are split pieces of bamboo with horsehair wrapped together. The hairs all have split ends to make a finer brush that will hold ink better. I get the pigment with one kind of brush, then I mix with the horsehair brush. I never use a roller.

CC: How long have you been working on this print?

YS: One and one-half years.

CC: You know, the painting only took three months to make.

YS: And I have been looking at this picture longer than Chuck.

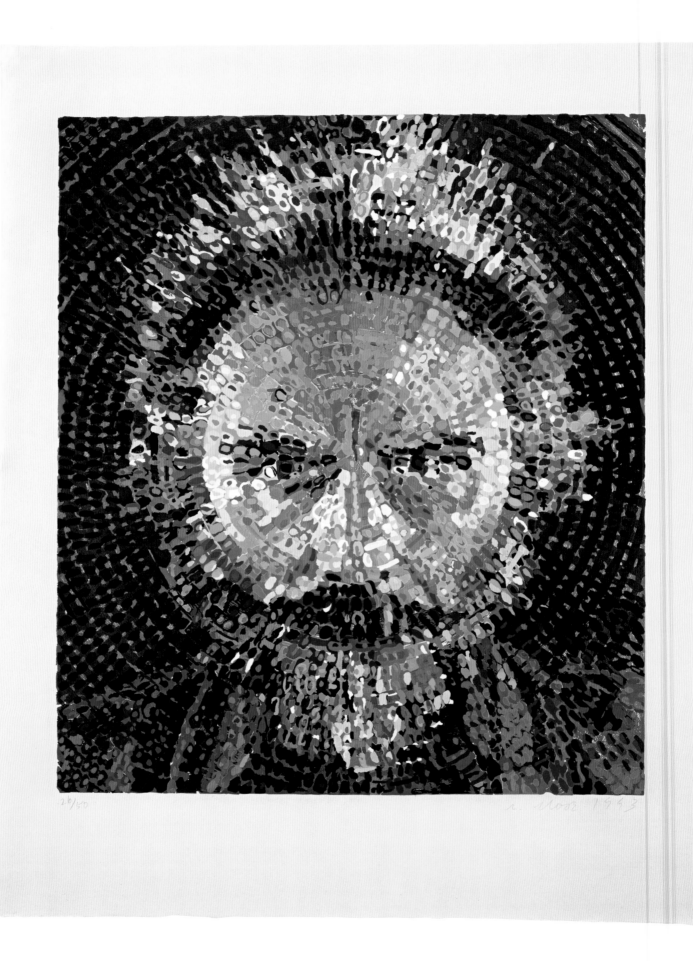

26/60 r. Moss 1997

European-Style Woodcut

KARL HECKSHER

THERE ARE TWO TYPES of traditional woodcut prints. Whereas Japanese-style woodcut prints are made with translucent, water-based ink, European-style woodcut prints are made with a thick, viscous oil-based ink. Close has completed only one European-style woodcut to date. Terrie Sultan visited with Close and master printer Karl Hecksher on July 22, 2002, in Close's New York studio to talk about the European-style woodcut print Lucas/Woodcut (plate 106).

TS: How did you come to work with Chuck?

KH: I knocked on Chuck's door, showed him my prints, and asked him for a job. Chuck pulled out the poster of the Lucas painting and said, "If you want to do a print, you can do this." I looked at the image and wanted to say, "You've got to be kidding," but I didn't. I think that Lucas was an image that Chuck had wanted to do for a while. He knew that as a relief print it would be an enormous task. Chuck is very much about pushing the medium and challenging printers.

TS: Why did you want to say, "You've got to be kidding?"

KH: It is such an involved image to make a woodcut out of.

CC: I think that by showing your work, you thought I would be impressed with your technical virtuosity and how much the prints looked like the original paintings. But what interested me was the physicality of your surfaces. Some people have a feeling for how ink goes down on paper, and others don't. I knew from the prints he showed me that Karl would be able technically to do what was necessary. But I liked the feeling, the physicality, and the object status that his

121

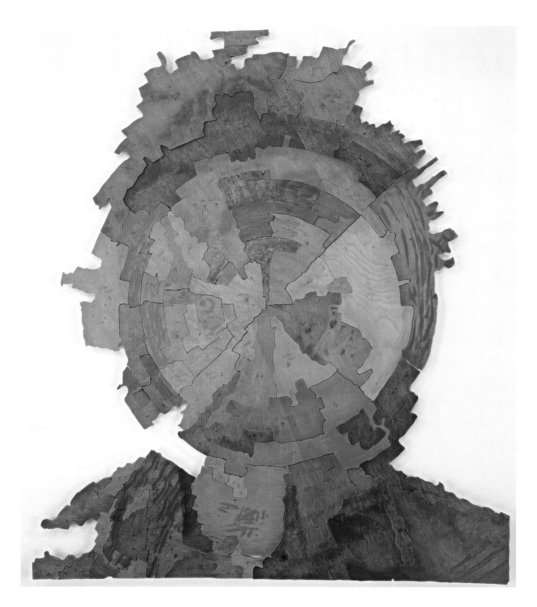

PLATE 107
Lucas/Woodcut, 1993
Woodblock jigsaw

prints had. I wanted to do *Lucas* as a European-style woodcut print, because in this technique you use a roller to roll viscous, thick, tacky, oil-based inks onto a raised surface. And in this, it is like painting in the most delicate way.

KH: It is a challenge to capture, as purely as I can, what Chuck does on canvas. I want the print to be a Chuck Close, and to feel like a Chuck Close. It's not a painting, so it's not identical, but it's got to have that essence. They are worked the same way that Chuck works his paintings. I know that the corrections he makes on the prints are the same kinds of corrections he makes on his paintings. They are the same painterly concerns, and there is no compromising that focus. There is no saying, "Well, I can't get that or I can't do that, or that's too hard." It's got to be right, and that is pretty much the extent of our dialogue.

PLATE 108
Lucas/Woodcut, 1993
State proof
46½ x 36 in.
(118.1 x 91.4 cm)

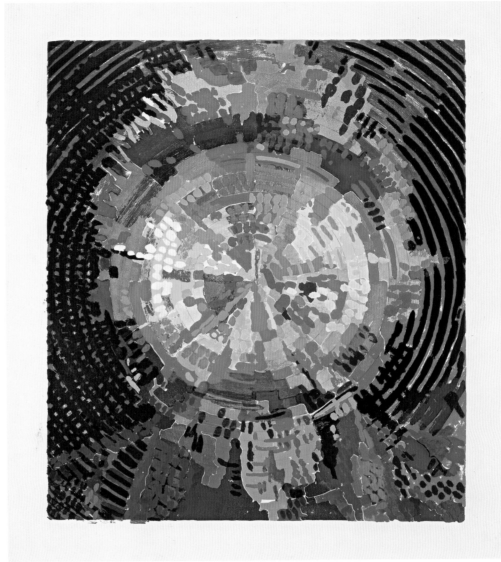

TS: Describe your process from start to finish.

KH: I look at what Chuck is doing on the canvas. I look at the pigments he is using, the way he builds the painting from the bottom layer up. Those are my clues. For example, he has a pink mark over a dark green background; I could cut through the background and put the pink on within the green, but that wouldn't be right.

CC: Karl made a kind of jigsaw form (plate 107) to create the underpainting, so he could print big flat areas of color. There are pegs on the back to hold it in place. He would ink each of the forms and set it into the block with pegs so it didn't move around. Then he could print the whole background area at once.

KH: I was able to remove the pieces, ink them off the block, and then plug them

PLATE 109
Karl Hecksher working
on **Lucas/Woodcut**, 1993

back in. While it looks like a clever way to go about resolving some technical questions about how to begin the print, more important it is exactly what he had done with the painting. I simply built off the layers that he had made.

CC: The underpainting was like a field on which the other colors began to rest. Then he carved many other blocks to continue to build up layers of marks and colors.

KH: Almost all the blocks have more than one color. There are times when the colors blur and mix.

CC: Then finally you did pochoir over the top of everything. You used stencils for that.

TS: Explain "pochoir."

KH: Pochoir is the French word for "stencil." I cut a Mylar stencil with a hole in it, and pushed the ink through with a brush. I remember in this print, I would often double-load the brush with more than one color and dab it on to get that kind of loaded color you see in Chuck's painting.

CC: Like wet-into-wet painting, it drags up color from underneath. If you look close, you can see delicate things that are going on in the background. I forget how you got the pencil grid on this.

KH: I drew it with a compass and a pencil.

TS: You did this for the entire edition of fifty?

■ PLATE 110
Lucas/Woodcut
in stages of printing
by Karl Hecksher, 1993

KH: Yes. What Chuck does on the canvas, I do on the print.

TS: How could you ensure the same result over and over?

KH: After a few times, you don't think about it. You continue to load one side of the brush with the pale green and the other side with the dark green and put it down and let it happen. You get the repetition, the choreography; the movements all fall into place.

CC: European woodblocks use oil-based ink, almost like what the original paintings are made from. You get viscosity and tack. Those prints look very different from the Japanese-style woodblocks, which are essentially watercolors with the block soaked until it's soft, and then water-based pigment is brushed on and the paper is rubbed from behind. You rubbed all of these too, right?

KH: Yes, with a *baren*. Barens can be flat, concave, or convex, depending on how you want to design them. They are beautiful tools, about twelve centimeters long, a little five-inch disk with bamboo coils wrapped and braided inside.

TS: How much time do you and Chuck spend discussing a project before you begin work?

KH: Chuck decides what image he wants to do; he decides what size he wants, what the margins around the image will be. He makes all the decisions. After he selects the image, he likes me to have the painting so I can see the color

balance, so I can see firsthand what he has done. In the case of *Lucas*, I didn't have the painting. I don't know how it would have changed the print if I had had the painting in the studio. I worked from an 8 x 10 inch transparency and had a color C-print made to the scale of the image. I used this to pull off the forms that I would then transfer to the block and carve, and I drew the forms by hand. In this case, the print is the same size as the painting.

TS: How did you separate and print the colors?

KH: I worked in the order of the layers that were put down on the original canvas.

TS: The jigsaw forms the outline of the figure. Did you lay down the background colors first and then print the jigsaw?

KH: There are other blocks that went around the head. It's essentially a red-magenta color that was done in two different blocks with the blending of two different shades of ink, and it's a very transparent color. There is a lot of luminosity in the red background.

TS: Are you tracing the marks from the painting?

KH: Each and every mark, each and every separation, is hand drawn. There are lots of blocks, and most have more than one color. In *Lucas* there is a dark or a black, and even that block was blended. The black became warmer, a really dark asphalt type of brown-black, that gets bluer on one side because I blended color in by hand.

TS: Can you project how many blocks and how many colors you are going to need?

KH: Generally, but in this case we built the print over time, and it really didn't snap together until that dark block, what I call the key block, was printed on.

TS: Because you are printing by hand, you have to make sure that your stroke, your pressure, is consistent throughout the edition process.

KH: Yes. I reach over the block. I spin the block around and get another corner if I can't reach it. I can see through the paper a little bit to see what's happening on the other side. I can lift it up and check it to see if there is enough ink. I can rub more or put more ink down. It took me six months to proof *Lucas* and build the image, and a year to edition it. That's with no days off. I had to handle the paper; it's a large piece of very delicate Japanese paper. Delicate in terms of showing fingerprints or soil on the edges or margins. It became very

heavy with the oil ink, and I had to handle each sheet of paper every day for a year. I'm amazed that it didn't stretch or fall apart at a certain point.

CC: Explain how you registered it.

KH: It is a large print, and I'm working entirely alone on the project, so I have to figure a way to get the paper on the block accurately. I invented a kind of wooden jig to place the paper on the block. It is a very accurate pinhole registration.

TS: In the background I can see woodgrain. Chuck, is that something you like to see?

CC: Yes, you can see grain and scumble marks on the blue back there and the red edge.

KH: You can see the piece on the block right there, where it is kind of scratched out. That was important, because there was a scratchy place on the painting. He didn't make the area solid. This was important to me.

TS: I get the sense that beyond the technical skill involved in making these blocks, there is also a certain amount of intuition on your part in terms of color and means of expression. It is as if you were intuiting Chuck's methodology.

KH: Other printers would have done it in a different way, and it would have looked different. In my case, I am trying to capture what is going on in the image that Chuck has made, not just assigning a certain mark the right color. It has to feel like Chuck, it has to feel like what he is intending to happen when he makes the painting. Even though it is not exactly like the painting, it has to speak to that power in the canvas. In a sense, there is not a lot of collaborating from my perspective, because I am not imposing or introducing elements into his imagery or affecting the result.

TS: Did you know that this was going to end up as a multiyear commitment?

KH: After a couple of months I knew it was going to take a long time. I had never done something like that before. I had to resign myself to the fact that each color had to be right and keep on going until it was done.

CC: I am going for a level of perfection that is only mine. Who is to say if it is right or wrong? But it is what I want. Probably 80 percent is close enough for most people, but I would not be happy there. Most of the pleasure is in getting the last little part perfect.

KH: Working with Chuck is an incredibly humbling experience.

CC: Register on the transcript that I have an incredulous look.

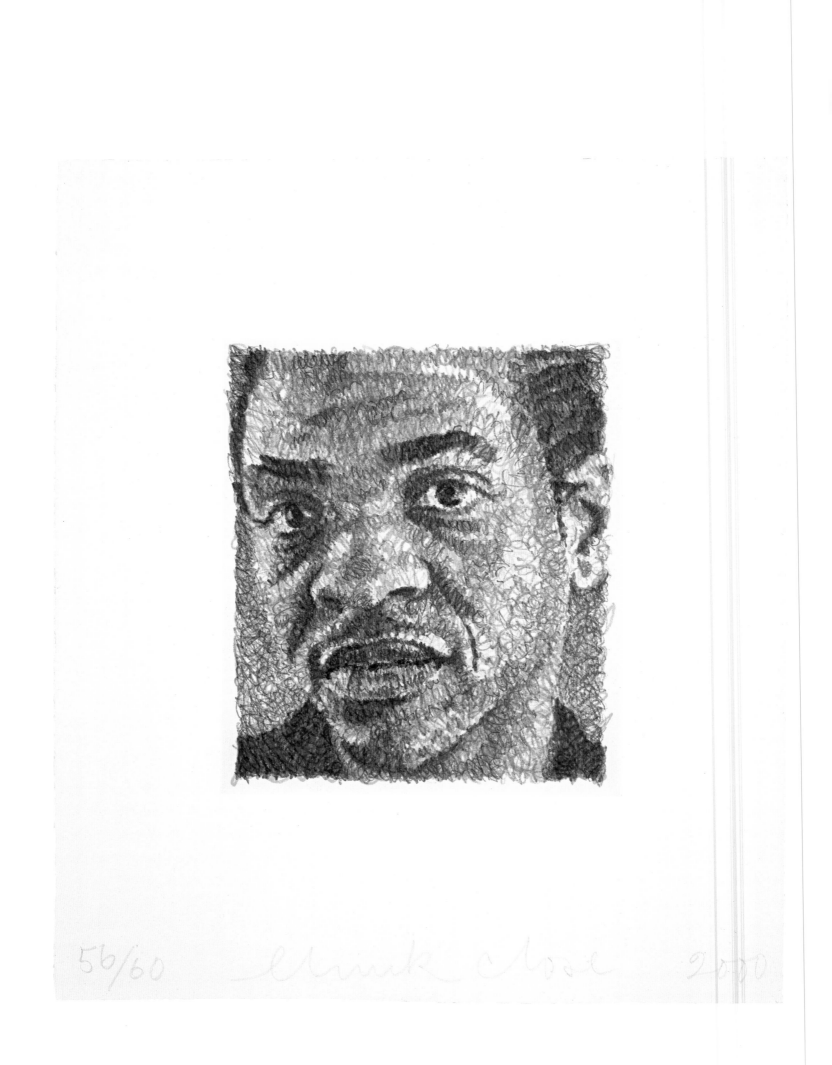

56/60 Chuck Close 2000

Scribble Etching

BILL HALL AND JULIA D'AMARIO, PACE EDITIONS, INC.

ALMOST ALL OF CHUCK CLOSE'S PRINTS are based on the same grid system he uses in his paintings. However, making the scribble etchings takes a different approach: drawing several layers of doodlelike lines that come together as an image. To talk about the scribble etchings *Lyle* (plate 111) and *Self-Portrait/Scribble/Etching Portfolio* (plates 112–36), Terrie Sultan met with Close and Bill Hall and Julia D'Amario of Pace Editions, Inc., at the Pace Editions offices in New York on July 23, 2002.

TS: What gave you the idea for the multicolor scribble etchings?

CC: Around 1970 I had the idea to try a print at Tyler School of Art in Philadelphia that was based on full-color paintings I was making that were created with only red, yellow, and blue layers. I had the idea to make my own separations for a print by drawing the magenta and transferring that onto a plate with soft ground, and then cyan and then yellow, on three separate plates. I did an experiment, but wasn't pleased. It didn't seem to have the kind of control I wanted. But I filed it away in the back of my head. It always gnawed at me that I hadn't managed to do it. Almost thirty years later, I made a collaborative Exquisite Corpse drawing for the Drawing Center. I made the head from red, orange, yellow, green, and purple lines, and I thought, hmmm, here's a chance to go back and take another crack at that idea of separating my own drawings.

BH: Chuck came into the shop and said, "I've got an idea." He asked, "How many plates can you print successively and have the full representation of that ink not be lost in the course of the printing, and the paper not be degraded after so many times through the press?" In other words, how many plates could one

PLATE 111
Lyle, 2000
8-color soft-ground etching
18¼ x 15¼ in.
(46.3 x 38.7 cm)
Edition of 60
Pace Editions Ink,
New York, printer
(Julia D'Amario,
Bill Hall, Kathy Kuehn,
Jessica Miller)
Pace Editions, Inc.,
New York, publisher

print together for a single image? We thought about it a little bit and said, "How about six?" because we were thinking in terms of one color, one plate each day for six successive days, because you can't keep paper dampened much longer than that or it may start to mold. You have to keep the dampness controlled for exact registration purposes. And Chuck said, "How about twelve?"

CC: I am always pushing the envelope.

JD'A: Well, we were just as adaptable. We thought we could print three colors a day, wet on wet, and adjust the color to account for the offset. So we did three colors a day for four days, and did a twelve-color print.

BH: We both said we would try it. Julia made tests using plates coated with soft ground and a strong Japanese paper for the drawing. We built an apparatus in the shop to mount a projector overhead, pointing straight down, so that Chuck could project a slide of the image onto a prepared plate positioned horizontally below.

CC: Ordinarily I never use projection, because I don't want to make decisions in the dark, and the projector wiggles. Usually, once I can get a grid on, I can gauge where I am in the drawing. However, two bodies of work required projection. One was the reduction linocuts, for registration purposes. The other was the scribble etchings, because I couldn't use a grid and I couldn't do a preparatory drawing. The Japanese paper is hinged in a matboard frame. Sandwiched between this paper and the plate is a piece of newsprint that is used to pick up the soft ground.

JD'A: Through this process the quality of Chuck's pencil marks on the final print is the same as on the original drawing, and simultaneously, a finished drawing is being created by the layering of the marks.

CC: I would scribble in the magenta, say, and that would go through the drawing and the newsprint, pulling the soft ground off the plate, opening up areas of the plate for exposure to the acid. We would put each plate in the acid, keeping track of which plate was intended for each color. I had brought in a lot of colored pencils, and we matched the ink to the color of each pencil that I used.

TS: Did you work from an already completed drawing?

CC: No, I worked from a gridded photograph, like I do for the paintings. The difference is that the drawing is not created via a grid, only through scribbles. That's why I had to start with a projected image of the photograph. After two or three

colors I hardly used the projector at all. We would print a couple of colors, I would check how the colors were stacking up, and I then would proceed with more colors. The number of colors in each one is different. The first self-portrait had the most colors at twelve. Lyle had the fewest, at eight, and the last self-portrait was nine.

JD'A: We learned a lot from the first self-portrait, and that helped make Lyle and the second self-portrait easier. For example, we realized that we could leave the plates in the acid a little longer, to give them more tooth. We also fine-tuned the mechanics of the hinged drawing/newsprint/plate apparatus. Chuck did the nine plates for Lyle in a day and a half. Everything just seemed to flow so easily.

BH: We also knew we would have to go through a proofing stage, adjusting the colors back and forth. And we didn't print them in the order in which they were drawn.

CC: Since we were printing several colors, wet into wet, we had to select related colors that wouldn't interfere with each other.

BH: To minimize plate cleaning, we would take several reds, do them in one day, and then print the blue and turquoise colors together, etc.

CC: They would show me comparison proofs in which the colors had been printed in different orders, and I would choose which one I liked best.

JD'A: We kept very good notes. You have to. We would write on the bottom of the paper in colored pencil the order of the printing. In this kind of work you can't depend too much on your memory.

TS: How long did it take to complete the *Self-Portrait/Scribble/Etching Portfolio?*

JD'A: Well, we started the project in 1998 and finished just a couple of months ago [the end of January 2002]. We had to print all the state proofs and the progressive proofs as editioned images, which we don't normally do. All together the process took about two and one-half years, with several long breaks between editioning the finished print and completing the portfolio of state proofs and progressives.

BH: It was one of those projects where even though the plate making was as straightforward as it could be, the proofing and the editioning were incredibly time-consuming. Also, when you have a lot of plates, you have to factor in a good bit of loss.

JD'A: Losing a print because of a mistake on plate ten is a very depressing thing. So you have to be very methodical.

TS: It is interesting that with the *Self-Portrait* scribble etchings you decided to include all the progressives and state proofs along with the final image as one work of art, boxed as a set almost like an artist's book. Normally, all the viewer sees is the editioned image. Why do you feel that showing the stages is essential?

CC: It's something I have been interested in from the start. Also, I wanted to demystify the process so that people understand how things happen. I don't think it detracts at all from the experience of the final print to understand how it got there; in fact, it adds something. In my very first exhibition at the Museum of Modern Art we showed *Keith/Mezzotint* with all the progressive proofs (plate 30).

BH: It was amazing to see Chuck take a red pencil and start drawing where he saw red from top to bottom, and make marks that identified the red, and then go on to the next plate and see where the blue should go. It was magical to watch that. I think the progressive and state proofs serve as visual representations of that.

CC: I came of age in the 1960s, when minimal, reductive, and process issues were certainly in the air, like those wonderful Sol LeWitt wall drawings with blue lines one way and other lines another way. That is something I was always aware of, and it interested me a great deal. I really did believe that process would set you free. Instead of having to dream up a great idea—waiting for the clouds to part and a bolt of lightning to strike your skull—you are better off just getting to work. In the process of making things, ideas will occur to you. If it isn't right the first time, you alter the variables and do something else. You never have to be stuck. I have never had painter's block in forty years, because all I have to do is alter one variable, and I have a whole new experience in the studio. I have plenty of time to dream up other things that I want to do. Showing how the prints got made really interests me. It's like exploding the singular view of things into a sequential plan. There are so many other things to look at other than iconography, so many other things to experience. Style is often embedded in process and not connected to iconography. A signature style is about how it happened, not what is made. I think of myself as an orchestrator of experience. I make experiences for people to look at.

PLATES 112–36
Self-Portrait/Scribble/ Etching Portfolio, 2000
Portfolio of 12 states, 12 progressives, and 1 final signed print
Soft-ground etching
18¼ x 15¼ in. (46.3 x 38.7 cm)
Edition of 15
Pace Editions Ink, New York, printer (Bill Hall, Julia D'Amario, Jessica Miller, Kathy Kuehn)
Pace Editions, Inc., New York, publisher

Pages 133–38:
States 1–12 (top row)
Progressives 1–12 (bottom row)

Page 139:
Final signed print

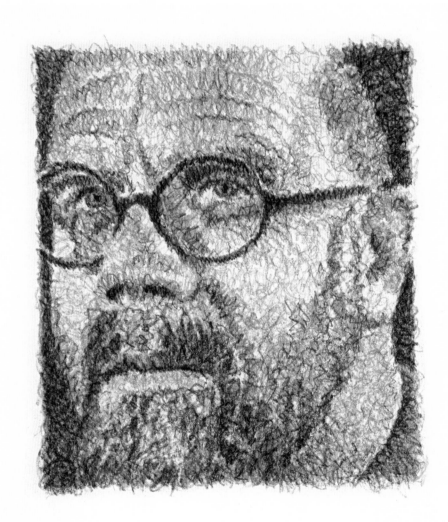

9/15 2000

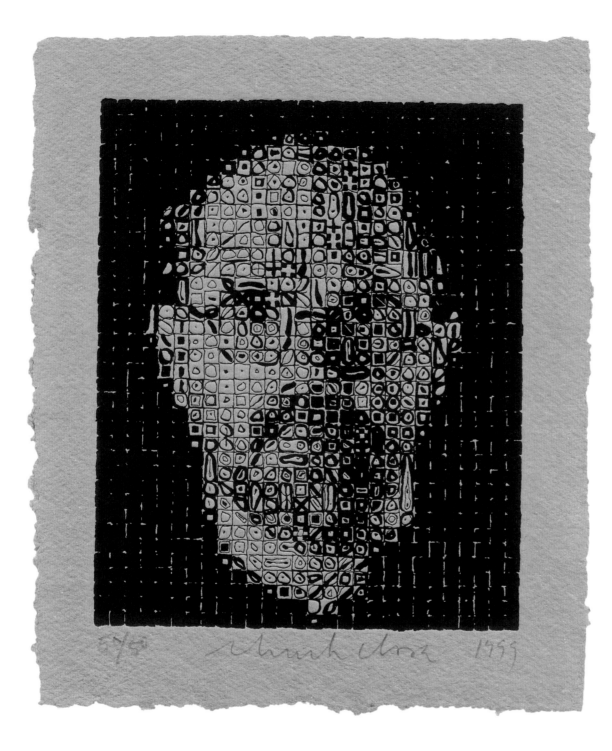

▪ PLATE 137
Self-Portrait I, 1999
(black ink on gray paper)
Relief print with
embossment
25½ x 20½ in. (64.7 x 52 cm)
Edition of 50
Two Palms Press,
New York, printer and
publisher (Pedro Barbeito,
David Lasry)

CHRONOLOGY

A Career in Printmaking

COMPILED BY ALEXANDRA IRVINE

THE FOLLOWING IS A HISTORY OF EVENTS, significant exhibitions, excerpts, and publications pertaining to Chuck Close's printmaking oeuvre. For more complete documentation of the artist's life and career, please refer to the chronology compiled by Fereshteh Daftari in Chuck Close (New York: Museum of Modern Art, 1998).

1940
Chuck Close is born in Monroe, Wisconsin.

1958–62
Close attends the University of Washington, Seattle. He receives his B.A. in 1962.

1962–64
Close attends graduate school at Yale University, where he serves as assistant to master printer Gabor Peterdi. He receives an M.F.A. in 1964.

1972
At the urging of Bob Feldman of Parasol Press, Close works with Kathan Brown of Crown Point Press in Oakland, California, on Keith/Mezzotint (plate 28). Parasol Press publishes an edition of ten prints. The Museum of Modern Art in New York purchases one of the edition for its permanent collection. The work is later considered seminal, as it is Close's first piece in any medium in which the grid is left exposed in the final work. Judith Goldman later writes, "For the mezzotint as for the painted continuous-tone portraits, Close used a grid to square off work areas. In the portrait, he painted the grid away. In the mezzotint Keith, he left a remnant of the grid across the face; fragmenting the face, the grid casts doubt on the photographic reality. By revealing his scaffolding, the artist anchors the portrait to its process and his hand. Keith marks the beginning of the artist's move toward abstraction. After 1972, the grids regularly appear in the paintings."[1]

1973
Keith/Mezzotint, shown in conjunction with its nineteen progressive proofs, is the focus of Close's first exhibition at New York's Museum of Modern Art, Project 11: Chuck Close/Liliana Porter, January 11–February 25, 1973. New York Times critic James R. Mellow writes, "The heady air of experiment and improvisation is one of the characteristic features of contemporary art. . . . As part of its continuing 'Projects' series, the museum is showing what it refers to as 'probably the largest mezzotint ever made.' It was executed by Chuck Close, the painter who has made a reputation by painting 9-by-7-foot portrait heads, rendered in pore-by-pore detail. The mezzotint measures 3 feet by almost 4 feet. . . .The print, which represents the artist's first attempt in the graphics medium, is quite respectable. But I suspect that the air of 'modern innovation' has been pumped into the event to make it appear more important than it actually is. What we have is a decent example of printmaking, much like any other example of printmaking, only a bit larger in scale."[2]

Brunelle, Al. "Reviews: Chuck Close at MoMA." ARTnews 72, no. 4 (April 1973): 73.

Dyckes, William. "A One-Print Show by Chuck Close at MoMA." Arts Magazine 47 (December 1972/January 1973): 73.

Frank, Peter. "Chuck Close and Liliana Porter." ARTnews 72, no. 4 (April 1973): 73.

Mellow, James R. "'Largest' Mezzotint, by Close, Shown." New York Times, January 13, 1973.

1974
Loring, John, "Photographic Illusionist Prints," Arts Magazine 48 (February 1974): 43.

1975
Close works with Jack Lemon and David Keister at Landfall Press in Chicago to create his first lithograph, Keith/Four Times (plate 2), where he is challenged by the parameters of the medium. The two-color lithograph was made from eight stones, several of which broke during proofing, requiring the artist to redraw the image a number of times before the image could be printed.3

Chuck Close: Keith, Mint Museum of Art, Charlotte, North Carolina, January 5–February 2, 1975. Traveled to Ball State University Art Gallery, Muncie, Indiana; Phoenix Art Museum, Arizona, June 1–29; The Minneapolis Institute of the Arts, July 18–August 31.

Recent American Etching, Davison Art Center, Wesleyan University, Middletown, Connecticut, October 10–November 23, 1975. Traveled to National Collection of Fine Arts, Smithsonian Institution, Washington, D.C., January 21–March 27, 1976. Catalogue, text by Richard S. Field.

1977
Chuck works for several months in his studio creating the plate for Self-Portrait (plate 32), an etching printed at Crown Point Press by Patrick Foy, with whom he also works on the aquatint etching Self-Portrait/White Ink (plate 33).

1978
Shapiro, Michael. "Changing Variables: Chuck Close and His Prints." Print Collector's Newsletter 9, no. 3 (July/August, 1978): 1, 70–73.

1979
Harshman, Barbara. "Photo-Realist Printmaking." Arts Magazine 53 (February 1979): 17.

1980
Steve Anderson, from Vermillion Editions in Minneapolis, comes to New York to help Close create his first fingerprint lithographs, including Phil/Fingerprint (plate 1). Pressing his fingers and thumb into lithography ink, Chuck works directly on an aluminum plate to avoid the previous pitfalls encountered with fragile lithography stones.

Printed Art: A View of Two Decades, The Museum of Modern Art, New York, February 13–April 1, 1980. Catalogue, text by Riva Castleman.

Close Portraits, Walker Art Center, Minneapolis, September 28–November 16, 1980. Traveled to The Saint Louis Art Museum, December 5, 1980–January 25, 1981; Museum of Contemporary Art, Chicago, February 6–March 29; and Whitney Museum of American Art, New York, April 14–June 21. Catalogue, text by Martin Friedman and Lisa Lyons.

1981
Close begins working with independent printer and papermaker Joe Wilfer on an edition of pulp-paper works at Dieu Donné Papermill, in New York City. Their experiments with different materials, techniques, and scales during the next three years produce sixteen works, including Phil III (plate 36), Self-Portrait/Manipulated (plate 40), Self-Portrait/String (plate 41), and Georgia (plate 45). In an article for Portfolio magazine, Judd Tully writes: "Close's new large portraits, executed in paper pulp in twenty-two shades of grey, break fresh artistic ground. Paper pulp and new techniques seem to have inspired Close not only with new ideas but also with new energy: in the previous fifteen years, Close had produced only five editions in various print media; in eighteen months, he and Wilfer have completed fourteen editions."4

Photographer as Printmaker: 140 Years of Photographic Printmaking, organized by The Arts Council of Great Britain, London. Traveled within Great Britain to Ferens Art Gallery, Hull, August 5–30, 1981; Museum of Art, Leicester, September 16–October 18; Talbot Rice Centre, Edinburgh, October 28–November 28; The Cooper Gallery, Barnsley, December 19, 1981–January 17, 1982; The Photographer's

Gallery, London, March 11–April 11. Catalogue, text by Gerry Badger.

American Prints: Process and Proofs, Whitney Museum of American Art, New York, November 25, 1981–January 24, 1982. Catalogue, text by Judith Goldman.

1982

Chuck Close: Paperworks, Richard Gray Gallery, Chicago, September–October 1982. Traveled to John Stoller Gallery, Minneapolis, October–November; Jacksonville Art Museum, Florida, December 10, 1982–January 19, 1983; Greenberg Gallery, St. Louis, September 10–October 15.

Perreault, John. "Paperworks." American Craft 42, no. 4 (August/September 1982): 2–7.

Worts, Melinda. "New Editions." ARTnews 81, no. 4 (April 1982): 102.

1983

Tully, Judd. "Paper Chase." Portfolio 5, no. 3 (May/June 1983): 78–85.

1984

Chuck Close: Handmade Paper Editions, Herbert Palmer Gallery, Los Angeles, February 4–March 16, 1984. Traveled to Spokane Center Gallery of Art, Eastern Washington University, Cheney, April 5–May 12; Milwaukee Art Museum, June 1–September 30; Columbia Museum of Art, South Carolina, November 18, 1984–January 13, 1985. Catalogue, text by Richard H. Solomon, published by Pace Editions, Inc.

The Modern Art of the Print: Selections from the Collection of Lois and Michael Torf, Williams College of Art Museum, Williamstown, Massachusetts, May 5–July 16, 1984, and Museum of Fine Arts, Boston, August 1–October 4. Catalogue, text by Clifford S. Ackley, Thomas Krens, and Deborah Menaker.

1985

Close creates a series of eleven fingerprint etchings at Graphicstudio in Tampa, with master printer Deli Sacilotto. Working in a method called direct gravure, the artist draws using his inked fingers, although this time on sheets of Mylar rather than directly on the printing plate. The image is transferred to the copper plate using a sensitized carbon tissue. In a later conversation with Arnold Glimcher, Close remarks: "The fingerprint is a very personal mark; even though it's more personal and physical, the way I'm working is still similar in the way the paintings are constructed or 'built.' I still work incrementally. The increments are now fingerprints."[5]

Chuck Close: Works on Paper, Contemporary Arts Museum, Houston, February 9–April 21, 1985. Brochure, text by Edmund P. Pillsbury.

1986

Close creates his first Japanese-style woodblock print, Leslie (plate 3), working in Kyoto with Japanese master printer Tadashi Toda and master carver Shunzo Matsuda.

Public and Private: American Prints Today, the Twenty-fourth National Print Exhibition, Brooklyn Museum of Art, New York, February 7–May 5, 1986. Traveled to Flint Institute of Arts, Flint, Michigan, July 28–September 7; Rhode Island School of Design, Providence, September 29–November 9; Museum of Art, Carnegie Institute, Pittsburgh, December 1, 1986–January 11, 1987; Walker Art Center, Minneapolis, February 1–March 22. Catalogue, text by Barry Walker.

Chuck Close: New Etchings, Pace Editions, New York, February 12–March 22, 1986.

Seventies into Eighties: Printmaking Now, Museum of Fine Arts, Boston, October 22, 1986–February 8, 1987. Catalogue, text by Clifford S. Ackley, David P. Becker, and Barbara Stern Shapiro.

1987

The Anderson Collection: Two Decades of American Graphics, 1967–1987/Prints, Monotypes, Works on Paper, Stanford University, Stanford, California, September 29, 1987–January 3, 1988. Catalogue, text by Betsy G. Fryberger.

Lyons, Lisa, and Robert Storr. Chuck Close. New York: Rizzoli, 1987.

1988

Works in New York with renowned French master printer Aldo Crommelynck on his first spitbite aquatint, Self-Portrait (plate 63). Deborah Wye notes: "Crommelynck garnered

particular fame for his ability to achieve glowing tonal gradations of aquatint. The spit-bite variation of aquatint afforded Close's compositions new expressive possibilities, and the ongoing dialogue between artist and printer had a character all its own."[6]

Close also completes Lucas (plate 70), a seven-step reduction block/linoleum cut print, working with Joe Wilfer, Ruth Lingen, and Kathy Kuehn at Spring Street Workshop in New York. In an article published in 1992 in American Art, Close describes the process: "The technique of reduction block printing utilizes a single printing block of linoleum that is carved and edition printed at each state—in seven different steps, in this case. There is no proofing, no room for error. The linoleum block can only be cut away further. With the final printing the edition is complete. The block, with more and more material having been removed at each state, has in a sense canceled itself."[7]

Chuck Close: Prints and Photographs, Pace Editions, New York, September 23–October 22, 1988.

1989
Chuck Close, The Art Institute of Chicago, February 4–April 16, 1989. Traveled to The Friends of Photography, Ansel Adams Center, San Francisco, November 8, 1989–January 7, 1990. Catalogue, text by Colin Westerbeck.

First Impressions: Early Prints by Forty-six Contemporary Artists, Walker Art Center, Minneapolis, June 4–September 10, 1989. Traveled to Laguna Gloria Art Museum, Austin, Texas, December 2, 1989–January 21, 1990; Baltimore Museum of Art, February 25–April 22; and The Neuberger Museum of Art, Purchase College, State University of New York, June 21–September 16. Catalogue, text by Elizabeth Armstrong and Sheila McGuire.

Aldo Crommelynck: Master Prints with American Artists, Whitney Museum of American Art at Equitable Center, New York, August 31–November 7, 1989. Catalogue, text by Adam D. Weinberg.

Chuck Close Editions: A Catalogue Raisonné and Exhibition, The Butler Institute of American Art, Youngstown, Ohio, September 17–November 26, 1989. Catalogue, text by Jim Pernotto.

Chuck Close: Works on Paper, Aldrich Museum of Contemporary Art, Ridgefield, Connecticut, October 29, 1989–February 25, 1990.

1991
The Unique Print, The Pace Gallery, New York, January 25–February 23, 1991.

Contemporary Woodblock Prints from Crown Point Press, Edison Community College, Fort Myers, Florida, April 13–May 24, 1991. Catalogue, text by Susan Tallman.

Chuck Close Editions, University Art Museum, University of Southwestern Louisiana, Lafayette, September 7–October 24, 1991.

Graphicstudio: Contemporary Art from the Collaborative Workshop at the University of South Florida, National Gallery of Art, Washington, D.C., September 15, 1991–January 5, 1992. Catalogue, text by Ruth E. Fine and Mary Lee Corlett.

1992
Johnson, Mark M. "Chuck Close: Editions." Arts & Activities III, no. 4 (May 1992): 18–21.

1993
Close and Wilfer travel to Wisconsin to work on a linoleum cut at Tandem Press. After a series of disappointments and disasters, the piece, Alex/Reduction Block (plate 72), is eventually editioned as a silk screen, printed by Robert Blanton at Brand X Editions in New York.

After nearly four years of planning, Lucas/Rug (plate 24) is produced by the Rugao Arts and Crafts Silk Carpets Factory in Rugao, Jiangsu, China. Each rug in the edition of twenty took three months to produce. The hand-knotted silk rug is described as "a logical extension of his work. While silk can't literally be built up layer upon layer, like paint, small lozenges and dots of color are woven next to each other to create the illusion of depth, as if blue overlaid lavender and a spot of brilliant red shone on top. From some angles, the piece seems to be composed of pure abstract color. From other angles, the image is clear: a portrait of the artist Lucas Samaras."[8]

American Color Woodcuts: Bounty from the Block, 1890s–1990, Elvehjem Museum of Art, University of Wisconsin, Mil-

waukee, January 30–April 4, 1993. Catalogue, text by James Watrous and Andrew Stevens.

Chuck Close Editions, Pace Editions, New York, March 20–30, 1993.

A Print Project by Chuck Close, The Museum of Modern Art, New York, July 24–September 28, 1993. Brochure, text by Andrea Feldman.

Malcolm, Daniel R. "Print Project by Chuck Close." Print Collector's Newsletter 24, no. 5 (November/December 1993): 178.

1995
Chuck Close: Recent Editions: Alex–Chuck–Lucas, Pace Editions, New York, March 10–April 13, 1995.

Printmaking in America: Collaborative Prints and Presses, 1960–1990, Mary and Leigh Block Gallery, Northwestern University, Evanston, Illinois, September 22–December 3, 1995. Traveled to The Jane Vorhees Zimmerli Art Museum, Rutgers, State University of New Jersey, New Brunswick, April 23–June 18; The Museum of Fine Arts, Houston, January 23–April 23, 1996; National Museum of American Art, Smithsonian Institution, Washington, D.C., May 10–August 4. Catalogue, text by Trudy V. Hansen, David Mickenberg, Joann Moser, and Barry Walker.

Chuck Close: Alex/Reduction Block, Lannan Foundation, Los Angeles, September 30, 1995–January 7, 1996.

Dellinger, Jade R. "Chuck Close." Printmaking Today 45, no. 1 (Spring 1995): 13–14.

1996
Master Printers and Master Pieces, Kaohsiung Museum of Fine Art, Taiwan, February 16–June 2, 1996.

Landfall Press: Twenty-five Years of Printmaking, Milwaukee Art Museum, September 13–November 10, 1996. Traveled to Chicago Cultural Center, March 15–May 8, 1997; Davenport Museum of Art, Davenport, Iowa, September 14–November 17; Springfield Museum of Art, Ohio, March 13–May 9, 1999. Catalogue, text by Joseph Ruzicka.

Brown, Kathan. Ink, Paper, Metal, Wood: Painters and Sculptors at Crown Point Press. San Francisco: Chronicle Books, 1996.

Tallman, Susan. The Contemporary Print from Pre-Pop to Postmodern. New York: Thames and Hudson, 1996.

1997
Finders/Keepers, Contemporary Arts Museum, Houston, May 10–August 3, 1997. Catalogue, text on Close by Alexandra Irvine.

Twenty-five Years at Crown Point Press: Making Prints, Doing Art, National Gallery of Art, Washington, D.C., June 8–September 1, 1997; Traveled to Fine Arts Museum of San Francisco, California Palace of the Legion of Honor, October 4, 1997–January 4, 1998. Catalogue, text by Karin Breuer, Ruth E. Fine, and Steven A. Nash.

1998
Chuck Close, The Museum of Modern Art, New York, February 26–June 2, 1998. Traveled to Museum of Contemporary Art, Chicago, June 20–September 13; Hirshhorn Museum and Sculpture Garden, Smithsonian Institution, Washington, D.C., October 15, 1998–January 10, 1999; Seattle Art Museum, February 18–May 9; The Hayward Gallery, London, July 22–September 19. Catalogue, text by Robert Storr, Kirk Varnedoe, and Deborah Wye.

PhotoImage: Printmaking 60s to 90s, Museum of Fine Arts, Boston, July 7–September 27, 1998. Traveled to Des Moines Art Center, Iowa, March 5–May 9, 1999. Catalogue, text by Clifford S. Ackley.

Chuck Close: Prints, Virginia Lynch Gallery, Tiverton, Rhode Island, September 27–October 25, 1998.

Brody, Jacqueline. "Chuck Close: Innovation through Process, An Interview." On Paper 2, no. 4 (March/April 1998): 18–26.

1999
Working with David Lasry and Pedro Barbeito at Two Palms Press in New York, Close produces Self-Portrait I (plate 137; black ink on gray paper) and Self-Portrait II (white ink on black paper). The relief print process involved making a laser-cut acrylic plate onto which either black or white ink was rolled. In a subsequent exhibition catalogue, Barry Schwabsky writes: "In the pair of self-portraits shown here . . . the images appear to be almost identical, but subtly each one turns the other inside out: In one, the 'positive'

elements are printed in black on a white ground while in the other, we see the 'negative' spaces around the abstract forms printed in white on a black ground. The artist's face stares out at us as though daring us to try and see through the illusion he weaves and unweaves."9

Chuck Close: Prints and Photographs, John Berggruen Gallery, San Francisco, January 12–February 17, 1999.

2000

Working with Pace Editions, Inc., Close creates two soft-ground etchings, Lyle (plate 111) and Self-Portrait/Scribble/Etching Portfolio (plates 112–36), which is editioned as a box set, containing the twelve progressive and twelve state proofs in addition to the final etching. New York Times critic Roberta Smith comments, "In his latest prints—12-color soft-ground etchings—Mr. Close unravels things to a degree that goes beyond his loosest paintings. In 12 single-color etchings, he picks out the constituent colors of a self-portrait photograph with delicate massings of marks and scribbles that verge on abstraction. A second series of 12 prints progressively combines the different colors, culminating in the finished, full-color print. The result is a bravura performance on a small stage that is unlike anything he has done in years, if ever. It will be interesting to see if this process, which completely dispenses with the grid, affects his paintings."10

On April 26, Chuck Close, Ruth Lingen, Richard Solomon, and Joseph Wilfer are presented the Dieu Donné Art Award honoring their contributions to the field of paper art.

Chuck Close: Recent Prints, Pace Prints, New York, April 8–May 6, 2000.

Chuck Close: Paperworks, Dieu Donné Papermill, New York, April 22–June 3, 2000.

Hard Pressed: 600 Years of Prints and Process, organized by the International Print Center of New York. Traveled to AXA Gallery, New York, November 2, 2000–January 2001; Boise Art Museum, Boise, Idaho, March 3–May 6; Museum of Fine Arts, Santa Fe, June 8–September 9; Naples Museum of Art, Naples, Florida, October 16, 2001–January 6, 2002. Catalogue, text by David Platzker and Elizabeth Wyckoff.

Chuck Close, Worcester Art Museum, Worcester, Massachusetts, December 9, 2000–March 25, 2001. Brochure.

Smith, Roberta. "Chuck Close." New York Times, April 7, 2000.

2001

Under Pressure: Prints from Two Palms Press, Lyman Allyn Museum of Art at Connecticut College, New London, February 2–April 1, 2001. Traveled to The Schick Art Gallery, Skidmore College, Saratoga Springs, New York, July 12–September 16; Meadows Museum, Southern Methodist University, Dallas, October 22–December 8; University Gallery, University of Massachusetts at Amherst, February 2–March 15, 2002; Kent State University Art Gallery, Kent, Ohio, September 4–28. Catalogue, text by Barry Schwabsky.

Chuck Close Self-Portraits, 1967–2001, Fraenkel Gallery, San Francisco, March 8–April 28, 2001.

Digital Printmaking Now, Brooklyn Museum of Art, New York, June 21–September 2, 2001. Catalogue, text by Marilyn Kushner.

From Rags to Riches: Twenty-five Years of Paper Art from Dieu Donné Papermill, organized by Dieu Donné Papermill, New York. Traveled to Kresge Art Museum, Michigan State University, September 4–October 28, 2001; Maryland Institute College of Art, Baltimore, November 9–December 16; Beach Museum of Art, Kansas State University, Manhattan, Kansas, April 2–June 30, 2002; Heckscher Museum of Art, Huntington, New York, November 23, 2002–January 26, 2003; Milwaukee Art Museum, April 11–June 22; and Fort Wayne Museum of Art, Indiana, July 26–November 2. Catalogue, edited by Mina Takahashi.

2002

After Close works with master printer Yasu Shibata for over two years, the Japanese woodblock print Emma (plates 20 and 97) is completed.

Chuck Close: Portraits, The American Academy in Rome, February 22–April 21, 2002.

Chuck Close Prints, The Neuberger Museum of Art, Purchase College, State University of New York, September 29–December 29, 2002. Brochure, text by Dede Young.

Chuck Close: Three New Editions, Pace Prints, New York, November 1–December 4, 2002.

2003

Chuck Close Prints: Process and Collaboration, Blaffer Gallery, the Art Museum of the University of Houston, September 13–November 23, 2003. Traveling to The Metropolitan Museum of Art, New York, January 13–April 18, 2004; Miami Art Museum, May 14–August 22, 2004; Knoxville Museum of Art, Tennessee, October 29, 2004–March 27, 2005; Mint Museum of Art, Charlotte, North Carolina, April 16–August 7, 2005; Addison Gallery of American Art, Andover, Massachusetts, September 6–December 4, 2005; Modern Art Museum of Fort Worth, April 16–June 18, 2006; Fine Arts Museum of San Francisco, California Palace of the Legion of Honor, July 14–September 24, 2006; Bellevue Art Museum, Washington, October 22, 2006–January 7, 2007; Orange County Museum of Art, Newport Beach, California, January 28–April 20, 2007. Catalogue, text by Terrie Sultan and Richard Shiff.

NOTES

1 Judith Goldman, "Chuck Close," in American Prints: Process and Proofs, exh. cat. (New York: Whitney Museum of American Art, 1981), 68.

2 James R. Mellow, "'Largest' Mezzotint, by Close, Shown," New York Times, January 13, 1973.

3 Jim Pernotto, "A Note on Chuck Close," in Chuck Close Editions: A Catalogue Raisonné and Exhibition, exh. cat. (Youngstown, Ohio: Butler Institute of American Art, 1989), n.p.

4 Judd Tully, "Paper Chase," Portfolio 5, no. 3 (May/June 1983): 82, 85.

5 "Dialogue: Arnold Glimcher with Chuck Close," in Chuck Close: Recent Work (New York: Pace Gallery, 1986), n.p.

6 Deborah Wye, "Changing Expressions: Printmaking," in Chuck Close, exh. cat. (New York: Museum of Modern Art, 1998), 77.

7 Chuck Close, "Janet," American Art 6, no. 2 (Spring 1992): 58.

8 http://masterworksfineart.com/inventory/close.htm.

9 Barry Schwabsky, "Between Matter and Memory: Reflections on Some Prints by Two Palms Press," in Under Pressure: Prints from Two Palms Press, (New London, Conn.: Lyman Allyn Museum of Art at Connecticut College, 2000), n.p.

10 Roberta Smith, "Chuck Close," New York Times, April 7, 2000.

GLOSSARY

This list of terms is not intended as a complete compendium but rather to assist the reader in understanding the many printmaking processes employed by Chuck Close. Please refer to the sources listed at the end of the glossary for more complete information on the history and techniques of printmaking.

There are four traditional printmaking methods:

INTAGLIO Images are produced by ink held in recessed areas of the printing plate. Intaglio methods include aquatint, engraving, dry point, etching, mezzotint, and spitbite.

PLANOGRAPHIC Images are produced on a flat printing surface, using chemicals to adhere ink to areas of the surface. Lithography is the preeminent example of planographic printing.

RELIEF Images are produced on a raised printing surface. Linocut, woodblock, and woodcut are all relief printing processes.

STENCIL Images are printed by pushing ink through the cut-away areas of a stencil. Types of stencil printing include pochoir and screen printing, or silk screen (also called serigraphy).

AQUATINT A form of intaglio in which the metal plate is dusted or covered with acid-resistant powder (rosin or asphaltum). Areas not covered by the coating when the plate is immersed in acid are etched, creating a pitted or grainy surface. These tonal areas can be further manipulated and are often used in conjunction with line etching. See *Self-Portrait/White Ink* (plate 33).

ARTIST'S PROOF (AP) A small number of prints, reserved specifically for the artist's use, made at the same time as the editioned prints.

BAREN A handheld burnishing tool traditionally used in Japanese printmaking. Constructed of bamboo and lacquered paper, this slightly convex tool is about five inches in diameter and is used to apply pressure to the paper when using woodblock or woodcut techniques. Rubbing the *baren* over the back of the paper transfers the ink from the block to the paper.

BITE The etching or corrosion produced on a metal plate when it is submerged in an acid bath.

BRAYER A hand roller used to apply ink to a printing surface.

BURIN A tapered, rod-shaped steel tool with a square or lozenge-shaped tip used for engraving metal or end-grain wood plates. Also called a graver.

BURNISH In intaglio printing, the process of rubbing or smoothing the raised metal surface of the plate, using a metal tool to compact the tooth of the printing surface. It is used in mezzotint to create the whites and is sometimes used as a method to correct mistakes. In relief printing, burnishing refers to the printing process, in which an image is transferred from an inked block to paper by hand rubbing.

BURNISHER A curved hand tool, such as a burin, used for smoothing or polishing the plate in the intaglio process. In

relief printing, it can be any tool used to print an inked surface by rubbing.

DIRECT GRAVURE A variation of the photogravure printing technique, developed by Chuck Close and master printer Deli Sacilotto while working on the fingerprint gravure portraits executed at Graphicstudio in Tampa, Florida, in 1986. For this fingerprint gravure series, Close used lithography ink to make fingerprint drawings on sheets of Mylar. The image was then photographically transferred to a copper etching plate. See Leslie/Fingerprint (plate 22).

DOT SCREEN A method of adding a tone to a printed image by imposing a transparent sheet of dots or other patterns on the image at some stage of a photographic reproduction process.

DREMEL A motorized hand tool with different types of attachments, used for carving into wood or metal.

DURATRANS A large-scale transparency or color film positive. Illuminated from behind, it is primarily used for advertising signage. Also called a translight.

EDITION A set of identical impressions produced serially from the same plate. Editioned prints are sequentially numbered, with the total number of prints written below the individual print number.

EMBOSSING An inkless technique used to create a slightly raised or three-dimensional effect by using pressure on a flat surface so that the paper takes on the physical characteristics of the relief plate or block. See Self-Portrait I (plate 137).

ETCHING An intaglio process that uses acid to bite an image into a metal plate. The plate is coated with an acid-resistant emulsion or ground, through which the image is drawn or scratched with a needle. The plate is then placed in an acid bath that penetrates or bites into the exposed areas, creating the depressions that will hold the ink. See Lyle (plate 111).

ETCHING NEEDLE A pointed steel tool used to scratch into a metal etching surface.

GOUGE A tool used for cutting into a wood or linoleum block. Points of various sizes and shapes can be used to create a V- or U-shaped groove.

GROUND A waxy or resinous substance that resists the acid used in intaglio processes.

HAND LOOM A weaving process in which individual strands of yarn are shuttled by hand through a warp of other strands to create a piece of material. See Lucas/Rug (plate 24).

HANDMADE PAPER The traditional technique of papermaking, in which a selected fiber (cotton, linen, or another plant fiber) is macerated and then suspended in water to form a pulpy liquid, or slurry. The slurry is contained in a vat. A wood framed mesh screen is lowered into the vat. When lifted from the vat, the screen is shaken as the water drains off to achieve an even distribution of fibers. The pulp can also be applied to the screen by hand. This formed sheet is then dried by air, so the sheet contracts, or in a press, using different backings to create varied effects. See Georgia (plate 45) and Self-Portrait/Pulp (plate 46).

HARD GROUND An acid-resistant substance used in etching that contains asphaltum, beeswax, and rosin. See Self-Portrait (plate 32).

IRIS PRINT A high quality inkjet print specifically produced by an Iris printer from a digital computer file; also known as a Giclée print. The Iris printer is capable of producing a continuous tone image on paper with a resolution of 1800 dots per inch.

LINOLEUM CUT OR LINOCUT A relief print in which the image has been carved from a surface of battleship linoleum (a soft linoleum with no grain), usually mounted on wood. See Lucas (plate 70).

LITHOGRAPHY The planographic printing method in which an image is drawn, using greasy ink or litho crayons, directly on the flat surface of a limestone or aluminum plate treated to accept ink and repel water. The image is fixed to the surface by a coating of acid and gum arabic, which lightly etches the stone or plate, not altering the height or depth of the stone. This mixture enhances the ability of the sections of the stone or plate that are not drawn on to hold water. During printing, the plate or stone is kept wet at all times by sponging. Oil-based ink is then rolled over the surface. The wetness of the negative areas of the plate rejects the ink, ensuring that the ink will stick only to the drawing. Images are

transferred from plate to paper by means of a press. See Keith/Four Times (plate 2).

MATRIX The physical, ink-holding base from which the print image is derived, such as an etching plate, lithography stone, or woodblock.

MEZZOTINT Meaning "half-tint" or "half-tone," it is the mechanical intaglio technique in which an entire metal plate is roughened to create a burr that holds ink, producing a dark background. The artist works from dark to light, using a rocker to burnish or smooth the surface to create areas that hold less ink. In this way, a full range of tones is produced. Because this method is so labor-intensive, mezzotints are usually small. This printing process, though relatively uncommon today, was widely used for portraiture in the eighteenth and nineteenth centuries. See Keith/Mezzotint (plate 28).

MYLAR A thin, transparent plastic sheet used for registration of the print or as a surface for an image to be drawn on in order to transfer the drawing to the plate photographically. Mylar is specifically used for these purposes because it is dimensionally stable, not stretching or shrinking when exposed to water.

PHOTOGRAVURE A photographic intaglio printing method using sensitized carbon tissue to produce an image on the printing plate. The carbon tissue is exposed to light to harden the emulsion, which remains softest where the image on the Mylar is darkest. Once exposed, the carbon tissue is adhered face down on the copper printing plate.

POCHOIR A French term for hand-coloring a print using a stencil. See Lucas/Woodcut (plate 106).

PROGRESSIVE PROOFS A series of trial prints showing each color separately, that are made in preparation for a multicolor print.

PUBLISHING The relationship between an artist and publisher in which the publisher funds a print edition in exchange for a percentage of the profits. The publisher may be involved in the printing process or may hire someone to execute the edition.

REDUCTION BLOCK A type of relief print made by alternately cutting and printing the same block, working from lighter to darker colors. See Alex/Reduction Block (plate 72).

REGISTRATION The precise alignment of the paper and printing plates—for example, when printing multiple colors—to ensure that each successive impression aligns correctly.

RESIST Any substance applied to a printing ground to prevent adhesion of another substance, such as ink.

ROCKER A steel tool with a serrated, curved front edge used in mezzotint to abrade the surface of the plate.

SILK SCREEN A form of stencil printing in which an image is produced by using a squeegee to push ink through a stretched mesh fabric (historically silk). Nonprinted areas of the screen are blocked off using a resist. See John (plate 80). Also called screen printing. See Lyle (plate 93).

SOFT GROUND A method of etching in which a nondrying or pliable acid-resistant ground is applied to a plate that produces softer lines and textures than hard-ground etching. The artist draws on a piece of paper placed over the plate. The pressure of the pencil or pen lifts the ground off the plate, exposing the plate for etching in acid. See Lyle (plate 111).

SPITBITE An aquatint method in which nitric acid is applied directly to the etching plate with a brush coated with water or saliva to help control the acid. See Phil Spitbite (plate 66).

SQUEEGEE A tool with a handle and a broad, hard rubber or plastic blade used to push the ink through the screen when producing silk-screen prints.

STATE PROOFS The series of trial prints that are made after each stage in the printing process, from start to finish. See Self-Portrait/Scribble/Etching Portfolio (plates 112–36).

TAPESTRY A heavy, handwoven, and often reversible textile used as a wall hanging, usually characterized by complicated pictorial designs. See Phil/Tapestry (plate 23).

TINT TOOL A tool used in intaglio processes and wood engraving for producing delicate detail lines or very fine hatch marks.

UKIYO-E The classic Japanese form of woodblock printing, historically used for making large quantities of popular images. In this type of relief printing, many individual blocks of wood are carved, often by a professional woodcutter, and then fitted together to form the printing surface. The use of water-based inks results in delicate, translucent colors similar to the effects of watercolor painting. The printing paper is placed on top of the inked blocks, and an impression is made by hand rubbing with a *baren*, rather than using a press. See Alex (plate 94).

WOODBLOCK The incised wooden plank or shaped wood blocks that hold the ink from which a woodcut is printed.

WOODCUT The oldest form of relief printing, in which portions of a woodblock are cut away using knives, gouges, and chisels. Ink is rolled over the elevated areas of the block, and absorbent paper is pressed onto the surface, transferring the image. See Lucas/Woodcut (plate 106).

SOURCES

Goldman, Judith. *American Prints: Process & Proofs.* Exh. Cat. New York: Whitney Museum of American Art, 1982.

Heller, Jules. *Printmaking Today: An Artist's Handbook.* New York: Holt, Rinehart and Winston, 1972.

Martin, Judy. *The Encyclopedia of Printmaking Techniques.* Philadelphia: Running Press, 1993.

Mayer, Ralph. *A Dictionary of Art Terms and Techniques.* New York: Barnes and Noble Books, 1981.

Saff, Donald, and Deli Sacilotto. *Printmaking: History and Process.* Tampa: University of South Florida, 1978.

Tallman, Susan. *The Contemporary Print: From Pre-Pop to Postmodern.* London: Thames and Hudson, 1996.

ACKNOWLEDGMENTS

IN 1994 THE WRITER PAUL GARDNER called me for an article he was preparing for ARTnews, posing questions to curators and critics about underrecognized artists deserving more attention. Chuck Close leaped to my mind immediately. Although certainly acknowledged as a challenging and provocative artist, it seemed that he had not enjoyed the broad and deep exploration that his career warranted since the 1980 retrospective organized by the Walker Art Center. Shortly thereafter I invited myself to Close's studio, hoping to learn more about what was behind the magnificent facades of his iconography. Since then, of course, Close has been the subject of a number of highly regarded exhibitions—including a full-scale retrospective organized by The Museum of Modern Art in 1998. What developed over the course of our conversations was an emphasis on the nature of Close's studio process, and this led to the idea for a project that would explore, in depth, one specific aspect of his work. Chuck Close Prints could not have seen the light of day without the incredible generosity of time and spirit that Chuck has dedicated to the project, patiently guiding me through the many aspects of his printmaking to ensure that this exhibition accurately addresses the nuances of process and collaboration so necessary to the success of each of his prints.

In 1989 The Butler Institute of American Art in Youngstown, Ohio, developed Chuck Close Editions: A Catalogue Raisonné and Exhibition. This exhibition was the first to explore this aspect of Close's career, and I found it a valuable starting point.

I would like to express my gratitude to Ruth Lingen, Julia D'Amario, Bill Hall, Yasu Shibata, and Mae Shore of Pace Editions, Inc.; Bob Blanton and Tom Little of Brand X Editions; Kathan Brown of Crown Point Press; Karl Hecksher; and Paul Wong of Dieu Donné. These master printers took hours out of their busy schedules to talk with me about their work. In a happy coincidence, almost all were engaged in various stages of a Close project, and I was able to see firsthand just how complicated and intertwined his diverse prints are. I would also like to thank Donald Traver at Pace Editions, Inc., for his help and his good cheer during the photographing, framing, crating, and shipping of more than 135 objects. Dick Solomon, president of Pace Editions, Inc., deserves a special note of appreciation for providing such a rich and creative environment in which artists and printers can work together.

Richard Shiff has contributed an insightful and enlightening essay. My colleague Alexandra Irvine created an informative chronology of Chuck's career as a printmaker to date, chasing down the myriad details that make such a document an important record.

Blaffer Gallery intern Rachel Freer accomplished a similar task, assembling a straightforward glossary of print terms to which readers can refer. Christopher French lent his skill and acumen as an editor, helping me distill some 70,000 words of interviews into a more manageable 15,000, making sense of the technical and aesthetic interactions necessary for the print medium. Publisher Nancy Grubb, designer Patricia Fabricant, and the art group at Princeton University Press worked diligently and creatively to produce this important book.

Special thanks to the staff at Blaffer Gallery, the Art Museum of the University of Houston, who were warmly supportive and attentive in all aspects of this project: Kim Howard, development director; Nancy Hixon, assistant director and registrar; Karen Zicterman, museum administrator; Paige Hebert, curator of education; Youngmin Chung, assistant registrar; Carrie Markello, education coordinator; Kelly Bennett, security and information services; Alexandra Irvine, director of public relations and membership; and to our colleagues in the School of Education, Bernard Robin, associate professor of instructional technology, and Sara Wilson McKay, assistant professor for art education.

I am very appreciative of my brother and sister-in-law, Donald and Susan Sultan, for generously offering a quiet place in the country where I finished the manuscript.

TERRIE SULTAN

I WISH TO JOIN TERRIE SULTAN in thanking all those who have made the exhibition and the accompanying book possible and for their efforts to present my work in such a lucid and intelligent manner. Special thanks to Terrie herself for spearheading these projects and effectively bringing them to fruition.

I also want to single out the publishers who have brought my various prints and multiple projects to a wide audience. Bob Feldman of Parasol Press convinced me to make prints in the first place, producing several costly and successful projects. Kathan Brown, first as a printer for the Parasol Press and later as the publisher of Crown Point Press, took me to Japan and exposed me to another form of collaboration with the traditional ukiyo-e woodcut prints. Recently, I have been happily involved with David Lasry of Two Palms Press.

Most of all, I wish to express my deep appreciation to Dick Solomon, with whom I have had the most significant and fruitful relationship and with whom I have made most of my prints since the late 1970s. His generosity, patience, understanding, and support of the myriad print projects over the years have helped to generate the work of which I am most proud.

Finally, I must pay tribute to the late Joe Wilfer—hired by Dick at my urging—with whom I collaborated more than anyone. I miss him and his voice on these pages.

CHUCK CLOSE

EXHIBITION TOUR

Blaffer Gallery, the Art Museum of the University of Houston
SEPTEMBER 13–NOVEMBER 23, 2003

The Metropolitan Museum of Art, New York
JANUARY 13–APRIL 18, 2004

Miami Art Museum
MAY 14–AUGUST 22, 2004

Knoxville Museum of Art, Tennessee
OCTOBER 29, 2004–MARCH 27, 2005

Mint Museum of Art, Charlotte, North Carolina
APRIL 16–AUGUST 7, 2005

Addison Gallery of American Art, Andover, Massachusetts
SEPTEMBER 6–DECEMBER 4, 2005

Modern Art Museum of Fort Worth
APRIL 16–JUNE 18, 2006

Fine Arts Museum of San Francisco, California Palace of the Legion of Honor
JULY 14–SEPTEMBER 24, 2006

Bellevue Art Museum, Washington
OCTOBER 22, 2006–JANUARY 7, 2007

Orange County Museum of Art, Newport Beach, California
JANUARY 28–APRIL 20, 2007

Boise Art Museum
MAY 12–AUGUST 11, 2007

Portland Art Museum
OCTOBER 6, 2007–JANUARY 6, 2008

INDEX

Published by Princeton University Press in association with Blaffer Gallery, the Art Museum of the University of Houston, on the occasion of the exhibition Chuck Close Prints: Process and Collaboration

Princeton University Press, 41 William Street, Princeton, New Jersey 08540
In the United Kingdom: Princeton University Press, 3 Market Place, Woodstock, Oxfordshire OX20 1SY
www.pupress.princeton.edu

Blaffer Gallery, the Art Museum of the University of Houston
120 Fine Arts Building, Houston, Texas 77204-4018
www.blaffergallery.org

For exhibition venues, see page 154.

The exhibition and publication were organized for Blaffer Gallery, the Art Museum of the University of Houston, by Terrie Sultan, Director
Project Manager, Blaffer Gallery: Alexandra Irvine
Editor, Blaffer Gallery: Christopher French

Publisher, Art Group, Princeton: Nancy Grubb
Art Book Production Coordinator: Sarah Henry
Production Manager: Ken Wong
Managing Editor: Kate Zanzucchi
Fine Arts Production Editor: Devra K. Nelson
Editorial Assistant: Cynthia Grow

Designed by Patricia Fabricant
Composed by Tina Thompson
Printed by Grafiche SiZ, Verona, Italy

Printed and bound in Italy
(Cloth) 10 9 8 7 6 5 4 3 2
(Paper) 10 9 8 7 6 5 4 3 2

Library of Congress Cataloging-in-Publication Data
Sultan, Terrie, 1952–
 Chuck Close prints : process and collaboration / Terrie Sultan; with an essay by Richard Shiff.
 p. cm.
 Exhibition at Blaffer Gallery, the Art Museum of the University of Houston, Sept. 13–Nov. 23, 2003.
 Includes index.
 ISBN 0-691-11576-1 (cl.) — ISBN 0-691-11577-X (pbk.)
 1. Close, Chuck, 1940– —Exhibitions. I. Close, Chuck, 1940– II. Shiff, Richard. III. Blaffer Gallery. IV. Title.

NE539.C56A4 2003
769.92—dc21 2003048297

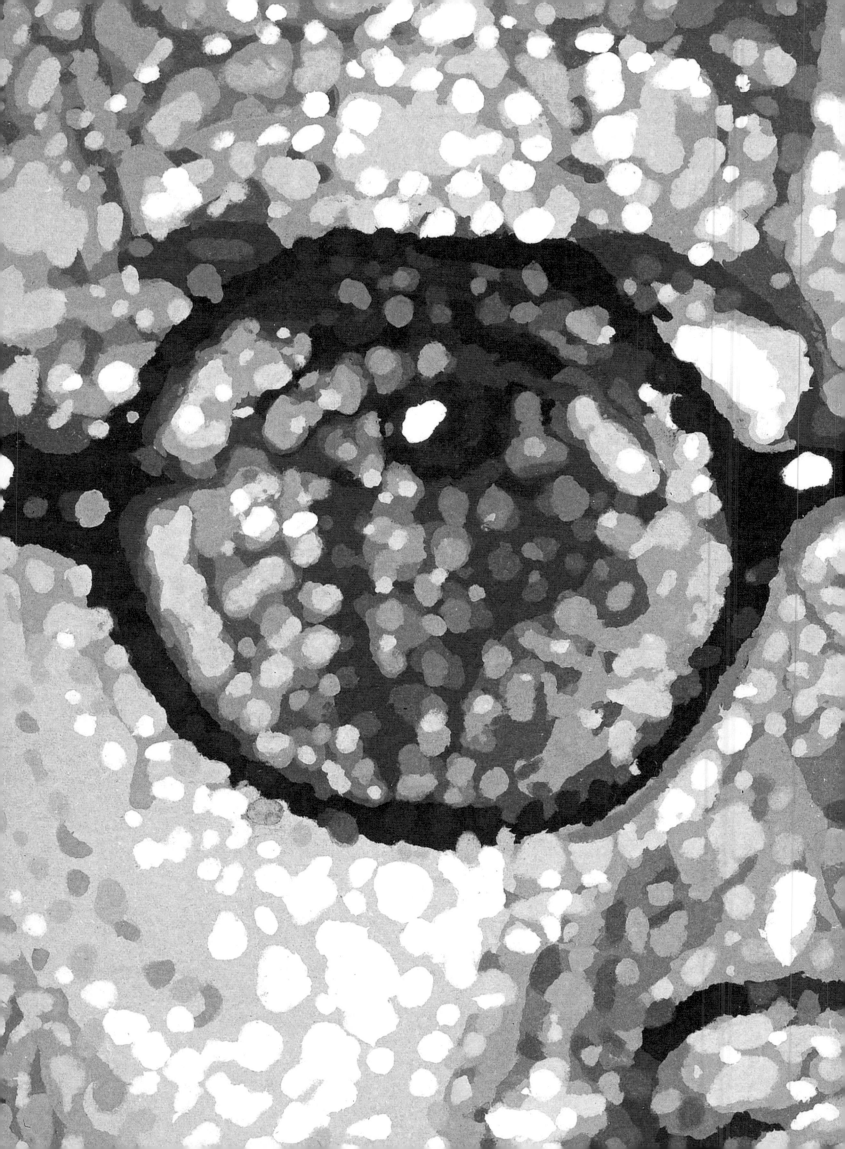